AUSTIN'S
FIRST
COOKBOOK

AUSTIN'S FIRST COOKBOOK

Our HOME RECIPES, REMEDIES and RULES of THUMB

MICHAEL C. MILLER

In Partnership with the Austin History Center

AMERICAN PALATE

Published by American Palate
A Division of The History Press
Charleston, SC 29403
www.historypress.net

All images are courtesy of the Austin History Center, Austin Public Library.

First published 2015

ISBN 978.1.5402.1295.5

Library of Congress Control Number: 2015932940

Notice: The information in this book is true and complete to the best of our knowledge. It is offered without guarantee on the part of the author or The History Press. The author and The History Press disclaim all liability in connection with the use of this book.

CONTENTS

Acknowledgements

The genesis of this book project originated with an exhibit at the Austin History Center, Austin Public Library, held in 2013. The exhibit, "How to Prepare a Possum: Nineteenth-Century Cuisine in Austin," explored all avenues of early Austin food, including what food was indeed local, how food was prepared, how and where people shopped for food, what it cost and where people went out to eat. One of the finds in the exhibit we were most excited about was uncovering *Our Home Cookbook*, published for the First Cumberland Presbyterian Church in 1891. After a little research, it was determined that this little book was in all likelihood the very first cookbook published in Austin. The copy at the Austin History Center was showing its age with loose binding and brittle pages. Only two other copies of this book have been located— one at the University of Texas at Austin and one at Texas Women's University in Denton, Texas. It became apparent to me that we were at risk of losing this book, but one way to preserve the book was to reprint it. But more than just reprinting the cookbook, we wanted to try to tell the stories behind the book—the women who created the recipes, the women who owned the History Center's copy and a look at the storied history of cookbook publishing in Austin. We hope that by telling these stories alongside these recipes, you will have a greater appreciation and understanding of Austin's culinary past. And when you buy this book, you get to help the continued preservation of our history, with all royalties from the sale of this book going to the Austin History Center.

Many people play a role in the making of a book, directly and indirectly. I have many to thank, but if I forget someone, all I can do is beg forgiveness. First I would like to thank all the staff at the Austin History Center, past, present and future. The work that is done here, and at archival institutions across the country, is so vital to preserving and celebrating our culture and history. The fact that copies of the original cookbook still exist for our enjoyment today is testament to the hard work that archivists do to preserve our history. I especially thank the AHC's exhibits team, Steve Schwolert and Grace McEvoy, and my volunteer/intern/researcher Amy Wolfgang for the work done on the "How to Prepare a Possum" exhibit that inspired this project, as well as all the current staff at the center for doing your jobs so well and making mine easier. Also, my current intern Molly Odintz did much of the yeoman work in preparing the cookbook bibliography and deserves much of the credit for its completion. I would also like to thank all the local food writers in Austin (and we have a bunch here) whose work helped guide our thoughts and research into the exhibit and this cookbook project. I am especially thankful to Addie Broyles, food writer/blogger at the *Austin American-Statesman*; MM Pack, food writer/blogger and chef; Elizabeth Engelhardt, American studies professor at UT; and Marvin Bendele, director of Foodways Texas, for your willingness to talk food history with me as I worked on the "Possum" exhibit project. I also thank Christen Thompson of The History Press for your patience with missed deadlines and your support and enthusiasm for the project.

I also thank my family for your support. Thanks to East Texas mystery writer extraordinaire Maryann Miller for reviewing a draft of the manuscript and offering suggestions—thanks, Mom! To my wonderful daughters Becky and Kat, thanks for your willingness to try new foods, and I'm glad you enjoyed the cranberry muffins. And to my awesome wife, Corina, thanks for putting up with me when I brought work home and my moods when it wasn't going well (especially the day before this manuscript was due and the file was corrupted, losing two months of work; I promise the cloud of curse words will dissipate eventually).

INTRODUCTION

Home to many food festivals and renowned eateries, Austin is becoming known nationally (and even internationally) as a "foodie" town. Austin chefs and restaurants are featured on shows on the Food Network and Travel Channel, and Austin has been at the forefront of the trailer food "revolution" that is transforming how Americans eat out. But for most people, food begins in their own kitchens, and this experience is flavored by the cookbook library that they maintain.

In Austin's earliest years, recipes (or "receipts," the preferred term of the time) were usually handwritten, and those homes with cookbooks had manuscript cookbooks or books published outside of Austin. For most homes, though, cooking was handled by those who learned to cook from their mothers or another relative, and the dishes were prepared so often that no written recipe was required. This was especially evident in more well-to-do households that used slave labor prior to the Civil War, and domestics and servants after the war, to produce the daily meals. Those who owned cookbooks may have had ones that they or their families brought with them from "back East" (for the Anglo immigrants to the area).

Austin's first cookbook was *Our Home Cookbook*, printed by Eugene Von Boeckmann in 1891 for the First Cumberland Presbyterian Church. It is reproduced in its entirety here, including all the front and end matter and handwritten notes in the copy that is housed in the archives at the Austin History Center (AHC), Austin Public Library. Like the vast majority of Austin cookbooks published (see the cookbook history essay at the end of

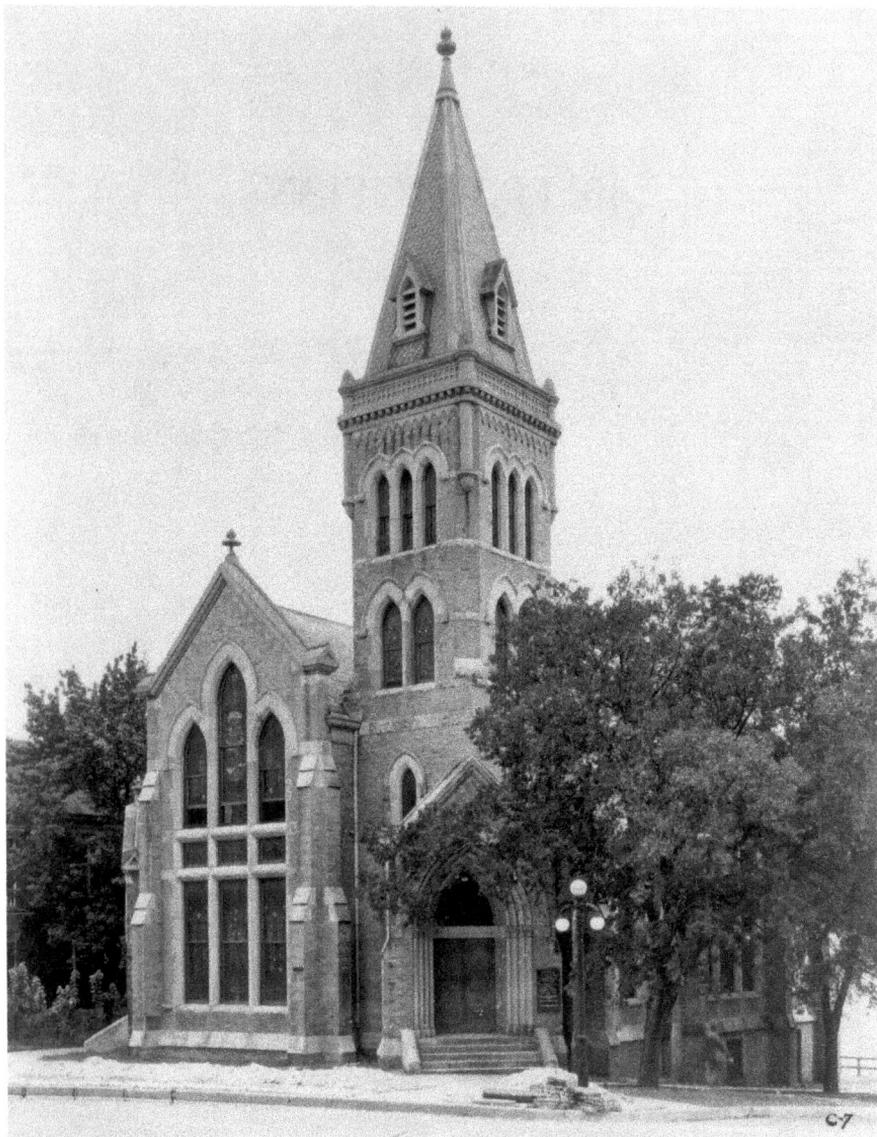

Cumberland Presbyterian Church. *C01317, Russell Chalberg Photo Collection, AHC.*

the cookbook), this cookbook was a fundraiser for a local organization—in this case, the Cumberland Presbyterian Church.

The Cumberland Presbyterian Church is one of the oldest congregations in Austin and can trace its roots to the 1840s. Members met in one another's

homes or in a building on Congress Avenue for a couple years until they built their first building, a log cabin at Seventh and Lavaca Streets, in 1846. When the locals began the church, they decided to affiliate with the Cumberland Presbyterians. The Cumberlands split off from the Presbyterian USA Church in Tennessee in 1810 over a disagreement on predestination (the Cumberland Church did not believe in it). For the first few years, they relied on traveling preachers. Reverend A.D. Crisman became the first permanent pastor in 1853. Shortly after the Civil War, they built a second, larger building on the same site that served as their house of worship until 1892, when they built their permanent sanctuary. It is quite possible this cookbook was used to help raise funds for this capital project.

In 1906, the national Presbyterian churches merged under the aegis of Presbyterian USA, but the issue of predestination remained as a theological split. Once again, the Cumberland Church split away. This had an impact on the local church, as the Cumberland congregation assumed they owned their sanctuary, but the Texas Supreme Court ruled in a lawsuit that the Presbyterian Church USA owned it. The church had to meet in members' homes or other spaces. The sanctuary building was bought by the Central Baptist Church, and a few years later, in 1914, it sold the building back to the Cumberland congregation. It would serve as their home for another forty-one years until they sold the property to build on a new site in northeast Austin.

In 1956, the Cumberland Church built a new sanctuary, designed by architect Doyle M. Baldridge, at 6800 Woodrow. At the time it was completed, it had one of only three pipe organs in the United States. No record can be found of whether members printed another cookbook to help construct their new building. The church expanded its campus in 1968, adding a gym, chapel and new education facilities designed by architect Robert Hill. The congregation continues to meet and is going strong.

THE WOMEN BEHIND THE COOKBOOK

Mrs. Paul F. Thornton and Mrs. I.V. Davis, parishioners of the church, compiled the more than three hundred recipes contributed by eighty-nine women. Medora M. (Rogers) Thornton was the wife of Judge Paul Fitzhugh Thornton. She was born in Clinton, Missouri, and married Paul on January 11, 1872. They had eight kids. Her uncle, General Willis A. Gorman, served

as the territorial governor of Minnesota. Sadly, she passed away shortly after the cookbook was published, on December 1, 1892. Her obituary described her as "possessing a naturally vigorous mind, highly cultivated by extensive reading and association with all classes of society, for her presence was more frequent in the house of the mourning and in the humble dwellings of the poor than the home of the wealthy." In addition to serving as one of the editors of the volume, she contributed seven of her own recipes: Dixie Biscuits, Perfection Bread, Beef Loaf, Italian Snow, Grape Preserves, Sugar Cookies and Mince Meat (for pies). Her partner, Lucy Lanier (Goodrich) Davis, contributed the most recipes of all the contributors with twenty-five, covering almost all categories in the original book. Lucy was married to Isaac Van Zandt Davis, a former employee of the Texas General Land Office and a real estate agent. Recipes she contributed include Beef Pot Pie, Roast Partridges, Mock Sweetbreads (using mutton or veal, oysters and beef suet to mimic the sweetbread), Apple Dumplings, Prohibition Fruit Cake, Fig Paste, Apple Custard, Beef Cutlets, Cream Toast, Stewed Leg of Mutton, Veal Cutlets, Consomme and Tea.

Thornton and Davis, like the other women who contributed recipes, were largely anonymous, including being identified by their husbands' names, and most often all that is known about them is through the work and achievements of their husbands. Few women worked outside the home, and most were expected, and indeed even trained, to take care of their homes and families, including preparing enjoyable and nutritious meals. Thornton and Davis acknowledge this responsibility in their original introduction to the cookbook: "A palatable and easily digested meal is a *sine qua non* to peace at home." They continue: "We toss into the lap of the inquiring house-wife, a feast of good things which is warranted to dispel the incubus hanging over an expected meal, a family dining, or a more ceremonious lunch."

The few who contributed and whose stories can be teased out of the available documents represent a cross section of Austin and some of Austin's more prominent families. The woman who contributed the most recipes next to Lucy Davis was Alice Tiller Littlefield, wife of George Littlefield, with thirteen recipes. She was born in 1846 in Virginia and moved with her family to Houston in 1855. It was there that she met her husband, George, in 1861, then a captain in the Confederate army. Littlefield made a fortune as a cattleman and banker, and they moved to Austin in 1883. They were also noted philanthropists, giving millions to The University of Texas at Austin. The Home Economics Building on the UT campus was dedicated in Alice's honor. The Littlefield building, located at Sixth and Congress, was the home

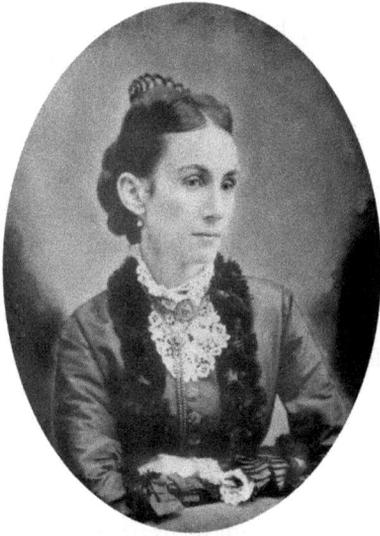

Alice Payne Tiller Littlefield. *C07945, Russell Chalberg Photo Collection, AHC.*

for his bank, the American National Bank. Alice Littlefield also founded the Senior Helping Hand of Austin, the first children's home in Austin. An adventurous cook may want to try her Mock Turtle or Calf Head Soup found on page 12. Other contributions from her include Corn Bread, Boiled Ham, Chicken Croquettes, Sardine Salad, Poor Sweet Potatoes, Welch Rarebit, Christmas Plum Pudding, Charlotte Russe (2), Fried Apples and Baked Apples. The AHC has a small collection of records from the Littlefield family (AR.1992.021), mostly records concerning the Driskill Hotel when they owned it.

Cumberland Presbyterians were not the only contributors to the book. The Littlefields attended the First Southern Presbyterian Church. Alice and Ellen Graham, unmarried daughters of Dr. Beriah Graham, contributed five recipes, such as Stuffed Veal, "A Lenten Dish" (a type of deviled egg dish served as a salad) and a layer cake filling. They were regular parishioners at the First Presbyterian Church. Their father was a well-respected physician in Austin, including serving as the personal physician to Sam Houston, and the former director of the Texas State Lunatic Asylum. Evelyn Bell Wright contributed seven recipes: Tomato Soup, Dried Beef, Cottage Cake, Milk Rolls, Drop Cookies, Sponge Cake and Beef Loaf. Her husband, Dr. E.B. Wright, was the pastor of the First Presbyterian Church in Austin. Other denominations got in on the act. Letitia Ann (Watkins) Walton, wife of Major William Martin Walton, contributed three recipes. The Waltons attended the First Methodist Church, and the AHC houses a portion of their papers (AR.C.010). Obviously, there was a spirit of cooperation among the Presbyterian congregations and other churches in town.

Nancy Elizabeth (Day) Driskill, wife of the cattle baron Jesse Lincoln Driskill, and her daughter Laura contributed eight recipes. J.L. Driskill built the Driskill Hotel in Austin, considered one of the finest in the South. Sadly, he lost his fortune shortly after building the hotel, and he died about a year before this cookbook was published. Nancy and Laura offered Lemon Pie,

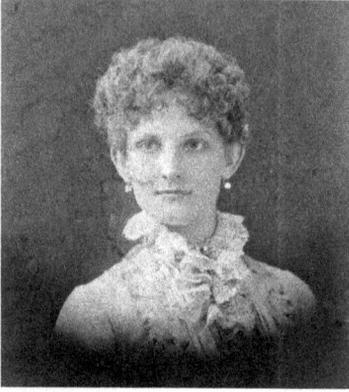

Nancy Elizabeth (Day) Driskill. *PICB 02529, AHC.*

Pineapple Ice, Eggs de la Crème (looks easy yet sinfully rich) and "How to Make Coffee" as part of their contribution.

Laura King (Allen) Orr, wife of local merchant John Orr, contributed six recipes. Laura and John married in Calvert, Texas, in 1871. In 1885, they moved to Austin, where John opened a grocery store on Congress Avenue. They split their time living in Austin and Llano, the site of their second store location. Their daughter Laura "Lollie" (Orr) Huberich opened a private school on the grounds of their home on Pearl Street, running it until she retired in 1956.

Evidence of the Orrs' love of food and cooking is evident in the records at the Austin History Center. The Orr, Huberich and Barton Family Papers (AR.Z.002; inventory online at www.lib.utexas.edu/taro/aushc/00020/ahc-00020.html) contain many handwritten and printed recipes from the homes of many of the women in the Orr and Huberich families. Among her offerings were Baked Fish and Mayonnaise Sauce, Moonshine (not the liquor, but a chilled custard-like dessert), Silver Cake, White Layer Cake and Dark Cake.

Loulie Hunter House, wife of political advisor Edward M. House, contributed two recipes: Baked Fish and Sweet Breads. Sweetbreads are "off-cuts" of meat, either the pancreas or throat/thymus gland. Loulie and Edward married in 1881 and moved to Austin after an extended honeymoon in Europe. House helped his friend James Stephen Hogg with his gubernatorial run in 1892 and developed an interest in politics. He continued to work behind the scenes in Texas politics to assist Democratic candidates and also worked on Woodrow Wilson's presidential campaign. His friendship with Wilson led to a diplomatic appointment when Wilson became president in 1912, and the Houses left Austin. They left behind one of the best examples of the Shingle style of residential architecture in Texas with their house at 1704 West Avenue. The house was demolished in 1967.

The women contributed more than three hundred recipes in a variety of categories: breads, soups, fish, meats and poultry, salads, pickles, miscellaneous dishes, pies, puddings, preserves and ices, Mexican receipts,

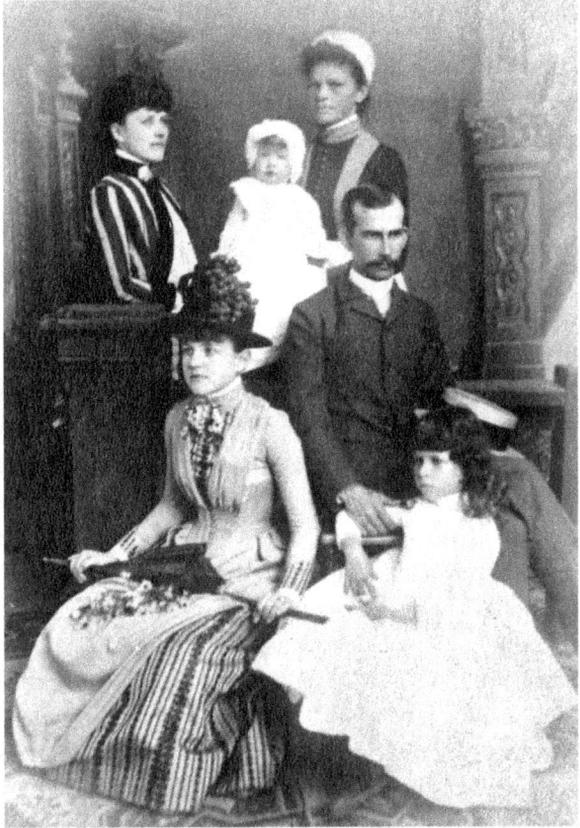

Right: The House family, *standing, left to right*: Louis Hunter House, Janet House and nurse; *seated, left to right*: Anna Hunter Mezes, E.M. House and Mona House. *PICB 04173, AHC*.

Below: The E.M. House House at 1704 West Avenue. *C07986, Russell Chalberg Photo Collection, AHC*.

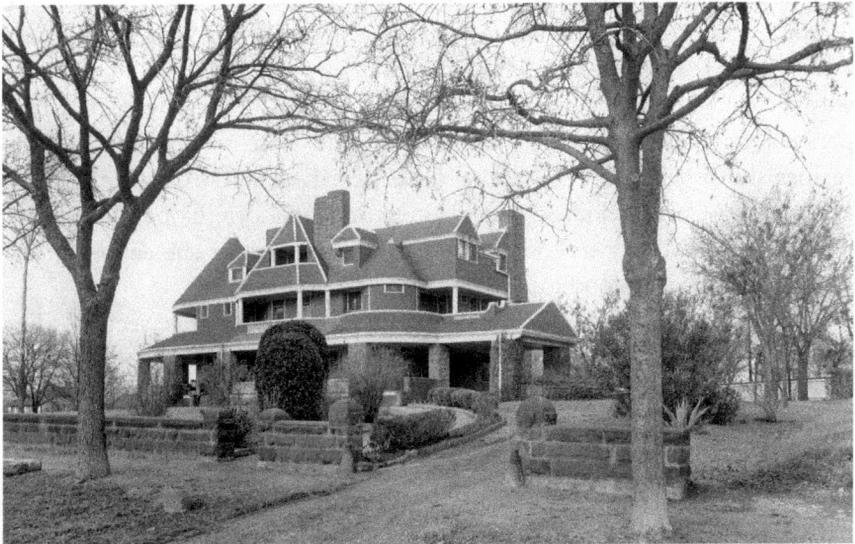

breakfast dishes, cakes, additional receipts and household receipts. The largest sections were the puddings, cakes and pies; apparently nineteenth-century Austin had an extra appreciation for dessert! In the cakes section, there are eleven recipes for fruitcakes. More likely, recipes for common or daily meals were not written down or needed. Cooks knew these dishes and could make them without any written assistance. Many of the recipes seen here appear to be special occasion dishes, made infrequently.

Two of the sections stand out: Mexican and household receipts. Austin boasted a large and vibrant Mexican American community, with many living in the southwestern area of downtown in a neighborhood called Mexico. There they lived, worked, played and ate. Mexican culture has a rich culinary tradition, and Austinites enjoyed this food. What makes this section interesting is the woman who contributed the recipes. With the many Mexican women living in Austin, it is perhaps a bit odd that an Anglo woman, Fannie Chambers (Gooch) Iglehart, contributed the six Mexican recipes. But one has to dig only a little into Fannie's life to understand. She is one of the few women mentioned here who worked outside the home, spending much of her life as a writer and student of Mexican culture. For her first book, *Face to Face with the Mexicans* (New York: Fords, Howard & Hulbert, 1887), she spent many years traveling and living in Mexico, studying the customs of everyday people. This work was received with much acclaim, earning her the honor of being named a Fellow in the Royal Society of Science, Letters & Art in London and in the American Historical Society. Her other publications were *The Tradition of Guadalupe and Christmas in Old Mexico* (Austin, 1890s) and *The Boy Captive of Mier* (San Antonio: J.R. Wood, 1909). The Texas Woman's Hall of Fame describes her as being "blessed with a firm physique, commanding presence, and subtle power, known as personal magnetism, which is known to the Mexicans as 'sympatica.'" The recipes she provided for *Our Home Cookbook*—Tamale de Cusuela, Chili y Huevos con Carne, Chili Reyenes, Quesode Almendra, Copas Mexicanas and Huevos Reales—were identical or similar to recipes she shared in the chapter on Mexican food in *Face to Face with the Mexicans*.

The other interesting section is the household receipts section. The nineteenth-century housewife, the intended audience for *Our Home Cookbook*, was expected to take care of a great many things for her family. She needed to be resourceful, and she did not have the modern conveniences enjoyed today. Dealing with a sick child did not mean a quick trip to the pediatrician or drugstore; it meant "Dr. Mom" had to whip up a home remedy to help heal minor ailments. Likewise, dry cleaners and specialty soaps, etc., were

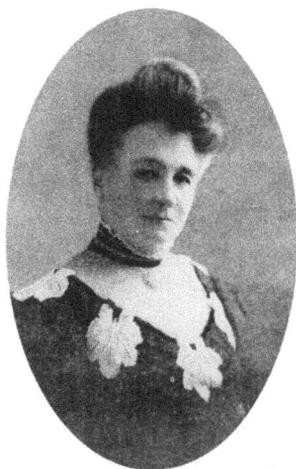

Fannie Iglehart. *PICB 04315, AHC.*

not available, so messy stains required creative cleanups. It was common in this era for women to jot down these household hints and share them with family, friends and neighbors. It was also common for cookbooks to include this section, something not often found in twenty-first-century cookbooks. Austin women provide numerous suggestions for treating bruises, coughs, neuralgia (nerve pain), poison oak, croup and burns and cleaning furniture and clothes, many of which could be used today.

The miscellaneous dishes section represents a hodgepodge of ideas, including Boston baked beans, "poor sweet potatoes," various cheese dishes (soufflés, etc.) and casseroles. Puddings seem to be very popular. This is perhaps a holdover from English colonial days, as puddings are a staple in British cooking. Charlotte Russe was a popular pudding in Austin, if this book, with six different recipes, is any indication. *Russe* is French for Russian, and it is believed this dish of ladyfingers and fruit and cream was created by Tsar Alexander I's personal chef and named in honor of his sister-in-law, Queen Charlotte. The "additional receipts" section appears to be a catchall for candies, plus lots of recipes that fit in existing categories, such as puddings and cakes.

THE WOMEN WHO OWNED THIS COOKBOOK

The specific copy of the cookbook reproduced here has an interesting history. At least one previous owner is readily identifiable, and possibly a second, and the two women associated with the book have interesting stories. Also, there are numerous notes scattered throughout the book that lend an interesting aside to our understanding of how this book may have been used.

The first name associated with this copy is "E. Kreisle." On the first blank page of the front matter of the book is a pencil notation "E. Kreisle 1902" at the top of the page, followed by a recipe. It is unclear from the available evidence if the book itself belonged to E. Kreisle or if a previous owner of the book noted a recipe provided by E. Kreisle. First of all, who was

E. Kreisle? Most likely, this is referencing Emilie Sophia (Sophie) Kreisle. Emilie was born on February 22, 1856, in Yorktown, Texas (though her obituary says Goliad), to Matthias (Matthew) and Sophia (Sophie) Kreisle. Matthias came to Texas from Germany in 1846 and worked as a merchant in Victoria, Yorktown and Goliad before moving his family to Austin in 1875. He opened a furniture store, originally partnering with Joseph Hannig, and operated a retail furniture outlet on Congress Avenue. They built their family home at 616 Trinity Avenue. The AHC has a small collection of the Kreisle Family Papers (AR.2005.002).

Emilie spent her entire time in Austin living at the Trinity Avenue home. She never married and, as near as records show, never held a job. The Kreisles were a musical family, and many of the musical textbooks owned by the family had Emilie's name inscribed inside. Little is known about her because of her lack of work history. She was known as "Big Aunt Emilie" mostly to distinguish her from her niece Emilie who lived with her for a time. She was described as wearing "severe" dresses that covered her from neck to floor. She was also remembered by her grandnephews for regularly quizzing them on the Bible and their prayer life. She died on March 18, 1937, and is

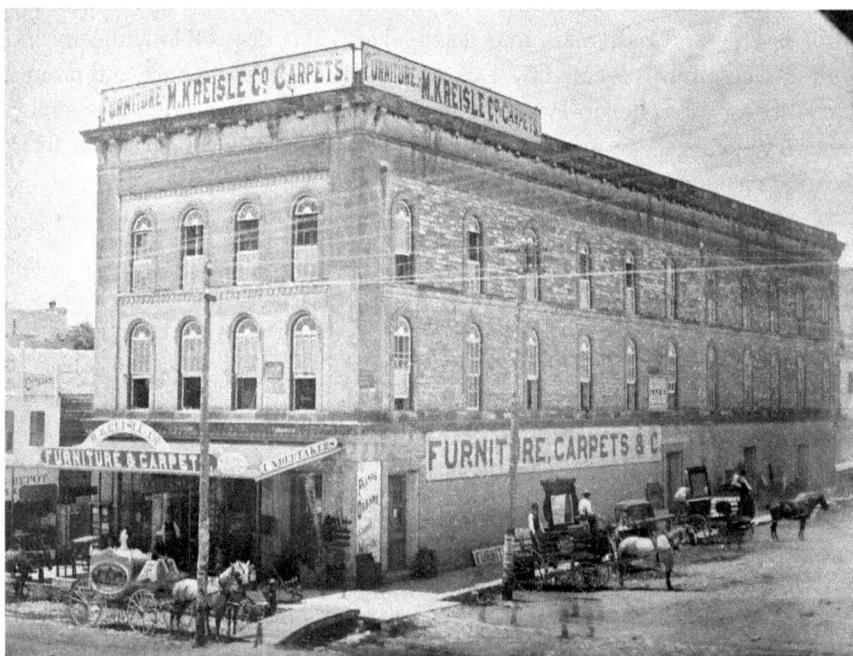

The Kreisle Store at 620–622 Congress Avenue. *C00178c, Russell Chalberg Photo Collection, AHC.*

buried in Oakwood Cemetery. After her death, the furnishings and Kreisle home were sold off, and the home was eventually demolished. Descendants of the Kreisle family continue to live and work in Austin, and archives of some of the family papers are housed at the Austin History Center.

The recipe included under Emilie's name was for cranberry muffins. She made some other notes, and the handwriting and fading of the pencil make this page almost impossible to read. Here is the best transcription possible; illegible words are noted with [???], and text inserted in brackets indicates the best guess at the illegible word or words:

E. Kreisle 1902
Austin Texas

From Mag Cumberland
Church

7 R[???]
9 [???]
66 corn fritters
7 [tin?] *biscuit*

cranberry muffins
2½ cps [cups] *sifted flo* [flour] *2½ tsp* [teaspoon] [?] *B Pow* [baking powder]
½ tsp salt 4 tbs [tablespoons] *butter or other fat*
2 well beaten eggs 1 cup cranberries coarsely
chopped 1 cup milk sift flour once
measure add BP & salt [???]
sift again [???] [butter?] [???]
grad [?] *& cream well* [add?] *Eggs combine*
crBrs [cranberries?] *& flr add to* [crumb?] *next* [altered?]
with milk small amount at a time
[???] *only enough to* [???] *bake*
in greased muffin pans in hot
oven [400 d?] *25 to 30* [minutes]
18 med[ium] *size muffins*

At first glance, the page makes little sense. Was Ms. Kreisle starting a list, perhaps for supplies for entertaining? Maybe she was participating

in a church potluck. But clearly, there is little or no connection between corn fritters and biscuits and a cranberry muffin recipe, other than the carbohydrates. And while the muffin recipe is difficult to make out and many of the words cannot be understood, there is enough here to re-create the recipe. Here is an adaptation, based on what can be read:

> 2½ cups flour, sifted
> 2½ teaspoons baking powder
> ½ teaspoon salt
> 4 tablespoons butter, softened
> 2 eggs
> 1 cup dried cranberries, chopped or whole
> 1–2 cups milk
> ¼–½ cup sugar (optional)

> Preheat oven to 400 degrees. Sift the flour, then mix in baking powder and salt. Mix in the softened butter to make a crumby dough. Beat the eggs and mix into the dough. Add the cranberries and mix well. Add milk ¼ cup at a time, mixing well, until desired consistency is reached (thicker than a cake batter, thinner than biscuit dough). Pour or spoon dough into a well-greased muffin pan and bake for about 20 minutes. If a sweeter muffin is desired, add some sugar to the dough mixture before adding milk.

The resulting muffin is denser than most muffins made today, almost like a biscuit in texture. At first glance it seemed odd that Kreisle's recipe did not include sugar, especially given how much sugar was used in the nineteenth century—far more than is used today. But when made without sugar, there is enough sweetness from the cranberries to make an enjoyable, but not too sweet, breakfast muffin.

Kreisle made more notes throughout the book, mostly cake and frosting recipes (perhaps "Big Aunt Emilie" was more than just a way to differentiate her from her niece). In addition to the notes on various pages, this recipe for some kind of cake was found on a scrap of paper inserted between pages 84 and 85:

> 1 cup sug. [sugar] 3 eggs 3 tabls [tablespoons] water
> 1½ teacup flour. 1½ teasp [teaspoons] B.P [baking powder]
> stirred through flr. Should
> be very thin when pour-
> ed in pan about ½ [???]
> when done for
> ice cream cake

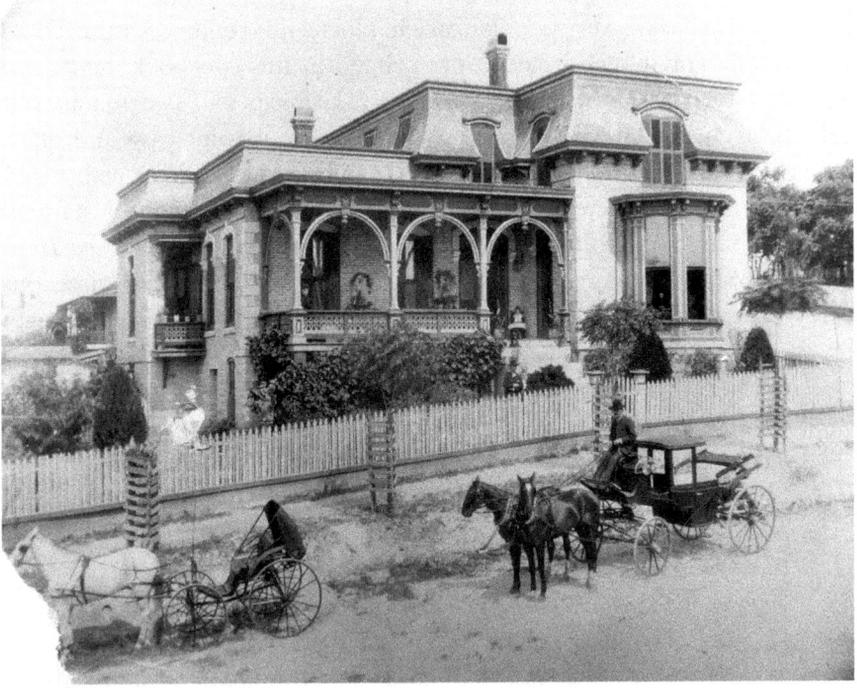

The Kreisle Home at 616 Trinity Avenue. *PICH 02850, AHC.*

When prepared as written, this makes a dense, spongy yellow cake. Perhaps it was meant to serve as the base for an ice cream cake, as the directions indicate. It does taste good with vanilla ice cream. Note that the original recipe calls for a teacup measure for the flour. It was common in the days before standardized measures (and measuring cups) for recipes to call for "teacups" or "coffee cups" in directions, with coffee cups holding about an ounce or so more in volume. You can make this recipe with a standard cup measure, but you will need about ten tablespoons of water instead of three to reach the desired consistency. Pour batter in a well-greased cake pan and bake at 350 degrees for about thirty minutes.

Kreisle also jotted down this recipe on page 98 of the original book:

Sponge Cake recipe:
4 eggs 2 scant cups sugar
2 cups flour ¾ cup boiling
water last thing. Maggie B

Sponge cake was a very popular cake in nineteenth-century Austin. There are six different sponge cake recipes printed in this cookbook, and there are more than a dozen different sponge cake recipes in two manuscript collections at the History Center. A simple cake, it is an easy and quick dessert to make for guests and family and can be served plain or with a fruit topping and whipped cream. This version, from Maggie B., possibly a friend of Emilie's, is simpler than the few sponge cake recipes found in *Our Home Cookbook*. What it lacks is preparation instructions. Following these directions will create a light and airy cake with a nice, crisp crust that is great with blueberries (or other berries) and whipped cream:

> *Separate the eggs. Beat the egg yolks for about 5 minutes until you have a thick, yellow cream that runs smoothly from the beater. Set aside. Combine the sugar and the egg whites and whip until you get soft peaks. Fold in the egg yolks, then fold in the flour. Add the boiling water and mix thoroughly and pour batter into a well-greased cake pan. Bake at 350 for 25 to 30 minutes or a toothpick inserted in the center comes out clean.*

Also, like many good cooks, Emilie was not afraid to alter the recipes to her or her family's tastes. On the same page as Maggie B.'s sponge cake recipe are notes of measurements for certain ingredients, probably changes to the White Layer Cake recipe printed on this page. If you are feeling adventurous, maybe you will play around with the recipe, too.

There are other handwritten recipes toward the end of the text. On page 120 of the original book, Kreisle noted recipes for spice cake and almond cookies:

> *Mrs. Porter's Almond macaroons*
> *½ lb. sweet almonds*
> *½ lb. sugar white*
> *whites of 2 eggs bake*
> *in cool oven*
> *Spice Cake*
> *yolks of 7 eggs 2 cups full brown*
> *sugar, 1 cup molasses 1 cup butter*
> *1 large coffee cup full of sour cream*
> *1 teaspoon soda (just even full) 5 cups*
> *flour 1 teaspoonful ground cloves 2 tea-*
> *spoon of cinnamon 2 teaspoon ginger*

> *1 nutmeg a small pinch of cayenne*
> *pepper; beat eggs, sugar and butter lightly before*
> *putting in molasses; then add molasses*
> *flour & cream; beat well together bake in*
> *moderate oven if fruit is needed add 2 cups*
> *of raisins* [flour?] *them well and put in last*

The illegible word is most likely "flour." Dusting the raisins in flour before mixing in the batter will keep them from clumping and from messing up the consistency of the batter. You may notice that these two recipes, as well as the others, do not include cooking times and temperatures. It was not until the year after this cookbook was published that electric ovens, with the ability to control and maintain a constant temperature, were invented, and it probably took quite a few years for them to become commonplace in people's kitchens. Prior to electric ovens, women used gas (common by the mid-1800s) or wood-burning ovens. Instead of specifying a temperature, recipes called for cool, moderate or hot ovens, related to the size of the fire and how much the vent was opened, and baked items had to be more closely monitored than they would today. The cooking time would vary widely. Looking through the printed recipes in this cookbook for cakes and breads reveals the same and indicates that these recipes were written for wood or gas ovens, not electric.

There is one more page with three handwritten recipes, found on the endpaper of the original cookbook:

> *4 eggs 2 scant cups sugar*
> *2 cups flr* [flour] *¾ cups boiling*
> *water last thing*
>
> *1 cup butter 2¼ cup sug*[ar] *1 of* [???]
> *1 heaping teasp*[oon]. *B*[aking] *Pow*[der]. *4 whole*
> *eggs 6 yolks 4 cups flr* [flour]
> *&*
> *6 whites for icing*
>
> *Lucas*
> *½ cup butt*[er], *1 1.2 lb. sug*[ar], *3 eggs*
> *1 c*[up]. *Sweet Milk 2½* [cups?] *flr* [flour] *1 heap*
> *teasp*[oon]. *B*[aking]. *P*[owder]. *1 teasp*[oon]. *vanilla*

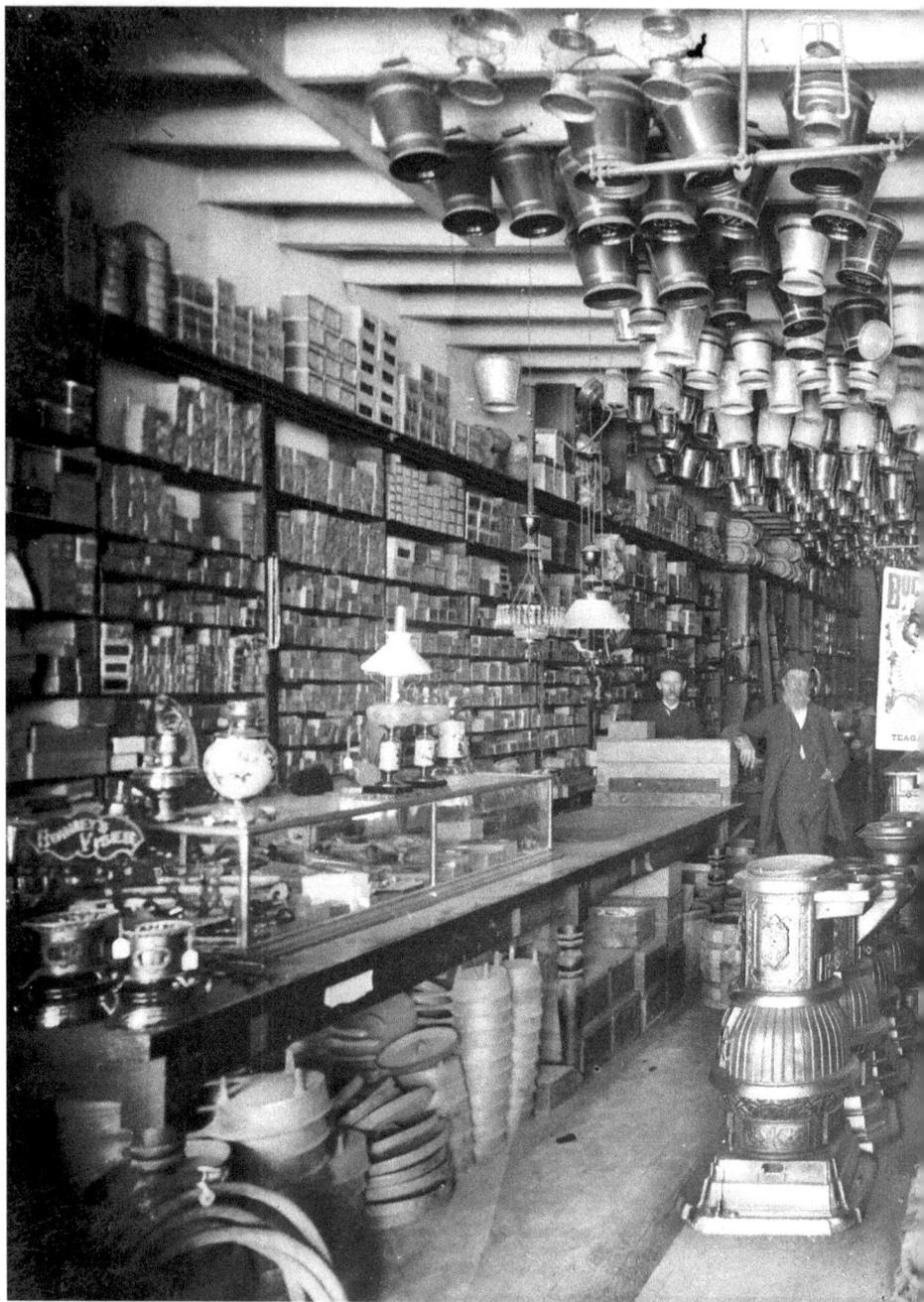

The interior of the Teagarden & Bass hardware store showing stoves and housewares. *J073, Hubert Jones Glass Plate Collection, AHC.*

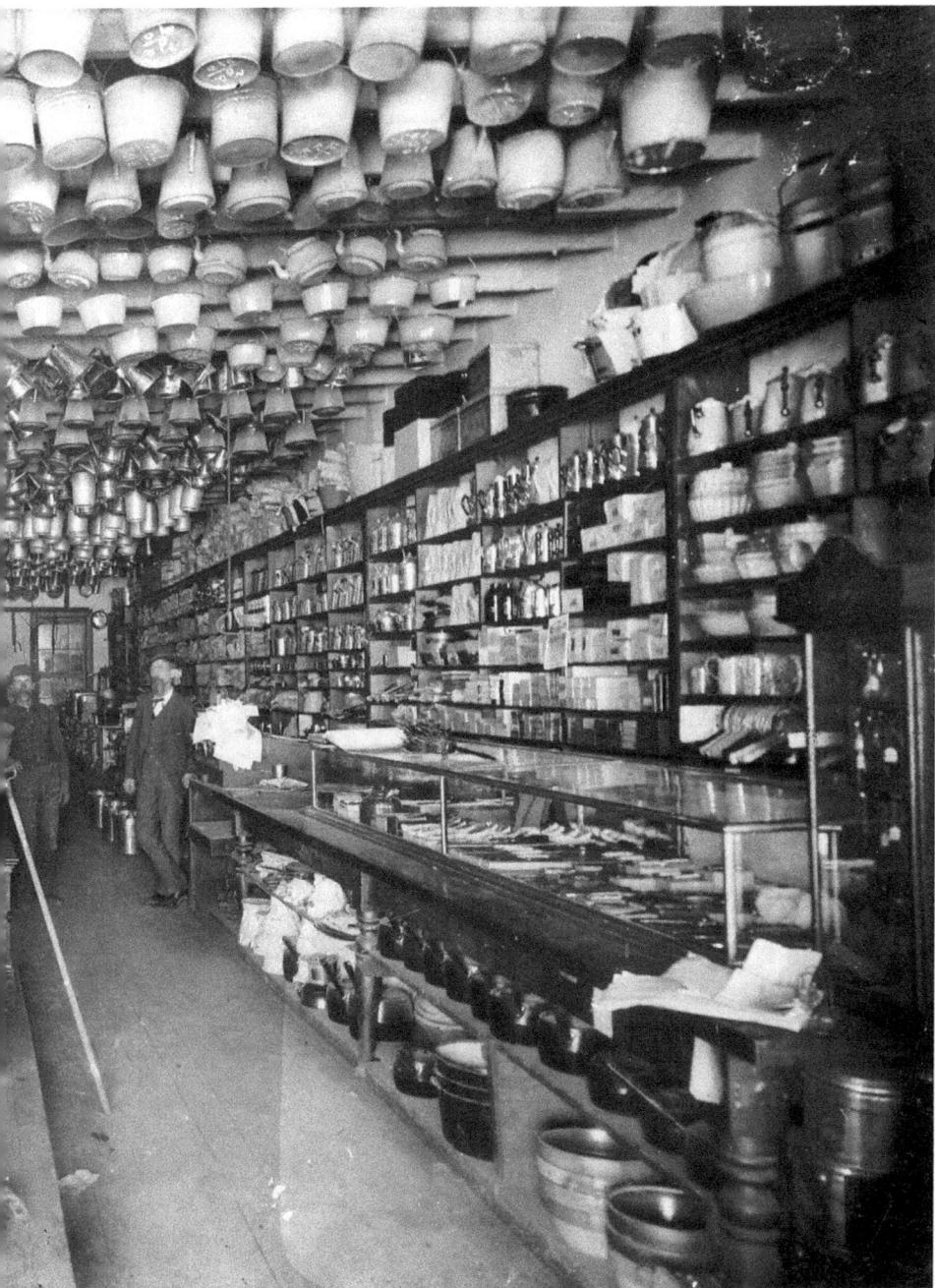

Caroline Bock. *PICB 00799, AHC.*

The first of the three recipes is a repeat of the Sponge Cake recipe that is handwritten on page 98. The other two appear to be cake recipes, though neither was attempted.

The second name associated with this copy is from a bookplate stamp that reads "Mrs. Carl Edward Bock," and it is safe to assume that she owned this copy at one time. Her name was Caroline Bock, and she was a longtime Austinite active in many clubs and organizations. Like the Kreisles, the Bocks were a musical family, and many of the organizations Caroline was involved in were related to music. She was quite active with the Women's Symphony League of Austin and the Austin Symphony Society. Her husband, Carl, was a charter member of the Austin Symphony and played the viola in the symphony for over thirty years. In addition to her work with the symphony, Caroline was a member (and held every officer position) with the Wednesday Morning Music Club and was active in the Texas Federation of Music Clubs. She served as president of the Texas Federation in 1962, and the *Austin American Statesman* named her its Outstanding Clubwoman of the Year in 1965. A small collection of the Bocks' papers are at the AHC (AR.1993.029).

The following pages are a true facsimile reproduction of the Austin History Center's copy of *Our Home Cookbook*, complete with handwritten notes, front and end matter and advertisements. In looking through the recipes, it is abundantly clear that the nineteenth-century housewife had more time on her hands, and many (but certainly not all!) of the dishes offered here require a significant time investment to create. It is up to you to judge if the time investment is worth it. Also, if you are having difficulty adapting the recipes to modern tastes, check out Nancy Crump's *Hearthside Cooking: Early American Southern Cuisine Updated for Today's Hearth and Cookstove* (EPM Publications, 1986; University of North Carolina Press, 2008). Crump's book offers a rich history of southern cooking, as well as plenty of tips and tricks to adapt the old-style recipes to modern tools and practices.

OUR

HOME

COOK BOOK

E. Kreisle 1902
Austin Texas

from Mrs g Cumberland)
Church

7 Ruok
9 Salzburn
86 corn fritters
9 very biscuit
cranberry Muffins, = C Bflow
2½ cups sifted flo 2½ tsp
½ tsp salt 4 tb but or Shorten
2 wellbin Eggs 1 cp cranberries coarsely
chopped 1 cp quick sift flernut
measure add B the salt & these to
sift again comb butt & sug
Cream & cream well to Eggs combin
by Bno & flv add to comb mix alter
with milk small amount at a time
add only enough to blend. Bake
gres muffins in hot
Or (4 oz 7) 25 tb 20 ashot
18 med Eve muffins

WAYLAND & CRISER,

-----Wholesale and Retail-----

·F·A·N·C·Y·

AND Family Groceries,

807 Congress Avenue.

Can't be undersold.

Receipt for Economy, Comfort and Happiness.

To make home cheerful, and everyone connected with it perfectly happy, the following instructions should be scrupulously carried out. A lady should always meet her husband with a bright and beaming countenance but cannot do so if she is worked to death. Her household cares can be so reduced that they will be a pleasure instead of a drudgery; provided, she has the proper appliances to do it with. These appliances are : A Monarch Vapor Stove, a Domestic Sewing Machine for labor saving, and Furniture, Carpets, Stoves and Tinware; Pianos and Organs for pleasure and comfort, all of which can be had from

N. V. DITTLINGER, The House Furnisher,

302 and 304 East Sixth street, Austin, Texas.

☛ Sold on easy weekly and monthly payments.

RANDOLPH & ROBINSON,

⟶RETAIL ∴ GROCERS,⟵

814 CONGRESS AVENUE, AUSTIN, TEXAS.

Make a specialty of FAMILY TRADE. Guarantee satisfaction in every respect.

Handle only the Best and Purest Groceries.

☞ Fresh roasted Coffee and Fine Teas always in stock. ☚

JOHN BREMOND. JOHN H. ROBINSON, JR.

JOHN BREMOND & CO.,

→Wholesale Dealers in→

Dry Goods, Notions, Hats,

BOOTS, SHOES,

GROCERIES.

109, 111, 113 PECAN STREET,

AUSTIN, ——————— TEXAS.

Fresh Roasted Coffees and Fine Teas a Specialty.

A. S. JOHNSON,

DEALER IN

Domestic and Imported Groceries.

918 CONGRESS AVENUE,

AUSTIN, - - - TEXAS.

GEO. B. LUCAS,

DRUGGIST,

821 CONGRESS AVENUE, ★ AUSTIN, TEXAS.

Use Lucas' Golden Gargle for a Sore Throat.

DO YOU EAT?

If so, be sure and get the best Cooking Stove or Range made. It lightens labor, makes the cook happy and you get better victuals to eat. We have used the Charter Oak and Superior Stoves in our families so long, we can safely recommend them to you, as the best and cheapest to buy. GEO. A. BRUSH, at 900 and 902 Congress Avenue, keeps a large stock of all sizes, as well as

CROCKERY AND GLASSWARE,

Which we know to be sold at modern prices, and then he has only one price, and you can rely on getting everything, Lamps, Cutlery, Refrigerators, etc., at the lowest prices.

Receipt for Economy, Comfort and Happiness.

To make home cheerful, and everyone connected with it perfectly happy, the following instructions should be scrupulously carried out. A lady should always meet her husband with a bright and beaming countenance but cannot do so if she is worked to death. Her household cares can be so reduced that they will be a pleasure instead of a drudgery; provided, she has the proper appliances to do it with. These appliances are: A Monarch Vapor Stove, a Domestic Sewing Machine for labor saving, and Furniture, Carpets, Stoves and Tinware; Pianos and Organs for pleasure and comfort, all of which can be had from

N. V. DITTLINGER, The House Furnisher,

302 and 304 East Sixth street, Austin, Texas.

Sold on easy weekly and monthly payments.

DON WILSON,

IMPORTER OF

Foreign and Domestic Dress Goods,

HOSIERY, GLOVES, RIBBONS, ETC.

BLACK GOODS A SPECIALTY

----AGENT FOR----

MME. DEMOREST'S RELIABLE PATTERNS.

OUR HOME

COOK BOOK.

COMPILED BY

Mrs. PAUL F. THORNTON,
Mrs. I. V. DAVIS.

AND

SOLD FOR THE BENEFIT

OF THE

First Cumberland Presbyterian Church,

AUSTIN, TEXAS.

AUSTIN, TEXAS:
EUGENE VON BOECKMANN, PRINTER.
1891.

We extend grateful thanks to the kind ladies who have generously given their recipes, (may their *every* effort at a dish, whether rarely dainty, or family daily, be a sure success); also to the courteous gentlemen who lent their substantial aid in advertisements. We request all Cumberland Presbyterians especially, to note advertisements, and return the favor whenever in their power to do so.

<div align="right">

MRS. I. V. DAVIS,
MRS. PAUL F. THORNTON.

</div>

PREFACE.

"We may live without poetry, music or art;
We may live without conscience and live without heart;
We may live without friends, we may live without books;
But—civilized man cannot live without cooks."

So, in setting adrift, this useful little volume, we feel assured that a helping hand is extended to each woman, who desires "to curry a hare," as well as curry the favor of her husband. A palatable and easily digested meal is a *sine qua non* to peace at home, so the diligent con of this little book will smooth out the rough places and cause frowns to dispel and dimple into ripples of laughter; make love overflow and good spirits abound; untie the knotted purse-strings, and secure to the mother of the household, the satisfaction, which only this contented state can produce. We toss into the lap of the inquiring house-wife, a feast of good things which is warranted to dispel the incubus hanging over an expected meal, a family dining, or a more ceremonious lunch. We must ever bear in mind Benson's words: "Over and over again, we have seen generous feasts transformed into barbaric meals by the lack of clean plates, clean forks and clean glasses." Like learning, there is no royal road to cooking. Practical sense and care, with sound and wholesome ingredients only, are necessary. Bread has been called "the staff of life" and how necessary it is that "the staff" should be light and reliable! "In the beginning," in Genesis, when

Abraham desired to hold a reception and entertain the three
angels, (not unawares), he said: "I will fetch a morsel of
bread and comfort ye your hearts." Then he bade Sarah
"make ready quickly three measures of fine meal, knead it
and make cakes upon the hearth." We tenderly throw these
carefully selected gems, fraught with many, so many hopes,
'or a very worthy cause, on the mercy of the female public.

BREAD, ETC.

YEAST CAKES.

Dissolve two fresh yeast cakes (from the bakers) in a pint of milk warm water, add a half dozen boiled Irish potatoes mashed to a paste, one tablespoonful of sugar, one teaspoonful of salt, and enough flour to make a stiff batter. Set in a warm place until it rises to a light sponge. Then stir in enough corn meal to make a dough stiff enough to roll out; cut with a biscuit cutter, put on a tray and set in the shade turning over every morning until dry. They will keep 6 or 8 weeks in a tight tin box. MRS. GEO. A. PROCTOR.

DIXIE BISCUIT.

Three pints of flour, two eggs, two tablespoons of lard, one cup of yeast, one cup of milk. Mix at eleven o'clock, roll out at four o'clock, cut with two sizes of cutters, putting the smaller one on top; let rise until supper, bake twenty minutes. MRS. PAUL THORNTON.

SALT RISING BREAD.

The yeast for this bread is prepared thus: At night take a teacup ⅓ full of meal, boil enough sweet milk to make the meal a thin batter, wrap it up and keep it warm over night. Next morning take a pint of warm water—about 90° (if a little too hot defeat is certain) in a perfectly clean bowl and stir up a thick batter, adding a teaspoon of salt and one of sugar; a thorough beating of batter is important. Set in a pot

of warm water to secure uniformity of temperature,· and in one
to two hours it will begin to rise; when your yeast is light,
take your bread pan two-thirds full of flour, make a hole in
the middle and put one teaspoon of salt, one teacup of lard,
one pint of warm water, to this add your yeast, mix and let
rise until light; then mould into loaves and let rise from one
to two hours, then bake in a moderately hot oven.

 (MISS) MOLLIE FLAINKEN.

EGG CORN BREAD.

Sift one quart meal, one-third teaspoon soda, and one
pinch salt, and mix with one pint sour milk, one-half ta-
blespoon melted lard, and one egg, well beaten; mix thorough-
ly and bake in a quick oven. MRS. J. M. PEACOCK.

FRENCH TEA BISCUIT.

Take one yeast cake, disolve in a pint of water, beat one
egg with two large spoons of sugar. Sift quart of flour of best
quality, into which pour the well beaten egg and sugar then
stirring in the yeast until you have a dough about as stiff as
biscuit dough, let stand to rise which ought not be more than 6
hours; after it is well risen, flour biscuit board and pour this
risen dough on it, put in salt and lard as in common biscuit,
work well, roll out the same thickness of other biscuit, cut
with cutter, placing them to rise again in a well greased pan.
Just before baking (which ought to be in a half hour in
warm weather), melt some lard and with a feather, brush
over the tops bake in a moderate oven. For a change they
can be moulded into any shape. MRS. M. HICKS.

BEATEN BISCUIT.

One quart of flour, into which sift, one teaspoonful of salt,
two tablespoonfuls of lard; mix into a stiff dough with equal
parts of sweet milk and cold water, beat the dough twenty
minutes. Work with the hand as much as possible. When

the dough becomes blistered, roll out moderately thin. Then bake, but not too quickly. Mrs. W. R. Hamby.

BEATEN BISCUIT.

Sift four teacups of flour, putting in salt for seasoning. Then cut with a knife into the flour until thoroughly mixed, one tablespoonful of butter or lard (or half and half of each, and this is better than all of one kind), then pour in three-fourths of a cup of sweet milk, mixing with knife, Then place upon biscuit board and beat until very smooth. Roll out, pick full of holes like crackers. Cut out and place in an oven just hot enough to cook them done at the bottom of the stove in about twenty five minutes. If properly made and cooked they will be light through and through, raised slightly oval and as brown as soda crackers. Mrs. F. R. Lubbock.

RUSK.

Two teacups raised dough, one teacup of sugar, half cup of butter, two well beaten eggs, flour enough to make a stiff dough; set to rise and when light, mould into high biscuit, and let rise again; sift sugar and cinnamon over the top and place in oven. Mrs. Dr. Shapard.

CORN MEAL MUFFINS FOR DINNER.

To one pint corn meal, add half teaspoon of salt and soda each, stir in sour or butter milk to make a thin batter, add two eggs and beat together. Have muffin-rings greased and on a hot stove. Drop the batter in rings and bake in a hot oven. Mrs. I. V. Davis.

BREAKFAST GEMS.

With one quart of flour sift a level teaspoon of soda, add one-half teaspoon salt. Rub in lard, the size of two hen's eggs, add enough sour or butter milk to make a stiff batter,

and stir in four eggs thoroughly. Heat muffin-rings hot and
grease. Drop the mixture in the rings while on the stove,
and bake in quick oven to a rich brown. Mrs. I. V. Davis.

SALT RISING LIGHT BREAD.

Take one-half pint new milk at night, heat, thicken with
meal and let it stand till morning. Heat one-half pint water,
put in one-fourth teaspoonful soda, teaspoonful salt, then the
scalded meal, and thicken with flour. Have this in a tin
quart can, put in a pot of warm water and let it rise, being
careful to keep the water warm. When light pour into a pan
of sifted flour, add a little salt and sufficient warm water to
make dough. This will make a pan of light rolls and three
loaves of bread. Grease the rolls, not the bread, and let rise·
When light grease bread and bake in a moderate oven about
one hour. Mrs. T. J. Bennett.

CORN BREAD.

Take one pint and a half of buttermilk, and one pint of
corn meal, one teaspoon of soda, one of salt and three eggs,
have the stove very hot, and do not bake in a very deep pan.
Put one tablespoon of lard in the pan and heat, pour in the
batter and stir quickly, then pour back in the pan. The bat-
ter will seem thin, but bakes nicely.
 Mrs. J. L. Driskill.

CINNAMON ROLLS.

Take half the quanity of a loaf of light bread dough, roll
it out till about half an inch thick, butter it, sprinkle with
powered sugar and cinnamon. Roll up like jelly rolls, and
cut slices from the end about an inch thick; place these in a
buttered pan and set to rise; when light enough, bake like bis-
cuits, about the same length of time. These are nice to put
up for lunches, and make a pleasant change from bread.
 Mrs. H. H. Bowman.

GRAHAM GEMS.

One-fourth cup of butter, one-fourth cup of sugar, one and one-half cups of sour milk, two and one-half cups of Graham flour, one egg, one teaspoon of soda—salt. Bake 25 or 30 minutes. Mrs. Denson.

A RELISH.

Roll a small quantity of rich pastry, and cut in squares as for biscuit, over each square put a thin slice of cheese, and bake in a hot oven. To be eaten with after dinner coffee. Serve hot. May W. Davis.

BEAT BISCUIT.

Three pints flour, one tablespoonful lard, usual quantity salt. Make up very dry with cold water, and beat until very light, or until the dough blisters. Mrs. G. S. Criser.

PERFECTION BREAD.

Three and one-third quarts sifted flour (whole wheat flour), one pint scalded sweet milk, one pint cold water, one-half cup granulated sugar, one-half cake compressed yeast, one-half teaspoon salt. Scald and cool the milk, dissolve the yeast in the water, then add milk and sugar, now stir in two-thirds of the flour and beat thoroughly. Set to raise, which will take from three to four hours. When raised add remainder of flour and salt. Knead and place in greased pans for final raising. When light, bake in a hot oven, covering the loaf if there is danger of scorching.

Mrs. Paul Thornton.

SALLY LUNN.

One quart of flour, three eggs, one tablespoonful of butter, one of sugar, and half a cup of good yeast. Mix at ten o'clock in the morning and it will be ready to bake for tea. Mix as soft as you can with your hands. Mrs. G. S. Criser.

CREAM BISCUITS.

One cup sour cream, one scant cup butter milk, one-half teaspoonful salt, one teaspoonful baking powder, one-half teaspoonful soda, or less according to the acidity of the milk; (use no lard); mix the baking powder and soda in the flour dry. Mix all the other ingredients thoroughly and quickly, and roll and cut as soft as possible without sticking to the bread board; bake in a quick oven and you will have delicious biscuits. MRS. DR. BRAGG.

SALT RISING BREAD.

Take three or four tablespoons well cooked corn mush, a pinch of salt, one teaspoonful sugar, either white or brown, and put into a jar, or pitcher is better than tinware; pour over this one-half pint of boiling water, set aside a few minutes till it cools to luke warm, then stir into this flour (dark or entire wheat is best) until the consistency of batter-cakes. Set in a warm place over night. In the morning place the jar inside a kettle of warm water, set on back of stove to keep warm, do not let it get too hot. Add a little more warm water and flour, beat well, cover both jar and kettle tightly; if water rises on top, stir in a little flour. It will get light in five or six hours and ready to mix. Use all the yeast, a little water, salt, sugar, make into loaves, place in buttered bread pan, and set in warm place to "rise" like any other yeast bread; bake a nice rich brown.

 MRS. DR. BRAGG.

SOUPS.

BOUILLON.

Four ponds of beef chopped at the butcher's, four quarts of cold water, two chickens cleaned and cut up with bones broken, put the meat in cold water and bring to a boil very slowly, taking nearly an hour. Simmer at the edge of the stove and never let it come to a hard boil. Keep this up for four or five hours until the water is reduced to nearly one-half. Take the meat out and set the bouillon aside to get cold; next day remove the grease and strain through thick cloth, put the liquor on the stove and bring to boil and stir in the white—beaten—and shell of eggs. Boil about two minutes and strain once more, the result will be a clear amber color fluid. This may be darkened by the addition of a little caramel.

MRS. LITTLEFIELD.

SOUP STOCK.

Four pounds of lean beef, or shin of beef, cut in several pieces, cracking the bones, four quarts of water (soft is best). Boil gently for six or eight hours until the meat is in rags, strain into a jar and when cold remove the grease. This will keep for several days in cool weather and from it can be made a variety of soups by adding macaroni, celery, asparagus, green peas and can tomatoes; celery and carrot seed may be used instead of fresh vegetables. To prepare soup. for dinner take a part of the jelly, add water, heat and serve. Whatever is added to this, such as nice tapioca, vegetables,

etc., may first be cooked before adding, as much extra boiling injures the flavor of stock. MRS. LITTLEFIELD.

MOCK TURTLE OR CALF HEAD SOUP.

Lay one large calf's head well cleaned and washed and four pigs feet in bottom of a large pot, cover with a gallon of water, boil three hours or until flesh will slip off bones, take out the head leaving the feet to boil steadily while the meat is cut from the head. Select with care enough of the fatty portions in the top of head and the cheeks to fill a teacup, and set aside to cool; remove the brains to a saucer, and also set aside; chop the rest of the meat with the tongue very fine. Season with salt, pepper, powdered marjoram and thyme, a teaspoon of cloves, one of mace, half as much of allspice, and a grated nutmeg. When the flesh falls from the bones of the feet, take out bones, leaving the gelatinous meat; boil all together sowly without removing the cover for two hours more. Take the soup from the fire and set aside until the next day, an hour before dinner set the stock over the fire and when it boils, strain carefully and drop in the meat reserved, which should have been cut when cold into small squares. Have these all ready as well as force-meat balls, to prepare which use the yolk of five hard boiled eggs beaten to paste in a wedge wood mortar or in a bowl, with the back of silver spoon, adding gradually the brains to moisten them, also a little butter and salt. Mix with these two eggs, beaten very light, flour the hands, make this paste into balls about the size of a pigeon's egg or smaller, throw them into the soup five minutes before taking it from the fire, stir in a large tablespoon of browned flour rubbed smooth in a little cold water, and finish the seasoning by adding a glass and half of sherry or Maderia wine and the juice of a lemon. It should not boil more than hal an hour on second day. Serve with sliced lemon.

MRS. LITTLEFIELD.

MOCK OYSTER SOUP.

One quart of sweet milk, one can of tomatoes, butter the size of an egg, salt and pepper to taste. Put the tomatoes in the milk before putting the milk on the fire. If fresh tomatoes are used or the milk is not real fresh, put in a pinch of soda to keep the milk from curdling. Let all come to a boil. Serve with crackers.　　ROSE MARY POINDEXTER.

CHICKEN GUMBO.

Fry a young chicken; after it is cool remove the bones. In another vessel fry one pint of tender ochra and two small onions. Put all in a porceluin kettle and add one quart or a little more water, and stew gently until done, season with pepper and salt and serve with a seperate dish of rice.
　　　　　　　　　　　　　　MRS. COLLETT.

PEPPER POT OR MOCK TURTLE SOUP.

Put on early after breakfast a good size soup bone, about 11 o'clock put in three carrots and one white turnip; let these boil for three hours, then strain the soup and pour the broth back in the pot; before pouring back throw into the pot two good size onions chopped (but not too fine), two tablespoonfuls of lard, three of flour, stir this steadily on the fire until it is brown, then pour in the broth; chop up some of the meat, that is, not too much, as it will make it too thick; add one quart of tomatoes first chopping it up, take a handful of celery tops, parsley and thyme. Chop very fine, add one teaspoonful of ground mace, one of allspice, one of cloves; let all boil until ready to serve, the yolk of three hard boiled eggs cut up, one teaspoonful of black pepper and a little salt. Stir these in; last stir in a half tumbler of cherry wine.
　　French receipt, and extra fine.　　MRS. A. J. BLOCKER.

OYSTER STEW.

Put one quart of oysters and their liquor with half a pint of cold water in a porcelain kettle, or a bright tin pan if you have nothing better; iron spoils the flavor. Add what salt they require, and heat them scalding hot. The scum will rise as soon as they begin to heat, and must be removed. Just as they are about to boil, skim out all the oysters into your soup tureen, add to their liquor one-half pint of cream or rich milk, a piece of butter the size of an egg, as much pepper as you like, and a little finely rolled cracker crumbs. When this is boiling hot, pour it on to the oysters and serve. The crackers to be eaten with the soup should be heated, as it makes them more brittle. MAY W. DAVIS.

FISH.

BAKED FISH.

Clean, rinse and wipe dry a fish weighing five or six pounds (red is best), rub inside and out with salt, pepper and lard, fill with stuffing as tor ponltry, but a little dryer, and sew up, and lay on wire gridiron across dripping pan containing hot water. Dredge fish with cracker crumbs rolled and sifted, lay on a few slices of salt pork cut thin, and bits of butter sprinkled well with black pepper; bake till nice and brown, basting occasionally. When taken up garnish dish with parsley and lemons sliced, and cut thin hard boiled eggs and lay over the fish. Mrs. Jno. Orr.

MAYONAISE SAUCE.

For fish or salads of all kinds. Beat yolks of two raw eggs till light, add yolks of two hard boiled eggs mashed fine as possible, add gradually a tablespoon mustard mixed smooth, three-fourths cup melted butter very slowly, stirring rapidly to prevent curdling, salt and pepper to suit taste, also lemon juice (say three good sized) and thin rich sweet cream about one-half cupful; add capers and small sprigs of parsley cut fine. This sauce is splendid. Mrs. Jno. Orr.

BAKED FISH.

A fish weighing from four to six pounds is a very good size to bake. It should be cooked whole to look well. Make

dressing of bread cumbs, butter, salt and a little parsley and onions and a little salt pork chopped fine. Mix this with one egg. Fill the body, sew it up, lay in large dripper; put across it some strips of salt pork to flavor it, put pint of water and little salt in pan; bake an hour and half; baste frequently; after taking up fish; thicken gravy and pour over it, adding two nicely sliced boiled eggs. MRS. PROCTOR.

BAKED FISH.

Skin the fish by starting at the head and drawing down towards the tail, then take out the bones, place the fish in a pan and pour over it the following sauce: One pint of stock, three tablespoonfuls of butter, two of flour, piece of one lemon, one tablespoonful of chopped parsley, a slice of onion chopped very fine; Worcester sauce to taste. Heat the butter in a frying pan and when hot add the dry flour (which has been browned), stir until a rich brown; then add the stock as soon as it boils; add the after ingredients, also a can of chopped mushrooms; cook the sauce until it is the consistency, of cream then pour it over the fish with bread crumbs and bake half an hour. This is sufficient sauce for three pounds of fish. MRS. E. M. HOUSE.

BAKED CRABS.

Make a dressing as follows: One tablespoonful of made mustard, one teaspoonful of Worcester sauce, three tablespoonful of sweet oil, cayenne pepper, black pepper and salt to taste, and vinegar enough to mix well. Take the meat from one dozen large crabs, put in a dish and pour over the dressing, mix well in, then add six soda crackers rolled fine, one raw egg, and mix all well together, then put into a dish or the shells, sprinkle over them cracker crumbs, put little pieces of butter on top and bake. MRS. J. W. SMITH.

SALMON CROQUETTES.

One can of salmon. Turn into a vessel (not tin) for awhile before using, to "air." Use two-thirds as much rolled cracker crumbs as you have salmon. Butter the size of the yolk of an egg melted in one-half cup of water. Pepper, salt and a few drops of lemon juice. Sift the rolled crackers, using coarser part to the salmon, finer to roll the croquettes in. After mixing ingredients thoroughly, mould, roll in beaten egg, then cracker crumbs. Fry in hot lard. MRS. JNO. WEBB.

ENTREE OF SHRIMPS AND TOMATOES.

Fry four slices of breakfast slip brown, and to the fat, add one can of tomatoes; stew three-quarters of an hour. Have one can of Baratara shrimps washed in cold water, well drained and any shells carefully removed; sprinkle them with one-third of a tablespoonful of cayenne, a pinch of black pepper, and a little salt. Put in a baking dish, add the tomatoes, cover with a layer of stale bread crumbs, grated. Drop small bits of butter on top then put in oven and brown nicely.

MRS. TALLICHET.

MEATS AND POULTRY.

TO BOIL HAM.

Boil slowly for four or five hours; when done set aside to cool; then take the skin off and trim to a nice shape, sprinkle a little sugar and black pepper on the skin side and set in the oven to cook slowly for an hour. MRS. LITTLEFIELD.

BROILED STEAK.

Broil steak without salting. Cook over a hot fire, turning frequently, searing on both sides. Place on platter. Salt and pepper to taste. Place second platter over it and carry to the table. MRS. C. R. GIBSON.

BEEF LOAF.

One pound round beef steak, one egg, one large slice of light bread, a small lump of butter, pepper and salt to suit the taste; chop these all together and make into a loaf and bake. When cold slice for lunch.

MRS. PAUL THORNTON.

STUFFED VEAL.

Take the hind quarter of veal; make two or three incisions with a knife, fill the cavities with the following dressing: Take bread crumbs, a little mustard, celery, salt and pepper to taste, a finely chopped onion, and mix the whole thoroughly together, adding a good sized lump of butter; stuff well into

the cavities, rub salt, pepper and plenty of butter over the roast. Dust on a little flour. Bake two hours, basting frequently. Excellent hot or cold.

MISSES ELEN AND ALICE GRAHAM.

RECIPE FOR "SCRAPPLE."

[A New England Dish.]

Take a five pound roast of beef, put it to boil into a po well filled with water. After it is perfectly tender, remove i, from the pot, and when sufficiently cool, cut it all up fine (as if for hash), and put it back into the pot, in the same water in which it boiled. Season with black pepper, salt, etc., just as sausage is seasoned, then add enough corn meal to thicken it so that the spoon will almost stand upright in it. Boil the mixture twenty minutes, then pour it all into a bowl; when it gets perfectly cold turn it out, cut into slices and fry a nice brown. It is a nice breakfast dish. MRS. DENSON.

TO COOK A HAM.

Saw off the bone at both ends; pare and scrape the flesh side; wash and scrape the rind well; put the ham into plenty of cold water to parboil; put in a small handful of sage and teaspoon of whole cloves; boil about an hour, then have boiling water ready to change, and boil till done; then take it out and give it a dash of cold water; then peel off the rind and put the ham in the oven to brown. MRS. McDONALD.

BEEF LOAF.

Grind about three pounds of beef, or chop fine, roll eight crackers fine, beat four eggs well, soften one tablespoonful of butter, cut fine one small onion; season high with pepper and salt. Mix these ingredients well (with the hand is best), shape to oblong loaf, put in dripping pan and let remain in a moderate, not cool oven, ten minutes, then add hot water, which use to baste every ten minutes adding hot water as needed;

when near done, which should be in one hour and a half cease adding water, and let the loaf absorb all in the pan; slice neatly when cold, place nicely on platter, garnish with parsley.

Use Marion Harland recipe for mince meat, found in her "Common Sense in the Household." MRS. JNO. WEBB.

BEEF POT PIE.

Three pounds of "chuck," salt and boil until tender; remove, seasoning with butter and pepper; put in a warm place. To the fluid in the pot add three sliced potatoes, medium size, butter and pepper, also water enough to cook the dumplings without fear of burning. Make the dumplings after the formula of ordinary baking powder biscuit and drop into the soup when it just simmers; cover closely and boil gently but steadily for forty-five minutes. Wetting the dumplings and pasting them on the side of the pot, partially submerged, is a good plan to follow with part of them, as it saves crowding.

Mrs. I. V. DAVIS.

VEAL LOAF.

Chop fine three pounds of leg or loin of veal and three-fourths pound salt pork, chopped finely together, roll one dozen crackers, put half of them in the veal with two eggs, season with pepper and with a little salt if needed, mix all together and make into a solid form, then take the crackers that are left and spread smoothly over the outside, bake one hour and eat cold. "Practical Housekeeping."

MRS. LESLIE WAGGONER.

SWEET BREADS.

Soak in cold water for one hour, then remove skin and blood vessels. Boil one pint of water into which is put one onion, one tablespoonful of vinegar, salt and pepper, then put the sweet breads into the water and let boil for five

minutes, put the sweet breads again into cold water and
allow to soak for one hour. When ready to cook, put two
tablespoonfuls of butter into the saucepan, with one tea-
spoonful of parsley and another of shallots. Put the sweet
breads again into the saucepan and cover with two or three
pieces of bacon, place it on the fire and let the butter melt,
then pour over it a cupful of broth and half a cup of white
wine. Let it cook slowly until done. MRS. E. M. HOUSE.

TO CURE A TONGUE.

Wash the tongue thoroughly, dry it, rub it with salt and
press it down for a day or two, to extract the blood. Mix
half a teaspoonful of salt petre, one-half teacupful of brown
sugar and a full half teacupful of salt. Make a little hole
on the lower side where the tongue begins to get thick, fill it
with the mixture, rub the rest over it, put it in a jar with a
plate over it. Rub it daily and turn it over. A thick short
tongue is best. I. A. STANIFORTH.

TO DRESS CURRY (BOMBAY).

Take two large cooking apples, four onions, one and a half
pounds mutton or fowl, cut into pieces about the size of a
mouthful, one-fourth pound of fresh butter, one teacupful of
sour cream, one tablespoonful of curry powder. First melt
the butter in a frying pan, taking care not to burn it, then
add the onions and mix them well with the butter, stirring
together for ten minutes; then add the apples stirring them
well together in the frying pan, then transfer the whole to a
saucepan with a close fitting lid, rinsing the frying pan with
a little boiling water. Let all stew for three hours and just
before serving add salt, the juice of half a lemon and a large
teaspoonful of chutney; a slice of pounded cocoanut may be
substituted for half the quantity of cream.

I. A. STANIFORTH.

TURKEY DRESSED WITH OYSTERS.

For a ten pound turkey, take two pounds of bread crumbs, half a cup of butter (cut in bits not melted), pepper, salt, a little parsley, or summer savory, if liked; mix thoroughly. Rub the turkey well, inside and out, with salt and pepper, then fill with first a spoonful of crumbs, then a few well drain- ed oysters, using a pint to the turkey. Strain the oyster liquor and use to baste the turkey. Cook the giblets and chop fine for the gravy. A fowl of this size will require, for roasting, three hours in a moderate oven.

Mrs. Geo. S. Criser.

FRIED CHICKEN.

Beat two eggs, to which add a little milk; pepper and salt your chicken, dip in your eggs and milk, then dip in grated crackers. Fry in butter until brown. Mrs. Davis.

CHICKEN PIE.

Cut chicken in small pieces and stew until tender. Season well with butter, pepper and salt. Thicken the gravy with tablespoon of flour, made smooth with water. Line the sides of a deep dish with rich crust. Put in layer of chicken and layer of raw crust cut in small pieces, repeat and pour the gravy over it. Place strips of crust across the top and bake brown. Then place strips the other way and bake until they are brown. This furnishes a supply of crust for the pie.

Mrs. Sarah Day.

PRESSED CHICKEN.

Take young tender fowls, boil until perfectly done; pick from the bones and chop as fine as for salad, then season with butter, salt, pepper and celery; work together and put in mold with heavy weight upon it to press, just as you do souce or head cheese; and when perfectly cold turn out and slice with a very sharp knife. Mrs. J. G. Booth.

TO BROIL QUAIL.

After dressing, split down the back, sprinkle with salt and pepper, and lay them on a gridiron, the inside down. Broil slowly at first. Have ready a hot platter with buttered toast While broiling, use butter on them, and turn, in cooking. Rabbits broiled in this way are nice. MRS. J. W. SMITH.

HOW TO COOK YOUNG CHICKENS.

Dress and joint them as usual. Place in a dripping pan and just cover with sweet cream, season with a little salt, pepper and a little butter; now set in the oven to cook and by the time the cream is almost cooked away the chicken will be done. They are splendid done this way.

MRS. C. A. TRIMBLE.

CHICKEN PIE.

Cut up the chicken and boil until tender, one pint of the liquor in which the chicken is boiled remaining, which take one-half for the inside of the pie, adding one cup of sweet cream to what remains for gravy, line a flat two quart pan with biscuit dough, place the chicken evenly inside, putting butter, salt and pepper over it to season, dust over it a tablespoon of flour, add the half pint of liquor hot, cover with dough, cutting a place through both upper and lower crust in the center. Bake in a moderate oven until done.

MRS. H. H. BOWMAN.

CHICKEN CROQUETTES.

Boil two chickens until very tender, mince fine, and season with pepper, salt and one-half pint of cream or soup stock, yolks of two eggs, a cup and a half of boiled rice mixed with the meat and rolled in pieces one inch thick and three long. Then roll the croquettes in cracker crumbs and fry in hot

lard to a nice brown, and serve in flat dish with boiled rice cooked so every grain seems whole. This is a convenient dish when the chicken is wanted in the bouillon.

<div style="text-align:right">Mrs. Littlefield.</div>

CHICKEN CHEESE.

Take a chicken. Cook very tender. Cook the gravy of the chicken down to a jell. Take out all the bones, and chop fine. Season with salt and pepper, boil hard six eggs, chop the whites and yellows separately, then put a layer of chicken, then one of whites, then one of chicken and one of yellows, until the bowl is full, then pour the water it was cooked in over it; flavor with celery if desired. Mrs. James Ford.

BAKED CHICKEN PIE.

Joint the chickens, place the pieces in a pot with some small pieces of salt pork, cover them with water and boil until tender; make a crust as for biscuits, with a half more shortening. With half of the crust, line a deep dish, put in the meats, pepper and salt to taste; cover the top with the other half of the crust, cut one or more holes in the upper crust for escape of steam, and bake about three-quarters of an hour. Mrs. J. A. McCuiston.

ROAST PARTRIDGES.

Pluck, singe, draw and truss three partridges. Roast for about twenty minutes, baste with butter; when the grease begins to run from them you may safely assume that the partridges are done. Place them in a dish together with bread crumbs fried nicely and arranged in small heaps. Gravy should be served in a tureen apart. Mrs. I. V. Davis.

CHICKEN TO FRICASSEE.

Boil a chicken, joint it, lay in in a saucepan with a piece

of butter the size of an egg, a teaspoon of flour, a little mace
or nutmeg, white pepper and salt. Add a pint of cream and
let it boil up once. Serve hot on toast.

Mrs. I. V. Davis.

TURKEY DRESSING.

To about one quart corn bread and one quart wheat bread
crumbs, add five tart apples chopped fine, and a pinch of salt
and tablespoon of melted buiter; moisten with cold water;
stuff the crop of a turkey and sew up. To one quart of corn
bread and one quart of wheat bread crumbs, add a pinch
of salt, tablespoon of melted butter and one pound chopped
oysters and their liquor. Stuff the other half of the turkey·

Mrs. S. G. Granberry.

MOCK SWEET BREADS.

Chop any amount of cold mutton or veal fine; half as many
oysters, one tablespoonful of finely chopped beef suet, one
of minced onion, a little mace, salt and cayenne pepper; mix
all with a beaten egg. Form into flat cakes and fry in a lit-
tle hot lard. Mrs. I. V. Davis.

WHITE FRICASSEE.

Cut the chicken in pieces and lay them in warm water for
quarter of an hour; dry them with a cloth and put them in a
stewpan with milk and water and boil until tender. Stir a
little cream and butter together until thick; when cool put
into it a little beaten mace and salt; stir all well together,
then take the chickens out of the pan, throw away the milk
and water in which they were boiled; pour over them the
sauce, shaking the pan until they are hot, then serve.

Mrs. I. V. Davis.

SALADS, ETC.

SARDINE SALAD.

Two boxes of sardines, a quart of boiled and mashed Irish potatoes, one-half teaspoonful of mustard, a sprinkling of black pepper and salt, one-half cup melted butter, one-half cup chopped pickles, one small, or one-quarter of a large onion grated, and vinegar to suit the taste, mix all together thoroughly with a potato masher. Garnish dish with four nice sardines reserved and parsley or celery tops.

MRS. LITTLEFIELD.

CHICKEN SALAD.

Nine eggs, one teacupful strong vinegar, one-half pound butter, or teacupful of olive oil, four tablespoonfuls of mixed mustard, two tablespoonfuls sugar, and one teaspoonful black pepper. Beat the eggs until smooth, and add the other ingredients. Place in a kettle over the fire, and stir all the time, cook until it becomes almost a mush. When cold add one-half teacupful of strong vinegar. Chop the chicken and celery any size your may wish, and sprinkle with salt to taste. Pour the dressing on, and mix well, just before serving; reserving some of the dressing to pour over the top. This dressing is sufficient for a medium turkey, or three chickens.

MRS. R. M. HALL.

CHICKEN SALAD.

Boil three chickens until tender, salting to taste, when cold cut in small pieces and add twice the quantity of celery cut up with a knife, but not chopped, and four boiled eggs sliced and thoroughly mixed through the other ingredients. For dressing, put on stove a sauce-pan with one pint vinegar, and butter size of an egg, beat two or three eggs with two table-spoons of mustard, one of black pepper, two of sugar, and a teaspoon of salt; when thoroughly beaten together pour slowly into the vinegar until it thickens. Be careful not to cook too long or the egg will curdle. Remove, and when cold pour over the salad. This may be prepared the day before, adding the dressing just before using. Add lemon juice to improve the flavor, and garnish the top with slices of lemon. MRS. A. M. BELVIN.

CHICKEN SALAD.

Boil one chicken tender, chop moderately fine the whites of twelve hard boiled eggs and the chicken, add equal quan-tities of chopped celery and cabbage, mash the yolks fine, add two tablespoons butter, two of sugar, one teaspoon mustard, pepper and salt to taste, and lastly, one-half cup good cider vinegar, pour over the salad and mix thoroughly. If no celery is at hand, use chopped cucumbers or lettuce and celery seed. This may be mixed two or three days before using. MRS. CHAS. EVANS.

OYSTER SALAD.

Slice delicately thin, with a very sharp knife, enough of the white part of celery to make one pint. Drop bits of ice over it, and set away to keep crisp till needed. Heat one solid quart of oysters to the boiling point in their own liquor, but do not allow them to boil. Drain them, cut each in several pieces, and pour over them the following dressing: Beat three eggs, and add to them one-half teacupful of vine-

gar, two tablespoonfuls of butter, one teaspoonful of made
mustard, one-half teaspoonful of pepper. Place in a double
boiler until it is as thick as very thick cream, stir constantly
and do not allow it to boil, or it will curdle. Pour this over
the oysters, stir lightly, and set away to chill. At serving
time, drain the celery of water and add it to the oysters, add-
ing also more salt if your taste demands it. Toss it up
lightly, garnish with blanched celery tops, and sliced olives
(if you wish), and serve. MRS. A. M. BELVIN.

CHICKEN SALAD.

Equal parts of chicken, white cabbage and celery. For
two chickens, use yolks of eight hard boiled eggs, rubbed fine
with the hand, one teacup pickles chopped almost to a pulp,
(the other ingredients must be chopped rather coarse), one
teaspoon red pepper, one black. For dressing beat together
yolks of six eggs, two tablespoonfuls dry mustard, three
tablespoonfuls sugar, one teaspoon salt, six tablespoonfuls
of butter, three of cream. Pour over this two cups boiling
vinegar, beating briskly. Put on the stove till it thickens.
Stirring all the time. If the chickens are fat the oil from
them is better than butter. MISS NELLIE MILLER.

DRESSING FOR SALADS, MEATS, ETC.

Six eggs well beaten, six tablespoonfuls of melted butter, six
tablespoonfuls of cream, two tablespoonfuls of mustard, two
of black pepper, one tablespoon of salt, two coffee cups of
vinegar. Boil all the ingredients except the eggs; when
thoroughly mixed, pour it over the eggs, stirring all the while,
then set it over the fire until it simmers; remove quickly to
prevent it being too thick. MRS. G. S. CRISER.

CHILI SAUCE.

Twelve large ripe tomatoes, four ripe or three green pep-
pers, two onions, two tablespoonfuls of salt, two of sugar, one

of cinnamon, three cups of vinegar; peel tomatoes and onions, chop (separately) very fine, add the chopped pepper with the other ingredients, and boil one and a half hours. Bottle and it will keep a long time. Stone jugs are better than glass jars. One quart of canned tomatoes may be used instead of the ripe ones. Mrs. A. M. Belvin.

SALAD DRESSING FOR LETTUCE.

To the yolk of one hard boiled egg, rubbed smooth, add one anchovy, one mustard spoon of Dusseldorfer mustard, two tablespoonfuls of olive oil, a little salt and pepper and one tablespoonful of best vinegar. The lettuce is better torn in small pieces and the dressing added by each person immediately before eating. Mrs. Tallichet.

COLD CHILI SAUCE.

One pint of ripe tomatoes chopped fine, pour off the juice; one onion, one small pepper, teaspoon of cloves, cinnamon, allspice, two teaspoons of salt, half cup sugar, half cup vinegar. Shake well before using. Mrs. C. F. Bissell.

CREAM DRESSING FOR COLD SLAW.

Two tablespoons of whipped cream, two of sugar, four of vinegar. Beat well and pour over cabbage previously cut very fine and seasoned with salt. Mrs. Geo. Hume.

A GOOD MAYONAISE DRESSING.

Put the yolks of two eggs in a deep dish, with a little salt and white pepper; into these stir briskly some olive oil; add a few spoonfuls of vinegar. This dressing should have an agreeable flavor, and rather stiff consistency. Salad oil should be kept well corked in a dry, cool place, and always in the dark. Mrs. G. S. Criser.

IRISH POTATO SALAD.

Mash and strain the potatoes through a colander, make them rich with butter; season with a sauce made by mashing the yolks of three hard boiled eggs for quart of potatoes, a teaspoonful of unmade mustard, salt and pepper, a teacup of good vinegar, two teaspoons of sugar. Mix thoroughly with the potatoes, put it in a stewpan and heat. Ornament the top with the whites of the eggs and sprigs of parsley. Some prefer this cold, it is good either way. MRS. COLLETT.

WARM SLAW.

Cut up white head cabbage very fine, and scald in water a few minutes; drain the water off, and pour over it a sauce made of one egg well beaten, with a little mustard, salt, pepper, and one teaspoon of sugar. Put this on the stove to cook a few minutes. MRS. DENSON.

CABBAGE SALAD.

One egg, one-half teaspoonful of salt, one of sugar, a half teaspoonful of mustard, a quarter teaspoonful of pepper, two-thirds of a cup of vinegar. Beat all together and boil over the steam of a kettle till quite thick; then turn the mixture over a small head of cabbage chopped fine; if too thick add cold vinegar. To be eaten when cold.

MRS. J. D. McCUISTON.

COLD CABBAGE SLAW.

Take one-half head white hard cabbage, shred or chop finely with a chopper, add a little salt, ground mustard, black pepper, three tablespoonfuls white sugar, one-half cup best vinegar, mix all thoroughly, then add one cup nice thick cream and stir. It will keep two or three days if kept in a cool place. Serve in sauce dishes.

PICKLES.

BEET PICKLES.

Boil tender, slice and place in a stone jar. Scald vinegar, to which has been added a little sugar. Flavor with cinnamon extract, teaspoonful to quart of vinegar, and they will keep without molding at this season for six weeks.

GREEN TOMATO PICKLES.

Take green tomatoes (they are best when nearly grown). Slice and scald them in one gallon of water with the addition of a little alum until they begin to be tender. Skin them out and put in a stone or glass jar. Take enough good vinegar to cover them, and to every quart, add one pound of sugar and spice to suit the taste. Scald them together, and while hot pour over the tomatoes. MRS. F. R. LUBBOCK.

CHOW CHOW.

One-half bushel of green tomatoes, one dozen onions, one dozen green peppers, all chopped fine; sprinkle over the mess one pint of fine salt; let it stand over night. Then drain off the brine and cover with good vinegar; let it cook slowly one hour, then drain. Take two pounds of sugar, two teaspoons of cinnamon, one of allspice, one of cloves, one of pepper, one pint grated horse radish, and vinegar enough to mix them;

when boiling hot pour it over the mess and then pack in jars ready for use. MRS. G. A. SEARIGHT.

CHOPPED PICKLES.

One peck green tomatoes, twelve green peppers, one head of cabbage, one-half dozen ripe cucumbers, one-half dozen green cucumbers, six large onions, two heads of celery, all chopped fine, and mix with one teacup of coarse salt. Let stand twelve hours; drain perfectly dry, and scald thoroughly in two quarts of vinegar. Drain and pack in jars. When cold, pour over two quarts of vinegar to which has been added one-half cup of grated horse radish, one tablespoon of ground mace, one tablespoon each of ground cinnamon, allspice, mustard and cayenne pepper, one-half ounce each of celery seed and mustard seed, three cups of sugar. Cover with plate to keep under vinegar. Cover closely the top with thick cloth. MRS. C. R. GIBSON.

PEPPER MANGOES.

Take the cap out of the pod, then scrape out the seed, lay the pods in salt water for an hour. Chop cabbage very fine, and to every quart, add one tablespoonful of salt, one tablespoonful of ground black pepper, two tablespoonfuls of white mustard seed, one tablespoonful of cloves, one of cinnamon and one cup of sugar. Mix all together. Drain the pepper pods and stuff them with the mixture, replace the caps, pack them closely in a stone jar, then pour on them strong vinegar. Then they are ready for use in a few weeks.
MRS. G. S. CRISER.

GREEN TOMATO SOY.

One gallon green tomatoes, sliced without peeling, six good sized onions, sliced, one pint sugar, one tablespoonful salt, one tablespoonful ground mustard, one tablespoonful black pepper, ground, one teaspoonful allspice, one teaspoonful

cloves, one quart of good vinegar. Mix all together and stew until tender, but not too long lest it becomes stringy, stiring often from the bottom to prevent scorching. When cold put in small glass jars, fill full, and seal.

<div align="right">MRS. J. L. VREDENBURGH</div>

CHOW CHOW.

Two gallons green tomatoes, one large head of cabbage, one dozen green peppers, one dozen onions, each chopped separately very fine. Mix all together, then put a layer of the mixture and a sprinkle of salt; then put it to drain all night; in the morning squeeze it perfectly dry, put in a dish, cover with cold vinegar; let it set six hours, then squeeze as before; season with one cup of mustard seed, three tablespoonfuls of celery seed, one of mace, three of spice, one quart of grated horse radish. Mix well together. Boil vinegar enough to cover one pound of sugar, pour it boiling over the pickle.

<div align="right">MRS. JAMES FORD.</div>

TOMATO PICKLES.

Two gallons of green tomatoes, sliced without peeling, twelve good sliced onions, two quarts of vinegar, one quart of sugar, two tablespoonfuls of salt, two of ground mustard, two of black whole pepper, one tablespoonful of allspice, one of cloves. Mix all together and stew till tender taking care they do not scorch. Put up in glass jars.

<div align="right">I. A. STANIFORTH.</div>

TOMATO CATSUP.

Boil one-half bushel of tomatoes three hours. Strain out the skins and seeds. To the remainder add three pints of vinegar, one-half pound of salt, one-fourth pound of black pepper, one ounce of cayenne pepper, one-fourth pound of allspice, one ounce of ground cloves, two pounds of brown sugar. Boil one hour.

<div align="right">MRS. GEO . HEFLYECWER.</div>

YELLOW PICKLE

made three years old in three hours: After cucumbers, cauli-
flowers, or cabbage have been in brine, soak nearly all the
salt out and boil them in weak vinegar. Take them out of
the vinegar. Then boil for ten minutes a gallon of strong
vinegar into which put two pounds sugar, two tablespoonfuls
of crushed celery seed, two tablespoonfuls of allspice, two
tablespoonfuls of ginger, one teaspoonful of mace, and one
teaspoonful of cloves. Put a gallon of pickles in a jar, and
pour this boiling vinegar over them, when cold add six whole
onions, three tablespoonfuls of turmeric, and three of grated
or sliced horse radish. All the spices ought to be crushed
before being boiled in the vinegar. Mrs. Ed. Wayland.

GREEN CUCUMBERS FOR WINTER.

Pare and grate green cucumbers and drain in sieve or cul-
lender eight or ten hours. Then add pepper, salt and vinegar
to taste. Put in small glass jars, cover with vinegar even
full, and seal. No cooking is required. This is excellent in
winter, cheap, and easily prepared. The secret of success,
however, lies in having the pulp well drained before adding
the vinegar, which must be strong and good.

 Mrs. J. L. Vredenburgh.

GREEN TOMATO PICKLES.

Cut in thin slices one peck of green tomatoes, sprinkle them
with salt, and let stand a day and night, slice one dozen
onions, mix one small box of mustard, half an ounce of mus-
tard seed, and one ounce of cloves. Put in kettle layer of
tomatoes, then one of onions and spice, till all are in. Cover
with good vinegar, and let simmer till the tomatoes are quite
clear. Mrs. James Ford.

SWEET PICKLE PEACHES.

To every ten pounds of pared peaches, allow four and one-half pounds of sugar, and one quart of vinegar. Place the sugar over the fire, with about a half teacup of water to every four and a half pounds of sugar. Boil and skim. Put in the fruit and boil five minutes, or until it can be pierced with a broom straw. Take out the fruit with a perforated skimmer and fill the fruit jars. Add the vinegar, and mace, stick cinnamon, and whole cloves to taste, to the syrup, boil ten minutes longer and pour over the fruit in the jars; removing all air bubbles by carefully running a knife down to them. Fill the jars full to overflowing with the syrup and seal immediately. Cling stones are the best for sweet pickle. MRS. J. L. VREDENBURGH.

SPICED PEACHES.

One peck peaches, one gallon vinegar, seven pounds brown sugar, one-half dozen whole cloves, one-half dozen sticks cinnamon broken into inch pieces. Boil the vinegar after putting in the sugar and spices; when it gets to boiling throw in as many peeled peaches as will cover the top of the kettle, and boil them until you can run a straw through them, and so on until all are done; fill the jars three-fourths full and fill up with the vinegar and spices.
MRS. JOSEPH SPENCE.

PEACH SWEET PICKLE.

Seven pounds of fruit, three and a half pounds of sugar, one pint of vinegar, one teaspoonful of whole cloves and double the quantity of stick cinnamon broke in pieces. Steam the fruit until a straw will pierce it. Boil the vinegar, sugar and spices together for five minutes. Put the fruit in jars and pour the hot syrup over and seal. Very fine. MRS. GEO. HEFLYBOWER.

CUCUMBER CATSUP.

Take cucumbers and peel them as for the table, grate them and drain all the water off through a seive. To one dozen cucumbers add one or two small onions chopped fine; pepper and salt to taste; add vinegar, one quart to every three or four dozen cucumbers. Put up in small jars, and stop very tight. MRS. JOS. SPENCE.

MISCELLANEOUS DISHES.

BOSTON BAKED BEANS.

One quart of beans nicely picked over; put them to soak in water over night; if old, parboil them a few minutes in the morning. Take a piece of pickled pork, say one pound, wash and scrape the rind; cut the rind in strips three-fourths of an inch wide, then put the beans in a bean pot, with the pork in the center, the rind even with the top of the beans; add about one-fourth cup of molasses; put in boiling water till the pork and beans are just covered; then put on a cover, put in a hot oven and keep them filled with water till night. Then let them dry down in a moderately warm oven. The next morning let them stand in a warm oven till heated through, when they are ready to serve. If baked right, they will be a delicate brown on top; and the longer they bake without burning, the better they are. If you have no bean pot, use a gallon stone jar.

A GOOD RECEIPT FOR POOR SWEET PO-TATOES.

Peel, slice, and place in crock or pan; two or three spoon-fuls of butter and half cup of sugar and cup of water poured over, and cooked until a nice light brown.

MRS. LITTLEFIELD.

CHEESE PUDDING.

One-half pound grated cheese, two ounces butter melted to oil, two tablespoonfuls milk, two eggs. Beat all together, and bake twenty minutes. Only half fill your dish, as it rises much. Mrs. L. R. Brown.

DRESSING FOR TOMATOES.

Beat the yolks of three eggs with two tablespoonfuls of good strong vinegar, two heaping teaspoonfuls of sugar, half a teaspoonful of mustard and a piece of butter the size of an almond. Put the ingredients in a tin cup, and stir over fire to a smooth paste. Do not let it boil. Put on ice till needed. Peel six large-like tomatoes, and when brought to the table pour salad over them. Mrs. V. O. Weed.

TO COOK RICE SO THAT ITS GRAINS WILL STAND ALONE.

Wash until the water is clear, then boil fifteen minutes (put in boiling water), strain, and place covered saucepan on the back of stove to steam for fifteen minutes, when the grains will crack open and be tender.

Mrs. Chas. Raymond.

CHEESE FONDEE.

One cup bread crumbs, very dry and fine; two scant cups of milk, fresh, or it will curdle; one-half pound dry old cheese grated; three eggs, whipped very light; one small tablespoonful melted butter; pepper and salt; a pinch of soda dissolved in hot water, and stirred into the milk. Soak the crumbs in the milk, beat into these the eggs, the butter, the seasoning, lastly the cheese. Butter a neat baking dish, pour the fondee into it, strew dry bread crumbs on the top, and bake in rather a quick oven until delicately browned. Serve immediately in the baking dish, as it soon falls.

Mrs. A. E. Habicht.

WELCH RAREBIT.

One-half pound of cheese cut in thin slices, one-half cup of sweet milk, two or three eggs slightly beat. Mix eggs and milk, with a pinch of salt, and pour the cheese, which is best cooked, in a pie pan. MRS. GEO. LITTLEFIELD.

CHEESE SOUFFLE.

One cup of grated cheese, one cup of milk, one tablespoon of butter, half teaspoon of salt. Dissolve the cheese in the milk. When slightly cool add two eggs well beaten, and one teaspoon of mustard, half a teaspoon of pepper. Bake a light brown, and serve hot. MRS. C. F. BISSELL.

BAKED MACARONI.

Take half a pound of pipe macaroni, break it in pieces about half an inch long, put in a saucepan of boiling water with teaspoonful of salt; boil from twenty to thirty minutes; drain well, then put a layer in a buttered baking dish, sprinkle lightly with cayenne and black pepper; cover with good, grated cheese. Repeat this until dish is full. Drop in bits of butter over top layer, add three tablespoonfuls of sweet cream or milk and a pinch or two of salt. Bake half an hour; brown nicely. MRS. TALLICHET.

A LENTEN DISH.

Remove shells and cut lengthwise, in halves, one dozen hard-boiled eggs; take out yolks and rub to a smooth paste, and mix with half teaspoonful mustard; salt and cayenne pepper to taste, and a generous teaspoon of Worcestershire sauce. Fill the sauce with this mixture, and serve on a bed of lettuce leaves, carefully selected. MISSES A. & E. GRAHAM.

IRISH POTATOES, MASHED.

Wash and pare eight or ten medium size potatoes, put into

cold water, if large cut into halves, wash once, put into a
porcelain, or nice iron kettle will do, and cover just to top
with cold water, boil quickly, try with a fork; when *just done*
(do not boil too long), drain off all the water, put in a pinch
of salt and beat all the lumps out with a potato masher, add
one cup cream and beat again, then put into a baking dish
smooth over the top and place in center of top one table-
spoonful of butter, sprinkle lightly over all with black pepper,
and bake in hot oven until nice brown on top; serve in the
dish they are baked in. The secret is to do all quickly
Potatoes prepared thus cannot be surpassed.

<div align="right">Mrs. Dr. Bragg.</div>

PIES, ETC.

TRANSPARENT CUSTARD.

Two teaspoonfuls butter, one cup sugar beat to a cream, (Wash salt out of butter); add yelks of three eggs and the beaten white of one. Bake in a rich crust—it is better to bake crust before putting the custard in. Add sugar to the other two whites, spread over top, and brown slightly.

MRS. T. J. BENNETT.

PIE CRUST.

Allow one cup of flour and a large spoonful of lard to each covered pie of ordinary size, sift the flour and take out a handful for rolling out; add a pinch of salt for each pie. Put your lard into the flour in lumps as large as an almond, but do not rub, as every lump will make it flaky. Work in as much cold water as will make a dough just soft enough to roll easily. Handle as little as possible. Roll the crust very thin and bake in a quick oven, and you will surely have good pie crust. For meat pies, use less shortening and put in a little yeast powder. MRS. G. S. CRISER.

LEMON PIE.

The yolks of six eggs, two cups of sugar, one cup of milk, one tablespoon of corn starch, the grated rind and uice of

two lemons—the juice to be put in last. Frosting:—The whites of six eggs and six tablespoons of sugar.

MISS MOLLIE FLANIKEN.

BUTTERMILK PIE.

For two pies. Half pint buttermilk, two eggs, one table-spoon of flour, butter the size of an egg, half teaspoon of soda. Sweeten to taste. Flavor with cinnamon.

MRS. C. R. GIBSON.

LEMON PIE.

One lemon grated, one cup of sugar, yolks of three eggs, small piece of butter, three tablespoons milk, two teaspoons of corn starch; beat all together, bake in a rich crust; beat the whites of two eggs with three tablespoons sugar, place on the pie when done, then brown in the oven.

MRS. GEO. HUME.

LEMON PIE.

Grate the yellow rind of two lemons; beat together the rind, juice, ten tablespoonfuls of sugar, and the yolks of four eggs, until very light; then add two tablespoonsfuls of water. Line a large plate and fill with the mixture; bake until the paste is done; beat the whites stiff and stir into them two tablespoonfuls of sugar, spread over the top and bake a bright brown. MRS. J. A. McCUISTON.

LEMON PIE.

Beat the yolks of five eggs and the whites of two eggs with one cup of sugar light; then add one and a half pints sweet milk and the grated rind of one lemon. Put this in crusts and bake; when done, beat the three whites stiff; add one cup sugar; the juice of one lemon; spread this over pies and bake until rich brown. MRS. CHAS. RAYMOND.

LEMON PIE.

Four eggs, one and a half cups sugar, two-thirds cup of water, two tablespoons flour, one lemon; beat the yolks of eggs a long time, and whip the whites well; add the grated peel of lemon and the sugar; beat well; stir in the flour and add the lemon juice (if the lemons are small two may be necessary), and lastly the water; stir well, and pour in pie pans lined with rich paste. When baked, take from oven and spread over them the whites of the eggs beaten dry and smooth with four tablespoons pulverized sugar; return to oven and brown slightly. The above recipe is for two pies.

MRS. J. L. DRISKILL.

LEMON PIE.

Three eggs, three tablespoonfuls of sugar, one of melted butter, half cup sweet milk, the juice and rind of one lemon; separate the eggs, and beat the yolks and sugar together; add the butter, lemon and milk; bake in one crust; when the custard is well set, spread on the meringue made of whites and sugar, and bake a light brown. MRS. TEN EYCK.

A DELICIOUS CREAM PIE.

Cover plate with crust and bake, watching carefully to press down the blisters. Cream two cups of milk heated to scalding; add teaspoonful of corn starch mixed with a little cold milk, one teaspoonful of vanilla, one teaspoonful sugar, yolks of four eggs. When baked to proper consistency, pour onto the crust. Beat the whites to a stiff froth, add a little sugar, spread over the top, and brown slightly in the oven.

MRS. EVERETT.

MOLASSES PIE.

Beat the yolks of four eggs; add one teacup of brown sugar, one-half nutmeg, two tablespoonful of butter, beat thor-

oughly, stir in one and a half teacups molasses; add the
whites of the eggs. Mrs. Dr. Rainey.

MOLASSES PIE.

One cup of sugar, one cup of molasses, one tablespoonful
melted butter, four eggs; beat yolks and sugar very light; add
the molasses, butter, and flavor with vanilla; beat the whites
to a stiff froth, and stir in thoroughly and bake in one crust.
This makes one pie. Mrs. Ten Eyck.

MINCE MEAT.--GOOD.

Three pounds beef tongue, well minced; three pounds suet,
well minced; six pounds stewed apples, three pounds pre-
served peaches, two pounds winter grapes, six pounds brown
sugar, two nutmegs, six tablespoons of cinnamon, six dozen
cloves, four tablespoons of spice, four tablespoons of mace, one
quart of vinegar, three pints of whisky, half pound citron,
three oranges, six green apples, two pounds stoned raisins,
two pounds currants. Mrs. C. R. Gibson.

CREAM PIES.

Yelks of five eggs well beaten, two teacups of cream or rich
milk, two teacups white sugar, one cup butter. Mix all well
together then add one tablespoonful of corn starch. Make
pastry for the bottom and use the whites of eggs for merin-
gue. This quantity will make two pies.
 Mrs. W. R. Hamby.

MINCE PIES.

Boil a fresh beef tongue tender. Let it get cold, then chop
it fine, with one pound suet, one-half peck apples, two pounds
of currants picked and washed carefully, one pound citron
sliced, half ounce each powdered cloves, allspice, cinnamon
and ginger, three pints of sweet cider, one pint of brandy,
with enough sugar to sweeten to your taste. This makes a
large jar. Mrs. James Ford.

JELLY PIES.

One cup jelly, one cup sugar, one-half cup butter, five eggs. Line pie plates with rich crust. Pour half in each of two plates, and bake slowly. Mrs. C. R. Gibson.

LEMON CUSTARD.

Two cups of sugar, five eggs, one heaping tablespoonful of butter, the rind and juice of two lemons. Beat well the yolks, sugar and butter together, add the whites beaten to a stiff froth, then add the rind and juice of the two lemons. Use rich pastry. Octavia Moore Proctor.

VINEGAR PIE.

One cup of sugar, one cup molasses, two eggs, one-half cup water, one-half cup of vinegar, two teaspoonfuls of flour.
Miss Mollie Flaniken.

PUDDINGS.

PLUM PUDDING.

Two eggs, one cup of sugar, one cup of sour milk, one tea-spoon of soda, one-half cup of butter, one-half cup of suet, chopped, two-thirds cup of citron shredded fine, one cup of currants, one cup of raisins chopped, flour to make a stiff batter. Place in a pudding pan, and set in a steamer; cover it closely with a thick cloth and the lid; steam four or five hours, keeping the steamer continually closed. Before serving, set in the oven until it browns nicely on top. Serve with the following sauce:

SAUCE FOR PLUM PUDDING.

One-half cup butter, one cup sugar, one cup thick sweet cream. Flavor with lemon or wine. Put all in a saucepan and heat to boiling point. MRS. P. THOMPSON.

PUFF PUDDING.

One quart milk, six eggs, six tablespoonfuls flour, salt to taste. Bake twenty minutes, and serve with lemon sauce.
MRS. G. CROW, SR.

SWEET POTATO PUDDING.

Take two or three good sized sweet potatoes, peel and grate them, add one teacup sweet milk, one-half teacup melted

butter, one teacup sugar, one pinch salt. Stir thoroughly, and bake in moderate oven. Mrs. J. M. Peacock.

WAFER PUDDING.

One tablespoon of flour, two eggs well beaten, two ounces butter. Mix with one-half pint of milk and a little sugar. Bake in buttered saucers. When dishing, lay some jam in one half and fold the other half over. Now sprinkle with sugar on top. Bake for half an hour.

Mrs. R. L. Brown.

TRANSPARENT PUDDING.

Four eggs, beat separately; one cup of butter, two cups of sugar; beat butter and sugar to a cream, add yolks and two tablespoonfuls of fruit jelly. Flavor to taste; add the whites as a meringue. Bake in paste, in pie plates. This quantity is sufficient for two. Mrs. R. M. Hall.

COCOANUT PUDDING.

Eight eggs, with the whites of three taken out; one pound of white sugar; lump of butter the size of a turkey egg—more makes it too rich. Beat well together, and then add one cocoanut grated. Bake in rich crust.

Ed. Mrs. Wayland.

LEMON PUDDING.

Five eggs, the juice of three lemons, one pound of sugar, one-fourth pound of butter. Mix half of the sugar in the eggs, and the other half in the lemons. Bake in rich crust.

Mrs. Ed. Wayland.

CHRISTMAS PLUM PUDDING.

Two dozen eggs, two pounds stale bread, two pounds suet, two pounds brown sugar, one pound sliced citron, three

pounds currants, three pounds seeded raisins, two nutmegs, half pint wine, half pint brandy, a tablespoonful pulverized cloves, allspice, two of cinnamon, one teaspoon mace and half spoonful of salt. Soften the bread crumbs, which must be grated, with the wine and brandy. (If you don't want wine or brandy water will answer). Beat eggs and sugar as for cake; add the bread and spice then the fruit which has been prepared before. (The raisins stoned and cut, currants washed through three and four waters). It is best to use a seive that can be put down in a pan of water; put the currants in this and rub well with the hand to dislodge all grits or pebbles which may be lurking in the harmless looking currants; then dry either in the air or in the stove if careful not to let them get burnt. Have ready eight or ten little domestic bags about three inches wide and fourteen long—old domestic is best if not threadbare—dip these in boiling water and take out and squeeze water out quickly and open with a puff of air, then throw in half a cup of flour and shake well until all sides of bag has coating of flour. Fill the bag, leaving about ten inches to allow for swelling. Tie with a good cord, adding a loop to hang them up when done. Drop the bags in boiling water and boil for five hours—a gas stove or oil is splendid for this. The boiling must never cease until done. When done take up and hang in some cool and dry place. They will keep for several months. When wanted plunge in boiling water and boil an hour; when ready to serve take out of the water and drop in cold water for a second only and then tear the bag off, place on flat dish and send to table smoking hot. Serve with hard sauce made with a cup and a half of pulverized sugar and one cup of butter creamed nicely; add wine glass of brandy to flavor.

MRS. GEO. LITTLEFIELD.

LEMON RICE PUDDING.

One and a half cups rice cooked in one quart of milk and one pint of water, a little salt. Let cook until thoroughly done. While hot add the grated rind of a lemon, yolks of

three eggs beaten light with one cup of sugar. When cold cover with meringue made of the whites of three eggs and two cups pulverized sugar, and the juice of one lemon. Brown a delicate color in the oven. Mrs. Jno. Webb.

BOILED COCOANUT CUSTARD.

To one grated cocoanut allow one pint and a half of milk, five eggs, and five large tablespoons of sugar. Beat the yolks of the eggs with the sugar until light and smooth. Put the milk over the fire to boil, and as soon as it comes to a boil scald the whites of the eggs in it, first heating them to a stiff froth. Let it boil a minute or two, then take out the whites and pour the milk scalding hot on the egg and sugar, Add the grated cocoanut, put the custard in a bucket, and place the bucket in a vessel of boiling water. Let it boil from five to ten minutes, stirring frequently; it must be stirred a good while after taking it from the fire. When cool, put it into custard cups and heap the whites of the eggs upon it.

Mrs. Botts.

RICE PUDDING.

Dissolve one tablespoon corn starch in one-half cup of milk, and add two and one-half cups of milk. Beat the yolks of two eggs with three-fourths cup of sugar, and set whole on fire, in a custard kettle. When hot, add one cup hot boiled rice; stir carefully until it begins to thicken, and then add flavoring to taste, and put in a pudding dish and set in a hot oven. Beat whites of the two eggs to a stiff froth, flavor and put it on pudding when done and brown. Excellent.

Mrs. V. O. Weed.

JELLY PUDDING.

Four eggs, two cups of sugar, one cup of jelly, one-half cup of butter, one cup of cream, two tablespoonfuls of vanilla. Separate the eggs, beat the butter and sugar together, add

the cream and jelly, beat the whites to a stiff froth and add
them last thing. Bake in a crust. MRS. EVERETT.

QUICK PUFF PUDDING.

One pint of flour; stir in two teaspoonfuls of baking
powder, a small pinch of salt, and sweet milk enough to make
a soft batter. Take six teacups, drop a spoonful of batter
into each, then a spoonful of fresh berries, then a spoonful of
batter. Steam twenty minutes. Eat with sugar and cream.
Any kind of fruit will do. MISS MOLLIE FLANIKEN.

MARMALADE PUDDING.

Two eggs, one-fourth pound bread crumbs, one-fourth
pound suet, one-fourth pound sugar, one-fourth pound orange
marmalade, a little milk. Put crumbs into basin and add to
them suet (finely chopped), then marmalade and sugar beaten
together. Add eggs, previously beaten with enough to mix,
and boil for two hours in buttered basin.

MRS. R. L. BROWN.

ORANGE PUDDING.

Peel and slice four large oranges. Lay in dish, sprinkle
over them one cup sugar. Three eggs, yellows only, beaten;
one-half cup of sugar; two tablespoonfuls of corn starch; one
quart of milk. Let this boil. and then thicken. Then let it
cool a little before pouring it over the oranges. Beat the
whites of the eggs and ponr over it. Set in oven to brown.

MRS. JAMES FORD.

BATTER PUDDING. (Very Nice.)

One pint of milk; four eggs, whites and yolks beaten sepa-
rately; two even cups of flour; one teaspoonful of salt; one
pinch of soda. Bake in a buttered dish, three-fourths of an
hour. Serve in the pudding dish as soon as drawn from the
oven, and eat with lemon sauce.

LEMON SAUCE FOR SAME.

One large cup of sugar, one-half cup of butter, one egg, one lemon (all the juice and one-half the grated peel), one teaspoonful nutmeg, three tablespoonfuls boiling water. Cream the butter and sugar, and beat in the egg whipped light, then the lemon and nutmeg. Beat hard two minutes, and add a spoonful at a time of the boiling water. Put in a tin pail, and set within the uncovered top of the teakettle, which you must keep boiling until the steam heats the sauce very hot, but not to boiling. Stir constantly.

MRS. S. E. BOTTS.

DELICIOUS LEMON PUDDING.

The juice and grated rind of one lemon, cup of sugar, yolks of two eggs, three well-rounded tablespoons flour, a pinch of salt, one pint of rich milk; mix the flour and part of the milk to a smooth paste, add the juice and rind of lemon, the cup of sugar, yolks well beaten, the rest of the milk (after having rinsed out the egg with it), line plate with puff-paste one-fourth inch thick, pour in custard, bake in a quick oven until done. Beat whites to a stiff froth, add two tablespoons sugar, spread over the top, return to the oven and brown. Serve with very cold cream. This is a very rich and not expensive pudding. The recipe makes sufficient for six.

MRS. CHAS. EVANS.

DANDY PUDDING.

Yolks of four eggs, two cups of sweet milk, one cup sugar, one tablespoonful of flour; boil until like starch, then beat whites of the eggs with sugar and spread on top, put in oven until light brown; flavor to taste.

MISS MOLLIE FLANIKEN.

TAPIOCA PUDDING.

One cup of tapioca, the coarse kind is preferable, soaked all night in sufficient water to cover it. Then add one quart of preserved strawberries, or any kind of good canned or stewed fruit, cut fine if pears or peaches, sweeten to taste. Cook one and a half hours in a moderate oven. Meringue improves it. Serve with whipped or plain cream. This is wholesome and very nice. MRS. JNO. WEBB.

APPLE DUMPLINGS.

To one quart flour sift teaspoon soda and add half teaspoon salt; lard size two hen's eggs; rub well together and work in enough sour or buttermilk to make a soft dough. Roll and cut size of saucer. Peel and slice half dozen large apples and add two teascups sugar and half teacup of water; let boil five minutes and put the fruit on the dough, bring the edges together over fruit and place in a greased deep pan; pour the liquid from boiled apples over; slice butter size of hen's egg over, and add one teacup sugar and two of water; grate nutmeg over surface, and bake in an oven not very hot, for one and a half hours. MRS. I. V. DAVIS.

CAKE AND SAUCE FOR DINNER.

Beat four eggs with one and a half cups of sugar; cream and add one cup butter and beat well together; mix with two and half cups flour, in which has been sifted two teaspoonfuls yeast powder, and add half cup water. Warm and grease pan and bake in a gradually heating stove. Sauce: One cup sweet milk heated to near a boil, add one and a half cups sugar, and mace to flavor, and tablespoon butter. MRS. I. V. DAVIS.

SNOW PUDDING.

Pour one pint of boiling water on one-half box of gelatine, add the juice of one lemon, and two cups of sugar. When

nearly cold, strain. Add the whites of three eggs beaten to a froth, beat the whole together, put in a mould and set on ice. With the yolks of the eggs, one pint of milk, one large spoonful of sugar and one teaspoonful of corn starch, make a boiled custard, flavor it with almond or vanilla extract. Serve cold by pouring the custard around portions of the snow placed in saucers. Very dainty and nice.

Mrs. G. S. Heflybower.

GELATINE JELLY WITHOUT BOILING.

To one box Cox's sparkling gelatine add one pint cold water; let it stand until dissolved, then add four pints boiling water, three lemons, juice and rind, two pounds sugar; one pint Madeira wine. Stir well and strain.

Mrs. Leslie Waggoner.

CHARLOTTE RUSSE.

Whip three pints of cream; sweeten and flavor to taste the whites of six eggs well beaten, whip the cream and skim alternately, and mix well; dissolve one-half box of gelatine and stir rapidly. Mrs. Rainey.

APPLE FLOAT.

Take a quart of stewed apples, press them through a sieve, sweeten and flavor to taste; then beat into them the well-frothed whites of three or four eggs. Beat well, and pile up in a glass bowl half filled with cream or rich milk.

Mrs. J. W. Smith.

DELIGHTFUL AMBROSIA.

One can of pineapple, three oranges and three bananas. Cut the pineapple and oranges in very small pieces, slice the bananas, and put in alternating layers, with sugar and grated cocoanut sprinkled between each layer. Pour in the pineapple juice, and if to be eaten right away the milk of the cocoanut may be poured in, but it is apt to sour if left over.

May W. Davis.

CHARLOTTE RUSSE.

Split two dozen lady fingers (sponge or other cake may be used), lay them in a mold, put one-third of a box of gelatine into half a pint of milk. Place it where it will be warm enough to dissolve. Whip three pints of cream to a froth, and keep it cool. Beat the yolks of three eggs, and mix with half pound powdered sugar; then beat the whites very stiff, and add to it; strain the gelatine upon these, stirring quickly, then add the cream; flavor with vanilla or lemon; pour over the cake, let stand upon ice two hours.

Serve with whipped cream. Some add a layer of jelly at bottom of mold. Mrs. A. M. Belvin.

CHARLOTTE RUSSE.

One quart of whipped cream, one-half box Cox's gelatine, four eggs, two cups of milk, two teaspoonfuls of vanilla, two dozen lady fingers. Heat the milk to boiling with the sugar in a farina kettle, dropping in a pinch of soda the size of a pea to prevent its curdling. Beat the eggs light and pour the hot milk on them, a little at a time; return all to the fire and cook until the custard is set, stirring constantly. Just before taking from the fire add to it the gelatine, which should have been soaked two hours in enough cold water to cover it. Let the custard become cool and stir the whipped cream into it. Line a plain mould with the sponge cake, and onto this pour the whipped cream and custard, and put on ice until needed. Turn on flat dish before serving. Mrs. Littlefield.

CHARLOTTE RUSSE.

Whites of six eggs, three pounds sugar, three pints rich cream (24 hours old), one-half ounce of gelatine. Dissolve the gelatine in one-half pint of water, whip the cream to a stiff froth, and lay on a sieve to drain; beat the eggs hard, add the sugar (pulverized), pour in the gelatine, stir well

until thoroughly mixed; put in the cream, beat as rapidly as possible, flavor with vanilla to taste.

Mrs. A. P. Blocker.

CHARLOTTE RUSSE.

Take half a box of Cox's gelatine and pour over it enough sweet milk to cover it well. While this is soaking, make a boiled custard of one pint of sweet milk, four tablespoonfuls of sugar, and the yolks of four eggs. When the custard is made, and before removing it from the fire, pour into it the gelatine that has been soaked in the milk, and stir constantly until it has all dissolved, then remove it from the fire and strain through a sieve into a vessel. Then take one pint of pure cream, sweeten and flavor to the taste. Whip the cream to a stiff froth. After the custard gets perfectly cold and commences to congeal, stir the whipped cream into it, until it is all well mixed; then whip the whites of four eggs to a stiff froth, and stir them rapidly into the Charlotte. Pour all into a bowl and set aside to congeal. The bowl can be lined with thin slices of cake, or lady fingers if preferred.

A SIMPLE BUT GOOD CHARLOTTE RUSSE.

A stale sponge cake sliced up thin and placed in a nice glass dish, or lady fingers are as good; on this pour a pint of rich cream, which has been whipped well and flavored with wine and sweetened to suit the taste.

Mrs. Littlefield.

RUSSIAN CREAM.

Half a box of gelatine beaten up with the yelks of four eggs and a small cup of sugar. Put one pint of milk in a saucepan and set it on the stove to boil. Stir in the above mixture and boil until like boiled custard. When half cold, stir in the beaten whites of the eggs, flavor to taste and pour in molds.

Mrs. G. S. Criser.

MOONSHINE.

This dessert combines a pretty appearance with a palatable flavor, and is a convenient substitute for ice cream. Beat whites of six eggs in large dish to a very stiff froth, add gradually six tablespoons of powdered sugar, beating for some time; then beat in half cup of jelly,—acid preferred, such as grape or plum,—set on ice until thoroughly chilled. In serving pour in each saucer some rich cream sweetened and flavored with vanilla, and in this cream pour a liberal portion of the moonshine. A rich, boiled custard will answer in place of sweetened cream. MRS. JOHN ORR.

MOONSHINE.

Beat the whites of six eggs in a large dish to a stiff froth, then add gradually six tablespoons powdered sugar (to make it thicker use more sugar), beat for thirty minutes, and then beat in one cup of jelly and set on ice until thoroughly chilled. In serving pour in each saucer some whipped cream, flavored with lemon and vanilla, and on this place a liberal portion of the moonshine. LAURA DRISKILL.

SPANISH CREAM.

One half box of gelatine, soak in one-half pint of milk, then put one quart of milk on to boil, beat the whites of six eggs to a stiff froth; when the milk is boiling hot stir in the beaten yolks and sugar to taste, and the gelatine; let it thicken as you would soft custard, then pour it boiling hot on the whites, stirring all the time; flavor with vanilla, and pour into molds to cool. Let it stand at least twelve hours in a cold place before using. MRS. PROCTOR.

FRUIT BLANC MANGE.

Stew nice fresh fruit (cranberries are very nice), strain off juice and sweeten to taste; place it over a fire in a double

kettle until it boils; while boiling stir in corn starch wet with
a little cold water, allowing two tablespoonfuls of starch for
each pint of juice; continue stirring until sufficiently cooked;
then pour into molds wet in cold water, and set away to cool.
To be eaten with cream and sugar. MRS. T. J. BENNETT.

GELATINE.

Soak one box of "Nelson's Brilliant Gelatine," or two
boxes of "Cox's Gelatine," in one pint of cold water for
twenty minutes, then add one pound of sugar, the juice of
four (4) lemons, and three pints of boiling water. Stir well,
pour in a mould, and set away to cool.
KATIE THORNTON.

SNOW, ICE AND THAW.

Soak for ten minutes one-half box of gelatine in four table-
spoonfuls of cold water and turn on a scant pint of boiling
water. Add the juice of two lemons, two cupfuls of sugar
and a tiny pinch of salt; cool, and stir in the whites of two
eggs beaten stiff; whip with a good egg beater to a stiff froth
and put in molds until next day. Make a custard of the yolks
of three eggs, one entire egg, one cupful of sugar, and one
pint of milk. Beat the whites of three eggs with three table-
spoonfuls of pulverized sugar. Put the gelatine (Ice) in a
glass dish, then the custard (Thaw), and lastly the whites
(Snow). MRS. T. B. LEE.

SEA FOAM.

Whites of ten eggs beaten to a stiff froth, one and a half
cups sifted sugar, one cup sifted flour, one teaspoon cream
tartar. Put in rings and bake quick. MRS. G. CROW, SR.

SNOW PUDDING.

One-half box gelatine, three-fourths pounds sugar, whites
of three eggs, juice of three lemons. Dissolve the gelatine

in one pint hot water; beat eggs to stiff froth, add lemon and sugar, then add gelatine and beat until stiff as cake batter. Make a custard of the yolks, one pint milk, sweeten to taste.

MISSES A. and E. GRAHAM.

ITALIAN SNOW.

Soak one-half box of "Cox's Gelatine" in a pint of cold water until thoroughly dissolved, then add whites of three eggs well beaten, one cup of sugar, flavoring of any kind of extract; beat with egg beater for twenty (20) minutes. Pour into molds to cool. To be eaten with cream.

MRS. PAUL THORNTON.

ORIOLE'S NEST.

Mold blanc mange in egg shells, having emptied and washed as many of them as will make a pretty nest. Having made a stiff jelly, partly fill a bowl with it and place the egg shapes upon it, in such a way as to look well when turned out. All around and over the eggs place long strips of preserved orange rind to resemble straw. Melt a cupful of the jelly reserved for the purpose and pour over the whole. After it is thoroughly congealed, turn out upon a glass dish.

MRS. L. S. ROSS.

PRESERVES AND ICES.

CITRON.

Pare and cut in pieces the watermelon rind and place in clear water for a day; then drain, and put into a strong ginger tea, allowing it to boil until tender. Have prepared a rich syrup, allowing three-quarters of a pound of sugar to a pound of the rind. Let it boil in the syrup for two hours. When done seal up air tight. Flavor with lemon extract when brought to the table. Mrs. E. C. Baker.

GRAPE PRESERVES.

After picking over the grapes carefully, squeeze the pulp from the rind, putting the pulp and rind in separate dishes. To every pound of pulp add one-half pound of sugar; after boiling this thirty minutes slowly, add the rinds and boil thirty minutes longer. Seal in glass jars for future use.
Mrs. Paul Thornton.

FIG PRESERVES.

Make a thick syrup of four (4) pounds of sugar, adding two lemons sliced; when boiled sufficiently remove the lemons, and drop in eight (8) pounds of figs; boil slowly for two hours; seal up in glass jars. Katie Thornton.

GRAPE OR DEWBERRY JELLY.

Pick over carefully eight pounds of the fruit; to this add one quart of water, and boil until tender; strain through a

flannel bag (previously rinsed in clear water); to each quart
of the juice add one pint of sugar, boil rapidly; if on drop-
ping a little into a tumbler of cold water it falls to the bottom
in solid torm, it is jellied. MRS. PAUL THORNTON.

ORANGE PRESERVES.

Take large, ripe muskmelons, cut off the rind, slice in
convenient pieces, then let stand four hours with equal weight
of sugar. To make them firm dissolve a level teaspoonful of
pulverized alum in water, and pour over the melon while in
the sugar. Pour off the juice, clarify with white of an egg,
boil and skim, then add the fruit. Boil one hour. Flavor
with Extract of Orange (Dr. Price's).
 MISS MOLLIE FLANNIKEN.

SHERBET.

Thre) teacups of sugar, juice of six lemons, one can grated
pine apple, whites of three eggs beaten to a froth, three
quarts of water. Add eggs just before freezing.
 MRS. LESLIE WAGGONER.

ICE CREAM.

One quart of cream, the whites of five eggs and the yolks
of three, one teacup of milk, stirred in the eggs and cooked
until it thickens a little, one tablespoonful of gelatine dis-
solved in a little water; sweeten and flavor to taste, and then
mix altogether and freeze. MRS. FRANK RAINEY.

PINEAPPLE ICE.

One can grated pineapple, juice of four lemons, four tea-
cupfuls sugar, a half gallon of boiling water. When cold add
whites of two eggs beaten to a stiff froth, and freeze till firm.
 MRS. R. M. HALL.

ICE CREAM.

One quart cream, one and a half quarts milk, one large cupful sugar; flavor to taste. Add beaten whites of three eggs and freeze till firm. This requires no cooking and is excellent. Mrs. R. M. Hall.

PINEAPPLE ICE.

Half gallon sweet milk; into this stir one cup of sugar, one can of grated pineapple. When it begins to freeze remove the lid and pour one cup of rich cream into it. Then turn until it is stiff. Laura Driskill.

MEXICAN RECEIPTS.

TAMALE DE CUSUELA.

(CORN MEAL POT PIE.)

One quart of corn meal scalded; add a little salt and four tablespoonfuls of melted butter or lard. The meat may be all pork or chicken and pork mixed, boiled until tender and cut up in small pieces. Stir into the meal a double handful of flour, two beaten eggs, and onto this pour enough of the broth to make a thin batter. Take two or three large red peppers chopped fine and half can of tomatoes, beat thoroughly together and cook in a little lard or butter until well done, then put the chopped meat into the last ingredients and mix well. After this line your pie dish with the corn meal mixture, having first greased it well, and then put in the mixture in layers as for a chicken pie. Bake very slowly, and when nearly done dress over the top with butter, put in the oven and cook until done. MRS. DR. IGLEHART.

CHILI Y. HUEVOS CON CARNE.

(PEPPER AND EGGS WITH MEAT.)

Toast the peppers in the fire, remove the seeds and cut in small pieces. Have ready some hot lard in a saucepan, into which throw a handful of chopped onions and half a cup of can tomatoes; pour in a cup of water, and when it is boiling put in four or more beaten eggs, stirring steadily for several minutes; put in the chopped peppers, and when on the dish

ready to serve, cover the whole with grated cheese. This is truly delicious. MRS. DR. IGLEHART.

CHILI REYENES.

(STUFFED PEPPERS.)

Take a dozen large green peppers, toast them in the fire, slit carefully down one side and remove the seeds. Take boiled meat of any kind, that is minced as fine as possible, a few cooked onions, minced, one can tomatoes, leaving out the juice that is in it, a little cinnamon, a little powdered cloves, a few currants, and one boiled egg, all made into a paste. Take the slit peppers, stuff them with the mass and close carefully, wrapping with a thread. Beat four eggs, whites and yellows separately, put them together, dip each pepper in, and fry in a large quantity of boiling lard until quite brown. MRS. DR. IGLEHART.

I subjoin a few of their *dulces*, (sweets):

QUESODE ALMENDRA.

(ALMOND CHEESE.)

To one pound of blanched almonds add one pound and a half of sugar, the yolks of eight eggs, and six ordinary glasses of milk. Put on the milk to boil; when well done set aside to cool until the cream rises; skim this off; stir the sugar in the milk, and when well dissolved strain through a sieve; after this put in the yolks of the eggs, well beaten, then place on the fire. Having the almonds beaten as fine as powder, when the ingredients begin to boil pour in the almonds, stirring continually, adding a little powdered cinnamon. The compound is done when you can see the bottom of the kettle each time you stir across it. The mass may be cut any shape or size while in the kettle, or remove to let it get cold, and slice. Truly delicious. MRS. DR. IGLEHART.

COPAS MEXICANAS.

The yolks of twelve eggs beaten light, half pound of pow-
dered sugar, and twelve lady fingers beaten into a powder.
Beat the sugar with the eggs thoroughly, add the lady fingers
and vanilla to taste. To be served in small glasses or cups.

MRS. DR. IGLEHART.

HUEVOS REALES.

(ROYAL EGGS.)

Beat a dozen eggs until very light, then put them in a ves-
sel, and again put this vessel in another of boiling water, to
remain until well done. Put one-half pound of sugar into a
pint of water to cook, until it makes a syrup; before it reaches
the candied state, cut the yolks into shapes or small pieces,
and put them into the syrup to boil. When cooked to a rich
consistency, place on a dish, and on each piece of egg place
blanched almonds and a few raisins.

MRS. DR. IGLEHART.

BREAKFAST DISHES, ETC.

SALMON FOR WINTER BREAKFAST.

Take can of best salmon, put it in boiling water for half an hour, keep water boiling. Put two tablespoonfuls of fresh butter in frying pan and stir gently over a slow fire until it is a dark brown color; then pour into it two tablespoonfuls of good hot vinegar, season with a pinch of salt and black pepper. Open can, empty salmon into a covered dish, pour sauce over it, and serve while hot. MRS. TALLICHET.

BREAKFAST DISH.

One cup of soft-boiled rice, hot, with a good deal of the water left in which it is boiled, one cup of sifted meal, mixed in while the rice is hot, one tablespoonful of lard, salt to the taste; one even teaspoonful of soda mixed in one pint of sour or buttermilk, two or three eggs well beaten and added at the last. Bake in a hot oven from one-half to three-fourths of an hour. MRS. EVERETT.

A NICE BREAKFAST DISH.--ONENDAW.

Stir a tablespoonful of butter into two teacups of cooked grits; beat four eggs light and stir them in the hominy; add in by degrees one-half pint of sweet milk, one-half pint of cornmeal. The batter should be the consistence of rich, boiled custard. If thicker than that, add a little more milk. Bake with a good deal of heat at the bottom of the dish, and not too much on top. MRS. BLOCKER.

CORN FRITTERS.

To one can of corn add four eggs well beaten, one table-spoonful of flour, one teaspoon of sugar, salt to taste, and fry in boiling lard a light brown. Mrs. Ten Eyck.

BAKED HOMINY.

One cupful of cold hominy (small grained), two cups of milk, one large teaspoonful each of butter and sugar, a little salt and three eggs. Work the melted butter well into the hominy, mashing all lumps, then the beaten yolks; next add sugar and salt, then gradually the milk, lastly the whites. Beat until perfectly smooth, and bake in a greased pudding dish until delicately browned. Serve in bake dish. A delicious breakfast dish. Mrs. Proctor.

FRIED APPLES.

Slice five or six good-sized apples without peeling. Fry three or four slices of bacon, take the bacon out and fry the apples in the grease, adding about two tablespoonfuls of sugar. Mrs. Littlefield.

BAKED APPLES.

Pare and core as many apples as are needed, and place in baking pan, put a small lump of butter on each, and sprinkle liberally with sugar; pour water in the pan until it measures about an inch, then put in the oven and baste frequently, until they are a nice, rich brown, and syrup is thick or jellied. Mrs. Littlefield.

EGGS DE LA CREME.

Boil a dozen eggs until hard, slice in rings. In the bottom of a baking dish place a layer of bread crumbs, then one of eggs; cover with bits of butter, pepper and salt. Continue

till all are used. Pour over them a teacup of sweet cream, and brown in the oven. LAURA DRISKILL.

DRESSED EGGS.

Boil one dozen eggs until hard. Take out, put in cold water, and peel while quite warm. Cut the eggs in two lengthwise and take out the yolks, being careful not to break the whites. Season the yolks with butter, salt, pepper, and add some finely minced cucumber pickles. Work all to a smooth paste and fill the whites with it; put in a shallow dish and set in the oven until a light brown. Can be eaten either hot or cold. Very nice for supper cold.

MRS. P. THOMPSON.

CAKES.

FRUIT CAKE.

One dozen eggs, one pound brown sugar, one pound flour (brown the flour), three-fourths pound butter, two pounds raisins (seeded), two pounds currants (washed and dried), one pound of citron cut fine, one pound almonds, one cup molasses, one tablespoonful of cinnamon, one tablespoonful of cloves, one nutmeg, one glass of brandy. Put the fruit in a pan and rub flour on it; mix the batter; afterwards add the fruit and bake about two and one-half hours.

MRS. G. S. CRISER.

FRUIT CAKE.

One pound of butter, one pound of brown sugar, ten eggs, one cup of molasses, two wine glasses of brandy, three pounds currants picked and dried, three pounds stoned raisins, one pound of almonds (blanched), one pound of citron, one teaspoonful of soda, one tablespoonful each of cloves, cinnamon, nutmeg and mace, one and one-fourth pounds of flour. Beat the sugar and butter to a cream, add the yolks (well beaten), the molasses, soda and brandy, and half the flour; then add the whites, beaten to a stiff froth. Mix the fruit with the other half of the flour and stir all together, and bake three and one-half or four hours. MRS. COLLETT.

OLD PLANTATION FRUIT CAKE.

Two pounds brown sugar, four pounds flour, one quart N.

O. molasses, thirty eggs, four pounds of citron, four pounds
raisins, four pounds currants, six teaspoonfuls baking powder,
brandy and spices to please the taste. Beat and mix as for
other cake receipts. MRS. MCDONALD.

This receipt was used in Aunt Peggy Ewing's family for
generations.

FRUIT CAKE.

One pound flour, one pound butter, one pound sugar, twelve
eggs, two pounds seeded raisins, two pounds currants, one
pound citron, one pound Manchat almonds, one pound
pecans, two wine glasses of brandy, two wine glasses of wine,
one tablespoonful of rose water, two tablespoonfuls of cloves,
two tablespoonfuls of cinnamon, two tablespoonfuls of spice,
one tablespoonful of mace, two tablespoonfuls of nutmeg.

Mrs. Joe H. Stewart's receipt, and best I have ever tried.
MRS. A. E. HABICHT.

BLACK CAKE, OR PLUM CAKE.

One pound of flour sifted, one pound of fresh butter, one
pound of white sugar, twelve eggs, two pounds of the best
raisins, two pounds of currants, two tablespoonfuls of mixed
spices, mace and cinnamon, two nutmegs powdered, a large
glass of wine, a large glass of brandy, half a glass of rose
water, mixed together, a pound of citron. Pick the currants
very clean and wash them, draining them through a colander,
wipe them in a towel, spread them on a large dish, and set
them near the fire or in the hot sun to dry, placing the dish in
a slanting position. Having stoned the raisins, cut them in
half, and when all are done sprinkle them well with sifted
flour. When the currants are dry, sprinkle them also with
flour. Pound the spice, allowing twice as much cinnamon as
mace; sift it and mix the mace, cinnamon and nutmeg to-
gether. Mix all the liquors and rose water in a tumbler or
cup; cut the citron in slips; sift the flour; stir the butter and
sugar to a cream; beat the eggs as light as possible; stir them

into the butter and sugar, alternately with the flour; stir very hard; add gradually the spice and liquor; stir the raisins and currants alternately into the mixture, taking care that they are well floured. MRS. W. M. WALTON.

FRUIT CAKE.

One pound of best brown sugar, one pound flour, three-fourths pounds of butter, one pound currants, one pound raisins, one pound citron, ten eggs, one wine glass of wine, one-half glass of brandy, and one teaspoon of cloves, one teaspoon cinnamon, one-half teaspoon of mace. Bake two hours.
 MRS. G. A. SEARIGHT.

MRS. HEFLYBOWER'S FRUIT CAKE.

One pound of butter, one pound of brown sugar, ten eggs, one cup of molasses, two wine glasses of brandy, three pounds of currants, three pounds of raisins, one pound of citron, one pound of almonds, one teaspoon of soda and cloves, cinnamon, nutmeg and mace to taste, one and one-fourth pounds flour. Beat sugar and butter to a cream; add the yolks and half of flour, the other half to be mixed with the fruit; add the whites, beat to a stiff froth; mix well and bake slowly three or three and one-half hours. This receipt has been used in our family for generations, and is very fine.

WHITE FRUIT CAKE.

Whites of ten eggs, one cupful butter, one pound of white raisins, one cocoanut, one pound almonds blanched, one pound citron, three cups of sugar, one half cup of brandy, one teaspoon baking powder, heaping. Put baking powder in the flour. Add a gill of warm water. I know this recipe to be good. MRS. J. G. BOOTH.

FRUIT CAKES.

Three heaping cups of flour, two heaping teaspoons of baking powder sifted together; add two cups of seeded and chopped raisins, one cup of English currants, one-half cup of citron stirred in the flour; cream together two cups of brown sugar and one large half teacup of butter; add two-thirds cup of liquid coffee; beat three eggs, whites and yolks separately; put into the flour and fruit two teaspoons cinnamon, one teaspoon of cloves and one of nutmeg. Stir all together, and bake in a slow oven until done.

MRS. H. H. BOWMAN.

WHITE FRUIT CAKE.

One pound of sugar, three-fourths pound of butter and one pound of flour, whites of sixteen eggs and one pound of sweet almonds, blanched and pounded, one teaspoon of bitter almonds, one ounce of citron, one grated cocoanut and a little rose water.

MRS. C. F. BISSELL.

PROHIBITION FRUIT CAKE.

Two pounds seeded raisins, two pounds well washed currants, one pound sliced citron, one pint pecan kernels carefully picked, one pound flour, one pound butter, one pound sugar, one dozen eggs. Two teaspoonfuls cinnamon, mace, cloves, white ginger and allspice, steeped over night in a pint of dark molasses. Break and separate eggs and add sugar to yolks; beat till very light; cream and add butter; stir in alternately flour and whites of eggs beaten to a stiff froth. Now add fruit, carefully dredged in part of the pound of flour; add spices. Cut thick papers to fit two common-sized cake pans, and grease pans; put in mixture and bake in a slow oven for two and a half hours. When done turn pans over plates, and lay a wet cloth over bottom; continue to wet till pans cool and cake will leave pans readily.

MRS. I. V. DAVIS.

ICING.

One cup of white sugar, white of one egg. Put the sugar into water, just sufficient to dissolve; set on stove and boil until thready; beat the white of the egg to a stiff froth; pour in the sugar, beating steadily and swiftly all the time, until quite cool. Ice the cake when cold, and the icing nearly so.

MRS. CHAS. RAYMOND.

BOILED ICING.

Two pounds of white sugar, one-half pint of water, boil to the candy point; the whites of six eggs whipped to a stiff froth; then pour the candy into the eggs in a small stream through a sieve, beating until smooth.

MRS. S. E. WHIPPLE.

ICING.

Mix three-fourths cup granulated sugar with just enough cold water to dissolve, and let boil till it ribbons, but does not candy; beat the white of one egg to a stiff froth, and pour the boiling syrup into the egg very slowly, beating hard all the time to prevent cooking the egg; beat the icing till nearly cold and use as a filling, or outside icing. For filling use three times the above quantity, and add and mix thoroughly with a soup-plate of seeded raisins and a little more than a soup-plate pecans, or English walnuts, mixed and chopped.

MRS. A. E. HABICHT.

WHITE PERFECTION CAKE.

Three cups sugar, one cup butter, one cup sweet milk, three cups flour, one cup corn starch, whites of twelve eggs beaten to a stiff froth, two teaspoons cream tartar in the flour, and one of soda in half the milk; dissolve the corn starch in the rest of the milk and add it to the sugar and butter, well beaten together, then the milk and soda, and the flour and whites of eggs.

LAURA DRISKILL.

TAYLOR CAKE.

Eight eggs, three-fourths pound sugar, one quart molasses, three-fourths pound butter, one pint of sour milk, one tablespoon of soda, flour enough to thicken to drop on pans.

MRS. G. A. SEARIGHT.

PINK MARBLE CAKE.

One teaspoon of cochineal to soak in two tablespoons of hot water; one of alum, one of cream tartar, one of soda. Strain through a piece of Swiss muslin into three-fourths of a teacup of the cake batter. Make the batter as you would for white cake.

MRS. S. E. WHIPPLE.

ANGEL CAKE.

Whites of eleven eggs well beaten, one and one-half glass powdered sugar, one glass sifted flour, one teaspoon cream tartar, one teaspoon vanilla. Sift flour and sugar seven times. Bake cake forty minutes in a quick oven.

MRS. G. CROW, SR.

ALMOND CAKE.

Take one-fourth pound sweet almonds, one ounce bitter almonds, or peach kernels, blanch and grate them. Use three-fourths of a pound of butter, one pound of sugar, one pound flour, whites of seventeen eggs. Mix the butter, sugar and almonds first, then add flour and eggs, little at a time. Very fine.

MRS. R. M. HALL.

MARBLE CAKE.

Light Part.—Whites of three eggs, one and one-half cups of white sugar, one-half a cup of butter, one-half cup of milk. Cream the butter and sugar; stir in flour till thick enough. Mix in one teaspooful of baking powder. Flavor with extract of lemon.

Dark Part.—Yolks of three eggs, one and one-half cups of brown sugar, one-half cup, of butter, one-half cup of sweet milk, flour to make it stiff, one teaspoon of baking powder, one teaspoonful each of cinnamon, allspice, cloves, mace, ginger, black pepper and nutmeg. Put in pan spoonful of each at a time. Bake an hour and a half. MRS. GEO. HUME.

SILVER CAKE.

Whites of sixteen eggs beaten to a froth, one pound pulverized sugar (two and three-fourths cupfuls), rolled and sifted, three-fourths of a pound of butter (one and three-fourths scant cupfuls), one pound sifted flour (four level cupfuls). Cream butter till light and white, add sugar and beat till well mixed, then add flour and whites alternately, one level teaspoon of yeast powders sifted, and flavor to taste.

MRS. JOHN ORR.

POUND CAKE.

One pound of sugar, one pound of flour, one light pound of butter, eight eggs. Beat butter and sugar to a cream; add the eggs and beat until very light; then add flour and flavoring. Bake in a slow oven about one and a half or two hours.

MRS. TEN EYCK.

WHITE LAYER CAKE.

Four cups flour, whites of eight eggs, three cups pulverized sugar, one cup butter (scant), one cup sweet milk. Cream butter first till light; add sugar, and beat; then flour, milk and eggs alternately; one teaspoon yeast powder.

MRS. JOHN ORR.

BIRTHDAY CAKE.—(Excellent.)

Six cups flour, three cups sugar, two cups milk, one and one-half cups butter, three eggs, two teaspoonfuls Royal baking powder, one teaspoonful cinnamon, one-half teaspoonful

cloves and allspice, one-half teaspoonful nutmeg, one-half pound raisins, stoned and cut, one-half pound currants, one-half pound citron. Cream sugar and butter; add beaten eggs; then part of the flour with baking powder in it (reserving the rest of the flour to mix with the fruit, which should be added last). The milk comes next, and then the spice and fruit. The citron can be omitted and one pound of raisins used instead, if desired. Never chop raisins, but cut in small pieces with scissors. and you will be better pleased with the result. Mrs. J. L. Vredenburgh.

WHITE CAKE.

One and one-half pounds of white sugar, one and one-half pounds of flour, three-fourths of a pound of butter, three-fourths of a cup of sweet milk, one teaspoon of cream tartar, one-half teaspoon of soda in warm water, the whites of fifteen eggs. Mrs. S. E. Whipple.

PINK CAKE.

Make a batter as for any white cake, into which put one teaspoonful of Burnett's extract of strawberry, and bake in a medium size biscuit pan. When done cover with icing, and before dry place at equal distances apart (say two inches), the half of the kernel of an English walnut (flat side down), and when dry cut in blocks, having a walnut on each piece. This cake looks beautiful mixed on a stand with slices of other cake. Mrs. M. Hicks.

DARK CAKE.

One cup of butter, two cups of brown sugar, one cup of dark molasses, one cup of milk, four cups of flour, four teaspoons each of nutmeg, cloves and cinnamon, yolks of eight eggs and one whole egg added, one teaspoon yeast powders. Mrs. John Orr.

YANKEE LOAF CAKE.

One cup butter, two of sugar, one of milk, four of flour. three eggs, two teaspoonfuls of yeast powder, mace and nutmeg, spices and fruit to taste. MRS. W. L. STANIFORTH.

COMPOSITION CAKE.

Two pounds of sugar, one and one-half of flour, one and one-fourth of butter, one and one-half of raisins, twelve eggs, one-half pint of milk, an even teaspoonful of soda dissolved in the milk, one-half teacup of cloves, one-half cup of cinnamon, one-fourth cup of spice, two nutmegs, one-half glass brandy. Beat eggs separately; mix the sugar with the yellows, beat very light; flour and butter mixed together; add whites alternately with the butter and flour; last add spices, then fruit, with one-half pound citron, flouring raisins well. Bake in a moderate oven two or three hours.

MRS. R. K. SMOOT.

SPONGE CAKE.

Two cups of sugar, two cups of flour, four eggs, two tea spoons of baking powder, flavoring, three-fourths cup of boiling water. Add the water last. Bake in square, shallow pans in a quick oven. When done ice the tops and cut into small squares to serve. Very nice.. MRS. I. E. BOTTS.

SPONGE CAKE.

Two cups sugar, two cups flour, nine eggs, two teaspoons White Rose baking powder, one teaspoon lemon, three-fourths cup boiling water. Add water last, stirring well. Excellent and cheap. MRS. G. CROW, SR.

SPONGE GINGER BREAD.

One cup sour milk, one of New Orleans molasses, a half cup butter, two eggs, one teaspoon soda, one tablespoon gin-

ger, flour to make as thick as pound cake. Put butter, molasses and ginger together, make them quite warm; add the milk, flour, eggs and soda, and bake as soon as possible.

MRS. DR. SHAPARD.

SPONGE CAKE.

Two cups of sugar, two cups of flour, eight eggs. Beat the yolks and sugar until very light, adding the whites, beaten to a stiff froth; then stir in flour, in which two teaspoonfuls of baking powder has been thoroughly mixed. Flavor to taste and bake in a quick oven.

MRS. GEO. A. PROCTOR.

SPONGE CAKE.

Ten eggs beaten separately, one pound of sugar, three-fourths of a pound of flour. Stir flour in lightly and flavor to the taste. Bake in a quick oven. MRS. ED. WAYLAND.

WHITE CAKE.

One-half pound of butter, one pound of sugar, three-fourths of a pound of flour (good weight), whites of fourteen eggs, one-half teaspoonful of soda, one teaspoonful of cream tartar. MRS. ED WAYLAND.

DELICIOUS CAKE.—ANGELS' FOOD.

Pound cake batter baked in jelly cake pans, two cocoanuts grated, one small cake of chocolate grated, the whites of four eggs beaten some, but not to a stiff froth, two pounds of sugar, and a tumbler of water. Boil water and sugar until it is thick, then beat into the eggs until white and stiff; then divide into three parts. Into the first part mix cocoanut flavored with lemon; into the next part mix the chocolate flavored with vanilla; then you place this in alternate layers between the cakes. When it is filled up high, ice the top with the third part, and sprinkle on it

some of the grated cocoanut, which you have kept for the
purpose. Mrs. Blocker.

ANGELS' FOOD.

Beat whites of eleven eggs to a stiff froth; sift into them,
little at a time, one and one-half tumblers powdered sugar;
mix carefully and lightly; then sift one tumbler of flour four
times, add level teaspoon cream tartar to the flour, and then
sift into the eggs and sugar a little at a time, mixing very
lightly. When all the flour is used, add teaspoon vanilla.
Do not butter or line cake mold; a new tin mould is the best.
Bake in a moderate oven about an hour. Do not open stove
for fifteen minutes after putting in. Test with a straw; if
the cake is ready to be taken from the oven, it (the straw)
will come out clean. Let it cool gradually. When cool,
loosen from the sides with a sharp knife, then turn it out.
 Mrs. J. W. Smith.

WHITE CAKE.

Take whites of six eggs, three-fourths of a cup of butter,
two cups of pulverized sugar, three cups of flour, one cup of
sweet cream or milk, small teaspoonful and a half of baking
powder. Season with lemon. Mrs. J. W. Smith.

IMPERIAL CAKE.

Whites of nine eggs, one teacup butter, two teacups sugar,
three and one-half teacups flour, teaspoon baking powder, a
teacup nearly full of sweet milk, tablespoon whiskey. Bake
this as for jelly cake—about three cakes, then a layer of fruit
between the cakes.

RECEIPT FOR THE FRUIT.

One pound blanched almonds cut fine, one pound chopped
raisins, one pound cut figs, three-fourths pound citron cut
fine, one wine glass whiskey. Mix all these well together.
Have icing made of the whites of three eggs, one-half pound

sugar. When the icing is stirred smooth and glossy, add
the fruit, and then put between the layers of cake. Ice on
the outside if you choose. Mrs. G. S. Criser.

CARAMEL CAKE.

One and a half cups sugar, three-fourths cup butter, half cup
milk, two and one-fourth cups flour, three eggs, one and a
half heaping teaspoons baking powder, or a small teaspoon
soda, and two teaspoons cream tartar. Bake in jelly tins.
Make caramel as follows: Butter size of an egg, pint brown
sugar, half cup milk or water, half cake chocolate. Boil
twenty minutes (or until thick enough), and pour over cakes
while warm, piling the layers one upon the other. For frost-
ing for top of cake take whites of two eggs, one and a half
cups sugar, teaspoon vanilla, three heaping teaspoons grated
chocolate. "Practical Housekeeping."
 Mrs. Waggoner.

ICE ATOM CAKE.

The whites of eight eggs, two cups sugar, two cups sifted
flour, one cup corn starch, one cup butter, one cup milk, two
teaspoonfuls baking powder. Bake in thin layers.

LAYER FOR ABOVE.

Whites of four eggs, four cups sugar. Pour half pint boil-
ing water over sugar, and let boil till clear and candied;
pour the boiling sugar over the eggs, stirring until a stiff
cream; then add a teaspoon citric acid and flavor with
vanilla. When cold, spread the icing between and over the
cakes. Misses A. and E. Graham.

WHITE LAYER CHOCOLATE CAKE.

The whites of seven eggs, one cup butter, two cups pow-
dered sugar, three cups flour, one small cup hot water, two
teaspoons baking powder. Mix, and bake in layers as for
jelly cake. For between each layer, the white of one egg and

one cup of sugar, boiled to a thick syrup. Beat the whites very stiff and mix with the syrup and as much grated chocolate as desired. This cake takes the whites of about eleven or twelve eggs. Tried and good. MRS. McDONALD.

CHOCOLATE CREAM CAKE.

One cup of butter, two cups of sugar, the whites of eight eggs well beaten, three well filled cups of flour and one of corn starch, one teaspoonful of yeast powder, one tablespoonful of extract vanilla. Cream the butter and sugar together, and add half cup of milk, and add flour and eggs. Bake in jelly tins.

FILLING.

One cup of grated chocolate, yellows of four eggs, one-half cup of milk. Beat well and boil all together, and spread between the cake as soon as cool.

MRS. COLLETT.

NUT CAKE.

One quart of kernels, one pound of raisins, one pound of flour, one pound of sugar, one-half pound of currants, one-half pound of butter, six eggs, one teaspoonful of soda dissolved in one cup of sour milk, one tablespoonful of ginger, cloves, and cinnamon to taste. MRS. G. A. SEARIGHT.

JELLY CAKE.

One cup of sour cream, one cup of butter, four of flour, two cups of sugar and six eggs, one teaspoon of soda, two teaspoons cream tartar, spice to taste.

MRS. G. A. SEARIGHT.

NUT CAKE.

The whites of eight eggs, two cups sugar, one-half cup butter, three-fourths cup sweet milk, three cups flour, two

teaspoonfuls baking powder, flavor with vanilla. This makes
four layers.

One cup nuts, one cup ràisins, one orange cut very fine;
chop nuts and raisins fine, and mix all together; one cup
sugar and a little water, boil until thick. Have the whites of
three eggs beaten very stiff, and beat the syrup and eggs until
thick; then stir in nuts and fruit. This is a delicious cake.

MRS. JAMES FORD.

ORANGE JELLY CAKE.

Sugar four and one-half cups, butter one cup, milk one
cup, five eggs, baking powder one and a half teaspoonfuls,
flour two cups, two oranges. Directions: Cream two and a
half cups sugar with the butter; beat the yolks of the eggs
and stir in the milk and sift in the flour, having the baking
powder in it. Bake in jelly cake tins.

FOR THE JELLY.

Beat the whites of the eggs and whip in the other two cups
of sugar, adding the juice of two oranges. Put between the
layers. MRS. C. A. TRIMBLE.

COCOANUT JELLY CAKE.

Sweet milk, butter, corn starch, each one cup, white sugar
and flour each two cups, whites of five eggs, cream of tartar
two teaspoonfuls, soda one teaspoonful. Bake in three layers.
For the jelly, white sugar one pound and boiled until candied;
when cold stir in the beaten whites of two eggs and one and
one-half cup rounded of grated, or one cup of dessicated
cocoanut, saving some for the top. MRS. C. A. TRIMBLE.

CHOCOLATE CAKE.

Sugar two cups, butter one cup, three eggs, sweet milk three-fourths of a cup, flour three cups, cream tartar two teaspoonfuls, soda one teaspoonful. Bake in jelly pans. For the icing or jelly, chocolate one-fourth cake, sugar one and one-half cups, sweet milk three-fourths of a cup, lemon extract two teaspoonfuls. Let boil until it thickens, so as to spread between the layers. Mrs. C. A. Trimble.

ICE CREAM CAKE.

Make good sponge cake; bake half an inch thick in jelly pans, and let them get perfectly cold; take a pint of thickest sweet cream; beat until it looks like ice cream; make very sweet, and flavor with vanilla; blanch and chop a pound of almonds; stir into cream, and put very thick between layers. This is the queen of all cakes. Mrs. Chas. Evans.

SPONGE JELLY CAKE.

One cup flour, three eggs, three tablespoonfuls sweet cream or new milk, one-half teaspoonful soda. Flavor with lemon. Spread with jelly while warm and roll it up.

Mrs. W. M. Walton.

ORANGE CAKE.

One cup of sugar, half a cup of butter, half a cup of sweet milk, two cups flour, three eggs, one and a half teaspoonfuls of baking powder. Bake in jelly tins.

ORANGE FROSTING FOR SAME.

One orange. Grate off the outside, and mix with juice, and add sugar until quite stiff, and make like jelly cake. Make four layers of the cake. "The Everyday Cook Book."

Mrs. Waggoner.

CAKES.

NUT CAKE.

Half cup of butter, one cup of sweet milk, two cups of sugar, three cups of flour, whites of nine eggs, two heaping teaspoonfuls of baking powder.

FILLING FOR NUT CAKE.

One cup of sour cream, half cup of sugar, one cup of chopped nuts, whites of three eggs beaten very light. Flavor with vanilla. MRS. FRANK RAINEY.

IMPERIAL CAKE.

One pound sugar, one of flour, three-fourths of butter, one of almonds blanched and cut fine, one-half of citron, one-half of raisins, rind and juice of one lemon, one nutmeg, ten eggs. This is delicious and will keep for months.
 MRS. S. E. WHIPPLE.

BANANA CAKE.

One-half cup butter, two cups sugar, three cups flour, five eggs, leave out the whites of two for icing, one cup tartar, three teaspoonfuls baking powder mixed with the flour.

ICING: One pound pulverized sugar, whites of two eggs, one gill water, juice half lemon. After spreading the icing lay slices of banana between the cakes and on top.
 MRS. L. R. FULMORE.

COCOANUT CREAM CAKE.

One cup butter, two cups sugar, three and one-half cups flour, whites of six eggs, one teaspoonful baking powder, half cup milk. Cream for filling. Half cup sugar, half cup flour, whites of two eggs, beat the eggs and stir in sugar and flour, add half pint boiling milk and cup Dunham's concen-

trated cocoanut, making frosting for outside, sprinkle thick with cocoanut before dry. Mrs. L. R. Fulmore.

SNOW DRIFT CAKE.

Five eggs (whites), two cups sugar, one-half cup butter, one cup sweet milk, three cups sifted flour, one heaping tea-spoonful baking powder. Mrs. L. R. Fulmore.

SPICE CAKE.

Yolks of six eggs, one cup brown sugar, one-half cup milk, one-half cup butter, one and one-half cups flour, one and one-half teaspoonfuls baking powder. Spice to suit taste.
Mrs. L. R. Fulmore.

SPONGE CAKE.

Beat seperately the whites and yolks of ten eggs very light, add to yolks one pound of sugar and juice and peel of one lemon. Then stir in whites together with half pound of flour. Bake as quickly as possible. Mrs. L. R. Fulmore.

LAYER NUT CAKE.

Whites of eight eggs, one cup butter, two cups sugar, two teaspoons baking powder, three cups flour, one-half cup sweet milk.

FILLING.

One pound raisins, cut up fine; one pound pecans, cut up fine; make an icing as for any other cake, using for this cake whites of six eggs, enough pulverized sugar to make stiff enough, reserving a small quantity for top and sides of cake; then stir fruit into balance, and spread as would jelly. This is a delightful cake. Mrs. M. Hicks.

FILLING FOR LEMON CAKE.

One-half cup butter, yolks of three eggs, one-half cup
sugar, juice and rind of two lemons. Beat eggs well; cream
butter and sugar; mix all together; set on fire, stirring con-
stantly till it thickens. MRS. T. J. BENNETT.

FIG PASTE FOR CAKE FILLING.

Clean one pound of figs and chop them fine; then put them
in a pan with one cup of sugar and one of water; cook them
until they become a thick paste, which must be spread be-
tween the layers of cake. MRS. I. V. DAVIS.

LEMON BUTTER FOR LAYER CAKE.

Dissolve one cup of sugar in the juice of one large lemon;
beat three eggs light, add and mix well. Put a piece of but-
ter the size of a walnut in a vessel on the stove. When
melted pour the above mixture into it and cook until very
thick, stirring constantly. MRS. EVERETT.

NICE FILLING FOR LAYER CAKE.

Two large tart apples, peel and grate; then grate one lemon
peel; squeeze and grate pulp. To this whole add one cup
sugar and white of one egg. Cook thoroughly, then spread
between cakes. MISSES A. AND E. GRAHAM.

GINGER BREAD WITH STRAWBERRY SAUCE.

One and a half cups molasses, half cup brown sugar, half
cup butter, half cup sweet milk, teaspoon soda, teaspoon all-
spice, half teaspoon ginger; mix well together; add three
cups sifted flour. Bake in shallow pans. For sauce: One

can of strawberries, one cup of sugar, one tablespoon butter, and one tablespoon corn starch. Put in a stewpan and place it on the stove. Let cook until it becomes thick. Serve either hot or cold. LAURA DRISKILL.

JUMBLES.

Three eggs, one-half pound of flour, one-half pound of butter, one-half pound of powdered sugar, one tablespoonful of rosewater, one nutmeg, one teaspoonful of mixed mace and cinnamon. Stir the sugar and butter to a cream; beat the eggs very light; put all in the flour; mix, and make in any shape desired. Bake quick. MRS. R. K. SMOOT.

SUGAR COOKIES.

One full cup of sugar, one-half cup butter, three eggs, one teaspoonful soda (scant), one quart flour. Sift the soda in the flour dry; add the eggs well beaten withh the sugar and butter; flavor with a little nutmeg, mace and lemon; mix to a very soft dough; roll thin and cut into cakes and bake. Before baking sprinkle the tops of the cakes with sugar, and stick a raisin in the center of each cake. Bake in a hot oven.
 MRS. P. THOMPSON.

TEA CAKE.

Three eggs, one-half pound butter, one pound sugar, one and one-half pounds flour, teaspoon of soda, cup of sour cream. Flavor with lemon. MRS. C. A. GIBSON.

TEA CAKES.

Three eggs, three cups of sugar, one-half cup of sour cream or butter milk, one cup of butter scant, one-half teaspoon of soda; flavor with nutmeg or lemon. Beat the eggs and sugar together very light; mix the butter with a quart of

flour; then add eggs and sugar; then milk and soda. It may take more flour, as it must be sufficiently stiff to roll out and cut into thin cakes. When properly baked they are brown and crisp. MRS. F. R. LUBBOCK.

CRULLERS.

Eight eggs, three pounds flour, one-half pound butter or one-fourth pound lard, one grated nutmeg. Work the butter or lard into the flour, reserving enough of the weighed flour to roll the cakes out. Beat the eggs very light; put into them the sugar and nutmeg; beat thoroughly and pour upon the flour, making a smooth dough, rather soft. Cut any fanciful shape and fry a light brown in boiling lard.
 MRS. JOSEPH SPENCE.

JACKSON JUMBLES.

Five cups of flour, two cups of sugar, two cups of butter, one cup sour cream, three eggs, one teaspoon of soda, one nutmeg. Roll the cake in white sugar, then bake.
 MRS. G. A. SEARIGHT.

DOUGHNUTS.

Two heaping teacups sugar, three eggs well beaten, seven tablespoonfuls butter, three teacups sweet milk, two teaspoons lemon extract. Stir in enough flour to roll out; cut and make in shapes, and fry in pure leaf lard from Refrigerator Market. MRS. H. H. BOWMAN.

VANITIES,—Good.

Beat two eggs, stir in a pinch of salt and a half a teaspoon rosewater; add sifted flour till just thick enough to roll out; cut with a cake cutter and fry quickly in hot lard. Sift powdered sugar on them while hot. Nice for tea or dessert.
 MRS. A. M. BELVIN.

TEA SCONES.

Three-fourths pound flour, two teaspoonfuls baking pow-
der, two ounces sifted sugar, one-half ounce butter. Rub
well together; mix with milk; then roll an inch thick and cut
in three-cornered bits. Makes about twelve scones. Bake in
hot oven for fifteen or twenty minutes; split open and butter.
Made in five minutes. Mrs. R. L. Brown.

ROCK CAKES.

Two pounds flour, one-half pound sugar, one-half pound
currants, one-half pound butter, three eggs beaten well.
Make into balls the size of an egg; teaspoon of baking pow-
der, a little milk may be added. Bake on tin sheets a light
brown. Mrs. R. L. Brown.

SAND TARTS.

Two pounds of flour, one and a half pound ot sugar, one
and a fourth pounds of butter, yolks of four eggs, glass of
brandy or wine, one grated nutmeg. Mix all together. Take
as much dough as will cover the bottom of the biscuit pan,
roll same, place in the pan and press out to fill the pan. The
dough is quite short and cannot be lifted if rolled too thin.
Cut with a knife into any size cakes wished. In the center
of each cake place a small quantity of brown sugar and cin-
namon, equal parts; add half an almond. When done turn
out of pan and cut apart. Mrs. R. K. Smoot.

ADDITIONAL RECEIPTS.

HOW TO MAKE COFFEE.

Take one pint of ground coffee and mix well with the white of an egg and enough cold water to thoroughly moisten it. Place in a well scalded coffee boiler and pour in one gallon of boiling water. Boil rather fast for five minutes, stirring down from the top and sides as it boils up, and place on back of the stove or range, where it will only simmer, for ten or fifteen minutes longer. When ready to serve add a little more boiling water. MRS. J. L. DRISKILL.

BLACKBERRY CORDIAL.

Take the ripest berries; mash them, put them in a linen bag and squeeze out the juice. To every quart of juice allow a pound of white sugar. Put the sugar into a large preserving kettle, pour the juice on it. When it is all melted, set it on the fire and boil it to a thin jelly. When cold, to ever quart of juice allow a quart of brandy. Stir them well t gether and bottle it for use. It will be ready at once. MRS. W. M. WALTON.

QUINCE CORDIAL.

Grate quinces and squeeze the juice out through a cloth. To one quart of juice take two quarts of water, three pounds of sugar, one quart of rum. Ready for use as soon as made. MRS. G. A. SEARIGHT.

CURRANT OR BLACKBERRY WINE.

One quart of juice, two quarts of water, three pounds of sugar, will make one gallon of wine. Put in jug, and as it ferments keep it filled with juice or sweetened water, and do not cork until after fermenting. Turn a cup over the top.

Mrs. G. A. Searight.

ENGLISH PLUM PUDDING.

Mix thoroughly one pound of finely grated bread with the same quantity of flour, two pounds of raisins stoned, two of currants, two of suet minced small, one of sugar, half a pound of candied peel, one nutmeg, half an ounce of mixed spice, and the grated rinds of two lemons. Mix the whole with sixteen eggs well beaten, and add four glasses of brandy. These proportions will make three puddings of good size, each of which should be boiled six hours. Mrs. T. B. Lee.

MINCE MEAT FOR PIES.

One quart of minced boiled beef meat, one quart of chopped apples, one quart of currants, one quart of stoned raisins, one-half pound of nicely chopped suet, good brown sugar and cider to the taste. One pint of brandy, and one teaspoon each of cloves and nutmeg. When you wish to make pies take as much of this mixture as is necessary, and to each quart add one-half teaspoon of black pepper, and one-half teaspoon of salt. Mrs. P. Thompson.

TRANSPARENT PUDDING.

Put eight well beaten eggs into a saucepan with a half pound of sugar, a half pound of butter, and some grated nutmeg. Set it over the fire, and stir constantly until it thickens. Put it in a rich paste, and bake in a moderate oven.

Mrs. S. E. Botts.

LEMON PIE.

One lemon, grated rind and juice, one-half cup boiling water, one egg, one tablespoon of flour, three tablespoons of sugar, butter the size of an egg. Cook until it thickens. Bake with two crusts. This is for one pie only.

MRS. S. E. BOTTS.

MEXICAN CANDY.

Take enough milk or water to moisten two pints of brown sugar (about one-half cup). When nearly boiled, put in a tablespoon of vinegar; then stir in the pecans (not quite half a pound), until it sugars. Pour out in little cakes on a cold piece of marble.

KATIE THORNTON.

CHOCOLATE DROPS.

Mix two and a half cups of sifted sugar with half a cup of water, and boil hard for three or four minutes. Stir into it two teaspoons of vanilla, take it off the fire, and stir quickly till it begins to be white and hard; then roll into little balls and put them on a greased pan, and when perfectly hard they must be covered with grated chocolate, which has been placed over the steam of the teakettle a few seconds until dissolved.

KATIE THORNTON.

MOLASSES CANDY.

One pint molasses, one cup sugar. Boil, and stir every minute. When partly cooked put in one-half teaspoon of butter. When it hardens in cold water it is done. Put in one-half teaspoon cream of tartar with the butter, and just before you turn it out, put in a scant teaspoon of soda.

EULA DAY.

CHOCOLATE CARAMELS.

One coffee cup of rich cream, one coffee cup of brown sugar, one coffee cup of molasses, butter size of an egg. Boil all together twenty minutes; then add seven tablespoons of powdered chocolate (two squares of the bitter), and boil until done. Pour into a flat pan and before hard make into squares.

EULA DAY.

SPONGE PUDDING.

One pint milk, one teacup of flour, two tablespoons sugar, seven eggs, one tablespoon butter. Mix flour and sugar in the milk; put to boil. When boiling put in the butter; then set it off to cool. Beat the eggs separately; when light, add the mixture; put into a buttered pan, the pan into a pan of hot water, and bake three-fourths of an hour. After the pudding rises well, set the pan out of the hot water and bake like cake. Serve hot.

SAUCE FOR SPONGE PUDDING.

One cup of sugar, one cup of wine, one cup of butter. Mix together and then put in a pan of hot water and stir until dissolved; then beat one egg and stir in.

MRS. J. M. DAY.

BOILED ICING.

Proportions.—One cup sugar, to white of one egg; add about one-third cup of water to the sugar and boil till it ropes from spoon; then stir till it begins to granulate; then add quickly the well-frothed white of egg, and beat until stiff enough. Flavor to taste. MISS BENNIE MOORE.

EGG PLANT.

Boil whole until soft; cut in half; remove the egg and mix

it with pepper and salt; cream a large spoonful of butter, bread crumbs, and half a teaspoonful of finely shredded onions. Stir in well the yolks of three eggs; return to the shells and bake brown, or cook in a baking dish if preferred.

Mrs. I. V. Davis.

TO FRY EGG PLANT.

Peel carefully and slice; sprinkle each piece with salt, and lay one upon another in a dish or pan; set a plate on top and, put a weight on it to press out the bitter juice. Let them so remain for an hour, then wash; again salt slightly, sprinkle with pepper and flour and fry in hot lard.

Mrs. I. V. Davis.

APPLE CUSTARD.

Pare and grate two large tart apples; add four tablespoonfuls melted butter, eight of sugar, juice and grated rind of one lemon, yolks and whites of six eggs separately beaten. Line dish with puff paste, fill and bake with custard.

SAUCE FOR PUDDING.

One cup sugar, one-half cup butter, beat to a cream; add one beaten egg, teaspoonful flour, wet with cold water; add one-half pint boiling water. Let boil a few moments, stirring constantly.

Mrs. I. V. Davis.

STUFFED GREEN PEPPERS.

Remove the seeds from six peppers, and prepare cold beef chopped fine, seasoned highly with salt and butter, and the pepper seeds; add equal quantity of bread crumbs and stuff the peppers. Put in a pan with a little water and butter, to prevent scorching, and bake in a slow oven.

Miss Bennie Moore.

BEEF CUTLETS.

Cut the inside of a sirloin or rump in slices half an inch thick; trim neatly; melt a little butter in a frying pan; season the cutlets, fry them lightly, and serve with tomato sauce.

Mrs. I. V. Davis.

LEMON SHERBET.

Six lemons, four eggs (the whites); two pints sugar. Make a thick syrup of one pint of sugar and about one pint of water; when cold, thin with the juice of six lemons, and water enough to make a rich lemonade. When it is about half frozen, add boiled icing made as follows: One pint of sugar moistened with water, and boiled until it is a soft candy; while hot add the stiff beaten whites of four eggs; flavor with vanilla and a little citric acid or cream tartar, and beat hard until thick and smooth, and add to the half frozen lemonade.

Moselle Davis.

CREAM TOAST.

Slice white bread into even slices, three-quarters of an inch thick, and neatly trim off the crust; toast the bread a pretty brown, do not dry it up in the oven; butter on both sides. Heat a pint of cream hot, but do not boil, and pour over each side of each slice a tablespoonful. The toast must be thoroughly buttered to be nice. Put a pinch or salt in the cream.

Mrs. I. V. Davis.

BEEF RISSOHS.

Chop fine the beef left from yesterday's dinner, season with pepper and salt; add chopped parsley and bread crumbs, melted butter, and yolks of two eggs. Make the mixture smooth, and form into balls; dip in a beaten egg, and then in

bread crumbs, and fry in hot lard. Serve with brown sauce
over them. Mrs. I. V. Davis.

STEWED LEG OF MUTTON.

Put the mutton into the stewpan with either broth or water,
two or three carrots, a turnip, an onion, or a few black pep-
per corns. After coming to a boil, simmer for two and a
quarter hours; take out the broth and vegetables, dredge the
meat with flour, and put it again in the oven to brown. Pulp
the vegetables through a sieve, and boil them up with the
gravy, adding a tablespoon of gravy; pour part of the sauce
on the meat, and send rest to table in a tureen.
 Mrs. I. V. Davis.

VEAL CUTLETS.

Steam the cutlets a few minutes, so as to partly cook them;
then wipe them dry. Have ready a dish with finely powdered
cracker dust. In another dish have four eggs yolks beaten
light and mixed with two tablespoonfuls of rich, sweet cream.
Season cutlets and egg mixture with salt and pepper. Have
ready a frying pan half full of boiling lard. Dip the cutlets
first on one side and then the other in the eggs, and then in
the cracker dust, after which put them in the boiling lard.
Do not disturb them until the under side is brown; then care-
fully turn; and when the other is brown, remove to a hot dish
and serve at once, while crisp. Do not attempt to serve
gravy with cutlets. Mrs. I. V. Davis.

MUTTON HAM.

In the autumn select a fine, tender hindquarter of mutton,
and trim it in the shape of a ham. Hang it for two days in a
cold place. Mix one-half pound of bay salt, two ounces of
saltpetre, half pound of common salt and one-half pound of

brown sugar. Pound the saltpetre fine and mix all well together, and heat nearly hot in a pan over the coals. Rub this well into the meat, turn it over in the liquor that runs from it, every day for four days; then add two more ounces of common salt; let it remain twelve days in the brine, turning it daily. Then take it out, wipe it perfectly dry, and hang in the smokehouse to smoke for one week. Slices of ham broiled and buttered are delightful. MRS. SMITH.

SAUSAGE.

Cut about twenty pounds of fresh meat in small pieces (for the mill), and season before grinding with sage, salt and pepper, and it mixes in the grinding. The ingredients of seasoning are one-fourth pound pulverized sage, three tablespoonfuls ground red pepper, same of black, and salt to taste.
MRS. S. C. GRANBERRY.

CONSOMME.

Put three quarts cold water over a soup bone, and set it to boil on the breakfast fire. Let it remain when the dinner fire is made and add half a pint of tomatoes, one-fourth cup rice, one onion and two Irish potatoes. When ready to serve, while on the fire, season to taste with salt and black pepper. Strain and serve with oyster crackers.
MRS. I. V. DAVIS.

SOUR KRAUT PICKLE.

Soak three pounds of sour kraut over night in fresh water; then drain through a cullender. Add six large onions chopped fine and three cups of sugar; season highly with pepper and salt. Cover over with vinegar, and boil until tender.
MAMIE SPAULDING.

TOMATO SOUP.

One quart water, one small can tomatoes, or eight good-sized tomatoes cut up. Boil twenty minutes and add one-half teaspoonful soda. Boil one pint (or more) of milk; just before serving pour tomatoes and milk together; season with butter, pepper and salt. MRS. EVELYN B. WRIGHT.

DRIED BEEF.—A Breakfast Dish.

About one-half pound dried beef sliced very thin, then pulled in small pieces. Have a quart of milk boiling, into which put the beef, with a good piece of butter and a little pepper. When it comes to a boil thicken with a little flour; then toast bread, poach eggs, and place one on each slice of toast; put all on a large platter and pour the beef over it, and send to the table hot. Lean ham may be used in the place of the beef. MRS. EVELYN B. WRIGHT.

ICED TEA.

Iced tea is a necessary beverage in southern summers. It is used without milk, and sugar seems to destroy the fine flavor. Prepare, some hours in advance of use, and make stronger than when served hot. Put in a close earthen vessel and place in ice-chest till required. Use black or green teas, or both mixed. MRS. I. V. DAVIS.

COTTAGE CAKE.

One tablespoonful butter, one teacup sugar, one teacup

milk, one egg, one pint flour, one heaping teaspoon baking
powder. To be eaten hot with sauce.

SAUCE.

Two cups sugar, one cup butter, yolks of two eggs beaten
to a cream. Heat in a vessel placed in boiling water, and
just before serving add the whites beaten stiff.

MRS. EVELYN B. WRIGHT.

WHITE LAYER CAKE.

Whites of eight eggs, two cups of sugar, three of flour, one-
half cup of butter, three-quarters of a cup of milk, two tea-
spoons of baking powder and lemon extract to taste.

BOILED ICING TO PUT BETWEEN LAYERS.

Take one cup of sugar and add enough water to wet it
thoroughly, and let boil until it flies off from the spoon like
a hair; pour on the white of one egg, beating quickly all the
time, and then add lemon to taste. One cup of sugar and
one egg is sufficient to ice one cake.

MAGGIE CASTLEMAN.

LEMON JELLY CAKE.

Take half the yellows left from the white cake, and add
two whole eggs, one-half cup of butter, three-quarters of a
cup of milk, two cups of sugar, three of flour, and two tea-
spoons of baking powder.

LEMON JELLY FOR FILLING.

One whole egg or two yolks, one lemon, three-quarters of a cup of sugar and one tablespoon of butter. Set in a pan of boiling water and let cook until thick enough to spread, stirring constantly. MAGGIE CASTLEMAN.

TEA.

The hotter tea is served, the better tea is. Scald tea pot; put in one teaspoon of tea for each cup required; cover the tea with boiling water; spread a thick and doubled napkin over and about it (the English would say "place tea cosy" over it), and let it remain five minutes before adding boiling water to required amount. Let this stand ten minutes, when it is ready to serve. MRS. I. V. DAVIS.

MILK ROLLS.

One quart milk scalded and cooled. When tepid, add one large yeast cake and flour to make a batter as stiff as for batter cakes. Let this rise all night, or make in the morning if for tea. When light, add one-half teacup (good measure) of lard, one tablespoonful sugar, one egg, salt, and one-fourth teaspoonful soda. Let rise again. Make into rolls, and when light, bake in moderate oven. MRS. EVELYN B. WRIGHT.

DROP COOKIES.

Two cups sugar, three-fourths of a cup of butter, one cup milk, four eggs, four cups of flour, caraway seeds, two large teaspoonfuls baking powder. Drop in pan and bake in a quick oven. MRS. EVYLIN B. WRIGHT.

ORANGE JELLY.

Two quarts of water, one box of gelatine, nine oranges and three lemons, a pound of sugar, whites of three eggs. Soak gelatine in a pint of water; boil the three pints of water and sugar together; skim well, add dissolved gelatine, orange and lemon juice, and beaten whites; let come to a boil; skim carefully; boil until it jellies, and pour into mold. The eggs may be omitted, when the jelly must be strained. The grated rind of one orange put in with the juice gives a fine flavor.

MAGGIE CASTLEMAN.

BANANA FRITTERS.

One cup of flour, yolks of two eggs, pinch of salt, two tablespoons of melted butter, and water enough to make thin batter. Add the whites beaten to a stiff froth, and stir in three or four bananas cut in slices. Dip with a spoon and fry in hot lard; dust with powdered sugar and serve with whipped, plain, or sweetened cream.

MAGGIE CASTLEMEN.

SPONGE CAKE.

Ten eggs, one pound sugar, one-half pound flour, grated rind and juice of one lemon, and a pinch of salt. The yolks of the eggs, the sugar and lemon juice should be stirred hard together for five minutes; then add (lightly) the whites beaten stiff. Last of all add the flour, but do not beat it after this. Line a tin with paper (do not grease it), pour the mixture in and bake in a pretty quick oven.

MRS. EVELYN B. WRIGHT.

BEEF LOAF.

Three pounds beef or veal chopped fine, three eggs, one teacup cracker crumbs, two tablespoonfuls melted butter, two teaspoonfuls salt, or salt to taste, one teaspoonful pepper, or pepper to taste. Mix well; make into a loaf; put in a baking pan, and pour around it one cup hot water. Bake slowly one and a half hours. MRS. EVELYN B. WRIGHT.

CHICKEN SALAD.

To one chicken chopped fine add six hard-boiled eggs, one-half bunch celery, a small bit of onion and chopped pickle. When chopped well, pour over it one cup of the juice left from boiling the chicken, and add the vinegar and salt to suit taste. MAGGIE CASTLEMAN.

POTATO SALAD.

Boil six large Irish potatoes, peel and mash smooth; add six hard-boiled eggs, one onion, and two teaspoons of salt. Chop very fine and pour over it one small cup of vinegar.
MAGGIE CASTLEMAN.

MOLASSES PIE.

Put a common sized tumbler of molasses in a saucepan and let boil; then add one spoonful of butter, and two well-beaten eggs; stir rapidly until it becomes thick, and bake in a crust, with a top crust made of narrow strips of the pastry.
MAGGIE CASTLEMAN.

EGG CUSTARD.

Beat together two eggs, one tablespoon of butter, one-half cup of sugar, and half pint of sweet milk, and bake in a crust. MAGGIE CASTLEMAN.

PINEAPPLE CAKE.

Dissolve one cup of sugar in one-half box of gelatine. Stir in one can of grated pineapple, and cook to a jelly. When cold put between layers of cake.

MRS. SPAULDING.

HOUSEHOLD RECEIPTS.

FOR FLESH BRUISES.

Rub well with butter and then with arnica.

POISON OAK CURE.

Bathe the affected parts long and well in sulphur and cream; in half an hour wash well in salt water. Repeat twice a day. Three or four applications will cure.

A FINE RECEIPT FOR A COUGH.

Make a strong tea of ten cents' worth of hoarhound and ten cents' worth of mullein leaves; strain off the leaves and add one quart of strained honey to the tea, boil until quite thick and bottle for use. Take one tablespoonful when the cough is troublesome.

RELIEF FOR NEURALGIA.

Apply to the part affected the oil of peppermint, saturate a piece of raw cotton with it and rub very gently till the skin burns; it frequently relieves pain when everything else fails.

FOR CROUP.

Apply vaseline to the outside of the throat.

FOR A BURN.

Get from the druggist equal parts of limewater and linseed oil, bottle, and keep ready for use. Saturate a piece of raw cotton, and place it on the burn.

TO TAKE BLOOD STAINS FROM GARMENTS OR TICKING.

Apply starch by rubbing it in thick with a wet cloth; then put in the sun.

TO KEEP EGGS FOR WINTER USE.

One pint of lime, one pint of salt, three gallons of water.

TO PREVENT CALICOES FROM FADING.

Put three gills of salt in four quarts of boiling water; put the dresses in while hot and leave until cold. In this way the colors are rendered permanent.

TO TAKE MARKS OFF OF FURNITURE.

White spots can be removed from varnished furniture and rendered glossy, by applying alcohol with a sponge. It has nearly, if not quite, the effect of varnish, and is much cheaper.

LIQUID BLUING.

One ounce of best Prussian blue, one-half ounce of oxalic acid, one quart of soft water. Put all in a bottle together and shake well. Put as much blueing in the water to make the clothes look clean. MRS. G. A. SEARIGHT.

LINIMENT.—*Good in Sprains, or Where Home Remedies Will Answer.*

Two tablespoons of vinegar, two tablespoons of turpentine, yolk of one egg. Shake well. Bottle for use.

MRS. GEO. HUME.

For fresh cuts and bruises, turpentine soothes and removes soreness. A grateful remedy for little children.

MRS. I. V. DAVIS.

WORTH KNOWING.

Rats detest chloride of lime and coal tar.

———

Coarse salt is very nice to clean and sweep carpets.

———

To clean a porcelain kettle, boil peeled potatoes in it.

———

Dry inkstains may be removed by putting into boiling milk.

———

Inkstains should be immediately dipped in new sweet milk.

The sting of insects can be cured by using a paste of soda and water.

———

One pound green copperas dissolved in one quart of water will utterly destroy all offensive odors.

———

For dry and painful eyes moisten a soft old cloth with camphor, and then dip in hot water and apply over eyelids hot, and an immediate relief is felt. Mrs. I. V. Davis.

INDEX TO RECEIPTS.

CONTENTS.

BREAD.

SOUPS.

FISH.

MEATS AND POULTRY.

SALADS, ETC.

PICKLES.

MISCELLANEOUS DISHES.

PIES, ETC.

PUDDINGS.

PAGE.

PRESERVES AND ICES.

MEXICAN RECEIPTS.

BREAKFAST DISHES, ETC.

ADDITIONAL RECEIPTS.

PAGE.

HOUSEHOLD RECEIPTS.

almond Macaroons
½ lb. sweet almonds
½ lb. sugar white
whites of 2 eggs bake
in cool oven

Spice Cake

yolks of 7 eggs, 2 cups full brown
sugar, 1 cup molasses 1 cup butter
1 large coffeecupful of sour cream
1 teaspoon soda (just even full) 5 cups
flour 1 teaspoonful ground cloves 2 tea-
spoon of cinnamon 2 teaspoon ginger
1 nutmeg a small pinch Cayenne
pepper; beat eggs, sugar & butter light before
putting in molasses; then add molasses
flour & cream, beat well together bake in
moderate oven if fruit is used add 2 cups
of raisins flour them well and put in last

GRAHAM & ANDREWS,

DRUGGISTS.

917 CONGRESS AVENUE, - *AUSTIN, TEXAS.*

Red Front Candy Factory,

AUSTIN, TEXAS.

D. G. LAMME. : : PROPRIETOR.

→ Wholesale and Retail Dealer in →

Confectionery & Fruit & Manufacturer of Home Made

CANDY.

CARAMELS, STICK AND NUT CANDIES.

TERMS STRICTLY CASH. ⟵⟶ COUNTRY ORDERS RESPECTFULLY SOLICITED.

M. Kreisle Co.,

Furniture and Carpets

: Largest Stock, :

and Lowest Prices in the City.

Receipt for Economy, Comfort and Happiness.

Chow chow
1 pk green tomatoes

4 eggs 2 scant cups sugar
2 cups flr ¾ cup boiling
water last thing

1 cup butter 2¼ cups sug 1½
1 heaping teasp Baking Pow. 4 whole
eggs 6 yel[ks] 4 [cups] flr
6 whites for Icing

Nut cake
2 cup butt. 1½ cho. sug. 3 eggs
1 C. Sweet M. 2½ cups flr 1 heap
teasp B. P. 1 teas vanilla

AUSTIN COOKBOOK HISTORY

Cookbooks have been around for hundreds of years and are a common sight in modern kitchens. The first American cookbook (written and published in the United States) was *American Cookery* by Amelia Simmons (Philadelphia, 1796). This was the first written acknowledgement that Americans cooked with ingredients that the British did not and needed recipes that used these foodstuffs not found in England. Ingredients such as corn, native to the Americas and not included in English recipes, changed the way Americans cooked, and recipes needed to follow suit. There were earlier books printed in America, such as Eliza Smith's *The Complete Housewife* (Williamsburg, VA, 1742) or Susanna Carter's *The Frugal Housewife* (Boston, 1772), but these were reprints or new editions of cookbooks originally published in England.

Inventor and businessman Gail Borden wrote the first Texas cookbook, *Directions for Cooking Borden's Meat Biscuit; or the Extract of Beef Dried in Flour, Invented and Manufactured in Galveston, Texas* (New York: D. Fanshaw, 1855). Borden created his meat biscuit in 1849 and spent seven years trying to market his invention. He nearly lost everything, and the meat biscuit business failed. The year after his cookbook came out, he received a patent for his process of condensing milk and made a fortune. The first cookbook published in Texas was published by the Ladies Association of the First Presbyterian Church, Houston, in 1883 and was called *The Texas Cookbook*. It collected recipes from all over the state but had only one Austin entrant. The list of contributors included Julia Crow of Austin. Most of the recipes were not signed, so it is

unclear how many recipes she submitted. Butter and wine seemed to be the most common ingredients. Recipe names include: Very Nice Chicken Soup, A Very Nice Way to Prepare Canned Salmon, Economical French Dish, A Nice Breakfast Dish—No. 1, Macaroni Pudding to Be Eaten with Meat and Kiss Pudding.

Women had been cooking in Texas for many years prior to this publication. While no definitive word can be given as to why no cookbook was published prior to 1883, a few guesses can be made. For one, cooking in the nineteenth century was generally considered a dirty job, work left to slaves, servants or poor women who could afford neither servant nor slave. Indeed, many of the recipes found in this and other early cookbooks may very well have originated from the former slaves or servants of the women who contributed them. For those who did their own cooking, recipes were rarely recorded but instead passed on through oral traditions—mother to daughter—and the cooks prepared the meals so often there was no need to record them. In the instances where recipes were recorded, they were usually recipes for dishes made on special occasions or only occasionally where it was necessary to record the ingredients and steps. Also, many of the women and families who came to Texas brought cookbooks from back East.

From the time that the cookbook reproduced here was published to the time of this writing, more than 400 cookbooks have been published with an Austin connection (476 by our last count). The vast majority of these cookbooks were fundraiser cookbooks for a local organization, and most were published from the 1970s to the present.

Only one more cookbook came out of nineteenth-century Austin: *The Capitol Cook Book: A Selection of Tested Recipes, by the Ladies of Albert Sydney Johnston Chapter, Daughters of the Confederacy.* This was a fundraiser for the Daughters of the Confederacy and was printed in 1899. It includes hundreds of recipes compiled by Louise Holland Meyers. Like *The Texas Cookbook*, this is a title that has been reprinted many times. In 1965, the Brick Row Bookshop in Austin issued a reprint, and in the new dedication, it appealed to readers for the preservation of the book, and others like it, because cookbooks are often not recognized for their literary or artistic content. State House Press issued another edition in 1995 and included new photographs.

Austin-associated cookbooks continued to be a slow business. In addition to the two nineteenth-century titles, about forty cookbooks came out of Austin from 1900 through the 1950s. In 1907, the University Methodist Church published a small cookbook. Like many cookbooks, these were meant to be used, and the copies owned by the Austin History Center

include many handwritten notations. It is easy to imagine these copies in one of Austin's early homes. The newly created Texas Department of Agriculture, established in 1908, put out a few early Texas cookbooks. The first commissioner, Robert Milner, published *Pecans and Other Nuts in Texas* shortly before resigning his post. The Department of Agriculture published two more cookbooks about pecans in 1911 and 1916.

The 1910s saw a big uptick in cookbook publishing, with eighteen. The University of Texas's Domestic Economy Department was responsible for much of this, coming out with thirteen. Jessie P. Rich, a lecturer and demonstrator in the department, published six cookbooks over two years, 1913–15, with recipes for cooking with tough meats, peanuts and potatoes. Other women who taught home economics at the university—Anna E. Richardson, Jennie R. Bear and Mary Lawrence—contributed half a dozen more from 1913 to 1918 on topics ranging from menu planning to cooking with cotton seed flour. The Greater Austin YWCA, affiliated with the university, added to the count when it published the *Good Cheer Recipe Book* in 1919. The AHC's copy includes a handwritten note by Miss Bertha Carrington for a "Salmon Loaf" on the inside cover.

University Methodist Church. *ND-49-27-01, Neal Douglass Photography Collection, AHC.*

The 1910s also saw the introduction of small cookbooks published by local food companies as marketing pieces. The Bon-Ton Bakery produced a small pamphlet, *Bread: The Most Important of All Foods*, that included a few recipes that used its breads (not for people to make their own). Adolph Kohn opened the Bon-Ton Bakery in 1902. Kohn was a baker and pastry chef at the Driskill Hotel when George Littlefield gave him a $12,000 loan to open the Bon-Ton Bakery on Congress Avenue. It became known for its Pan Dandy brand of bread, a very popular bread found in grocery stores throughout Texas, until it closed in 1953. A second promotional cookbook from that era came from the L.T. Eck Pecan Co., *Choice Recipes for Preparing Texas Pecans (The Nut with a Flavor) into Candies, Cakes, Ice Cream, and Salads*. Eck came to Austin with his family in the 1870s and bought a local mercantile business. In 1898, he opened a store on South Congress, becoming the first merchant to open a retail business south of the Colorado River. Some of the Eck Company records are housed at the AHC (AR.1992.023).

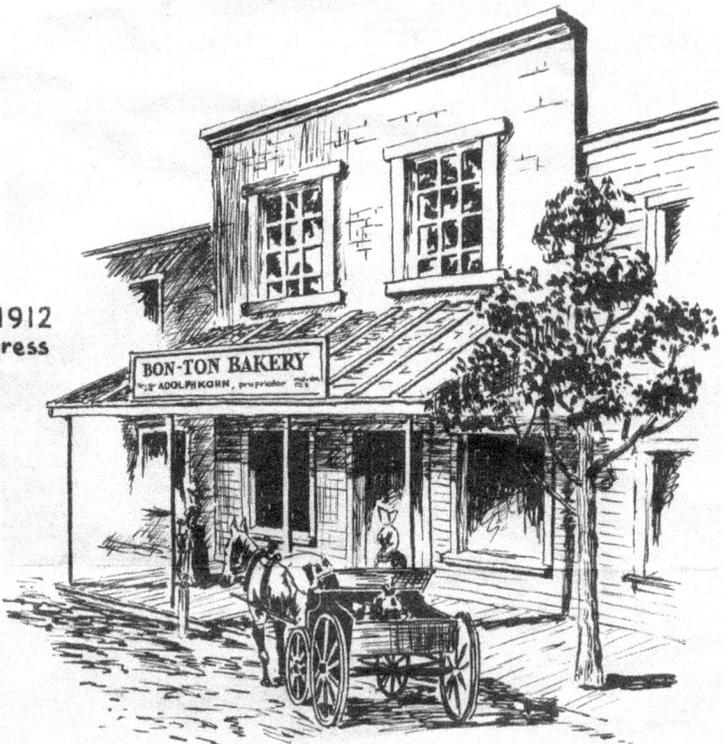

1902 - 1912
720 Congress

Bon-Ton Bakery, from flyer.

L.T. Eck store at 1200 South Congress Avenue. *PICH 03446, AHC.*

The 1920s saw more local business–produced recipe books. The J.C. Bryant Creamery Co. offered *A Cook Book for the Modern Home Maker Showing the Value of Using More Milk in the Menu* to encourage Austinites to use more milk. The Baptist Women's Missionary Union and the Austin Woman's Christian Temperance Union also issued fundraiser cookbooks during the same period. The Baptist Women's Missionary Union stated that the funds raised from the sale of its book were exclusively for "Mexican mission work." The missionaries were trying to acquire property in Austin to set up a mission to bring baptism to the Mexican population of Austin. The Cumberland Presbyterian Church produced a second cookbook in the 1920s, *The Cumberland Cook Book: A Collection of Recipes*. Like the center's copy of *Our Home Cookbook*, the center's copy of *The Cumberland Cook Book* includes many handwritten recipes and notes from previous owners.

A few more cookbooks came out in the 1930s and 1940s, again mostly fundraisers for local groups. The Hyde Park Christian Church, Catholic Daughters, Austin Red Cross and the Austin Woman's Club all issued fundraiser cookbooks during this time. The Catholic Daughters book, *When the Hostess Entertains*, includes recipes for large parties and offers tips on setting a table for large events such as luncheons. The local Red Cross

Canteen Corps, a group dedicated to disaster assistance and feeding troops in various "canteens" around the city, used its book to raise funds to run the canteens. "As a guest at the Grill [business that supports the canteens] and as a buyer of this cookbook, you have done your bit in furthering these projects. This Canteen Corps is grateful to the public and to the members of the local chapter for an attitude that is 'muy simpatico.'"

In addition to these organizational cookbooks, another local food company, Walker's Aus-Tex Chili Co., issued a small pamphlet of recipes sometime in the 1930s, *Rare Recipes "From Mexico,"* which featured its products. This was the second recipe booklet the company published. Walker's also released a small chili con carne recipe book in 1918. William

Red Cross Canteen hostesses. *AS-62-40812-2*, Austin American-Statesman *Photographic Morgue Collection, AHC.*

Walker's Austex Chili. *C05843, Russell Chalberg Photo Collection, AHC.*

Walker came to Austin in 1871 and opened a general store in the wagon yards on East Fourth Street. In 1900, Walker and his brother started manufacturing and canning Mexican spices and foods along with the grocery business. Walker's produced Mexene Red Devil Chili Powder, chili con carne, tamales, enchiladas, beef stew and spaghetti with meatballs. In 1911, Walker's installed the first ever automated tamale-making machine, capable of producing thirty-eight thousand tamales per hour.

The 1950s brought a small increase in the number of volumes published. The bulk of the 1950s cookbooks were church fundraisers. Central Christian Church (with two), Crestview Methodist Church and Immanuel Lutheran Church (Pflugerville) issued cookbooks. Additionally, the Bryker Woods School and the Women's Architectural League of Austin issued fundraiser cookbooks. The 1950s also saw The University of Texas at Austin (UT) return its attention to cookbook publishing. UT Press published *The Diabetics Cookbook* in 1955, and the University Ladies Club and the Resident Hostess Association of Women Students issued cookbooks during this time. Their books included general recipes, with an emphasis on southern cooking.

The 1960s saw the first double-digit total of cookbooks since the 1910s with seventeen. The University Ladies Club issued another cookbook, ten years after its first. The Anderson Mill Gardeners published two editions of their *Kingdom in the Hills Cookbook*, and many other local organizations offered cookbooks compiled from recipes of their members and sold as fundraisers. The 1960s also introduced local food writer Mary Faulk Koock. Koock grew up on the grounds of Green Pastures in south Austin. After her father passed away, she bought the estate. She started entertaining on the grounds, hosting parties and weddings for friends. After World War II, she decided to open a restaurant at Green Pastures, which she ran until 1968, when she turned the business over to her son Ken. She wrote two books in the 1960s, *The Texas Cookbook* and *Cuisine of the Americas*. In her first, Koock recounts her life through food and recipes, incorporating recipes into the overall narrative. Her second book was a bilingual cookbook of haute cuisine created for the HemisFair and included recipes from politicians from the United States and Central and South American countries. Koock would contribute to many more cookbooks through the 1990s. Her papers, including records of her work on the cookbooks she wrote, are at the AHC (AR.Z.034).

Mary Faulk Koock (center), with Mr. and Mrs. Bock. *PICB 04942, AHC.*

Cookbook publishing in Austin took off in the 1970s with over sixty Austin-related cookbooks published. Many of these were projects of local organizations tied to the country's bicentennial celebration in 1976, with many groups choosing to compile a cookbook as a way to commemorate this event. This decade also saw the start of reprinting historic cookbooks. In addition to the 1973 reprint of *The Capitol Cookbook* mentioned previously, Austin's Steck Company reprinted *Buckeye Cookery and Practical Housekeeping*, originally published in 1877 in Minneapolis, Minnesota, and one of the most popular American cookbooks. Another local publisher, the Pemberton Press, issued a facsimile reproduction of *First Texas Cookbook* in 1970. Along with the dozens of cookbooks published by churches, school groups and local nonprofits, the 1970s saw the introduction of Austin publishers entering the cookbook game, another reason for the large uptick in publications. Local printers such as Austex Printing, Steck, Hart Graphics and Von Boeckmann-Jones (the same firm that printed *Our Home Cookbook*) and publishers Encino Press, Oasis Press, Lone Star Publishers and Little House Press produced cookbooks during this time. Some records of Hart Graphics, Inc. and the Steck Co., mentioned previously, are at the AHC as part of the Hart Graphics, Inc. collection (AR.2003.036: www.lib. utexas.edu/taro/aushc/00169/ahc-00169.html).

Steck Company. ND-48-388-02, Neal Douglass Photography Collection, AHC.

The largest number of Austin cookbooks came out of the 1980s with over one hundred. Again, another major anniversary, this time the Texas sesquicentennial celebration in 1986, contributed to the increase in cookbooks. The 1980s also introduced cookbooks tied to local restaurants. Alicia Garces published the *Green Pastures Cookbook* in 1986 to profile and highlight the historic Green Pastures restaurant owned by Mary Faulk Koock. *Austin American-Statesman* food writer Diana Gomez wrote *Dining with Diane*, profiling twenty-one area restaurants and including over 150 recipes. Even the Highland Mall Food Court got in on the act, publishing *Simply Scrumptious Cookbook* in 1984 containing recipes from the restaurants in the newly opened food court.

Austin cookbook publishing began declining slightly in the 1990s but was still a sizeable number with over 90 cookbooks. From 2000 to the present, more than 120 have been published. Some highlights from the last twenty-five years of Austin cookbook publishing include an entertaining book from Joe Sears, co-creator of *Greater Tuna*, writing as one of the

University Ladies Club Tea at Green Pastures. *AS-63-43354-4*, Austin American-Statesman *Photographic Morgue Collection, AHC.*

Tuna characters, Aunt Pearl. Angela Shelf Medearis, an Austin culinary historian specializing in African American culture and cuisine, produced a series of books related to African American cooking, shining a spotlight on this previously under-studied area of culinary history. Similarly, local chef and restaurateur Matt Martinez Jr., son of the founder and owner of Matt's El Rancho, wrote 3 books highlighting his family's recipes and Tex-Mex cooking. Matt grew up working in his parents' restaurant, starting when he was eight years old. His grandfather opened the first Mexican restaurant in Austin, El Original, in 1925, starting a multigenerational family tradition in the restaurant business. Matt Martinez Jr. moved to Dallas to open a series of restaurants but made regular treks back to Austin to help with the family restaurant until he died in 2009.

Lastly, five cookbooks from the publisher of this book have come out over the last few years: three volumes of *Trailer Food Diaries Cookbook* by Tiffany

Matt's El Rancho (Matt Martinez Sr., seated at far right). *PICA 15953, Bill Malone Photo Collection, AHC.*

Harelik, *The Austin Food Blogger Alliance Cookbook* by Addie Broyles and *Austin Breakfast Tacos* by Mando Rayo and Jarod Neece.

The following bibliography of Austin cookbooks lists over four hundred cookbooks that have some connection to Austin. Criteria for inclusion on the list were:

- Cookbook was published in Austin by an Austin printer/publisher;
- Cookbook was published by or for an Austin-area organization;
- Cookbook was created or written by an Austin-area writer/chef;
- Or, the contents of the cookbook include a significant contribution from an Austin-area writer/chef or organization.

We have made every attempt to be inclusive and comprehensive in compiling this list. In addition to consulting the cookbook collection at the Austin History Center, we used the national bibliographic database WorldCat and the Texas cookbook collections at Baylor and Texas Women's Universities. It is quite possible some early publications were missed, particularly ones produced by food companies. These publications were small and considered ephemeral, and often these items were not kept. If you know of an Austin cookbook that is not included here, drop us a line at the Austin History Center (www.austinhistorycenter.org) with publication information, and we will update the bibliography periodically.

Austin Cookbook Bibliography

A list of cookbooks about, whole or in part, or printed in Austin, Texas

Abiding Love Lutheran Church [Austin, TX] Cookbook Committee. *Cooking with Love.* Collierville, TN: Fundcraft Pub., 1984.

Adopt-a-Recipe: The Texas General Land Office Cookbook. Austin, TX, 1990.

Adventures in Eating Group of the University Ladies Club, University of Texas. *1960 Cookbook.* Austin, TX, 1960.

————. *Our Adventures in Eating.* Austin, TX, 1950.

Alan, David. *Tipsy Texan: Spirits and Cocktails from the Lone Star State.* Kansas City, MO: Andrews McMeel Publishing, 2013.

Allen, Barbara. *Remember the Flavors of Austin: A Restaurant Guide & Recipe Sampler.* Austin, TX, 1998.

Alter, Judy. *Great Texas Chefs.* Fort Worth, TX: TCU Press, 2008.

Amaric Corp. Employees. *Rx for Good Eating.* Austin, TX: Amaric Corp., 1986.

American Academy of Child and Adolescent Psychiatry. *The Happy Humpty Dumpty Cookbook.* Austin, TX: Bright Books, 1990s.

American Association of University Women, Austin Branch. *Texas Jubilee Cookbook.* Olathe, KS: Cookbook Publishers, Inc., 1986.

A.N. McCallum High School PTSA. *Knights' Delight.* Lenexa, KS: Cookbook Publishers, Inc., 1983.

A.N. McCallum High School Supporters. *Knight's Kitchen.* Lenexa, KS: Cookbook Publishers, Inc., 1979.

Anderson Mill Gardeners, Inc. *Kingdom in the Hills Cook Book.* Volente, TX: printed by Mrs. J.H. Sudbury, 1960.

———. *Kingdom in the Hills Cook Book.* 2nd ed. Volente, TX, 1962.

Andrews, Jean. *The Peppers Cookbook: 200 Recipes from Pepper Lady's Kitchen.* Austin: University of Texas Press, 2005.

———. *The Pepper Trail: History and Recipes from Around the World.* Denton: University of North Texas Press, 1999.

———. *Red Hot Peppers: A Cookbook for the Not So Faint of Heart.* New York: Macmillan General Reference, 1993.

Angel, Joy Moffett. *Taste of Texas Cookbook: Around 300 Recipes for Down Home Texas Cookin'!!!* Austin, TX: Eakin Press, 1987.

Ansel, David. *The Soup Peddler's Slow & Difficult Soups: Recipes and Reveries.* Illustrated by Liza Ferneyhough. Berkeley, CA: Ten Speed Press, 2005.

Armed Forces Retired Officers' Wives [Austin, TX]. *Star-Spangled Recipes.* Lenexa, KS: Cookbook Publishers, Inc., 2000.

Arnsberger, David Dryden, and John Booher. *Spamarama: The Cookbook.* Austin, TX: Whole Hog Productions, 1998.

Association of Texas Electric Cooperatives. *The Second Typically Texas Cookbook: A Collection of Recipes Used by Rural Electric Cooperative Member-Consumers and Employees.* Austin: Association of Texas Electric Cooperatives, 1989.

———. *Typically Texas Cookbook: A Collection of Recipes Used by Rural Electric Coop Members.* Austin: Texas Electric Cooperatives, Inc., 1970.

Aulick, Marie, and Carrie Weaver. *Blue Bonnet Cook Book.* Austin, TX: City Union of the Baptist Women's Missionary Union, 1926.

Austin Art League, Group 1. *Favorite Recipes.* Austin, TX: Art League, n.d.

Austin District Dental Assistants Society. *The DA's Cook Book.* Austin, TX: The Society, 1964.

Austin Junior Forum. *Best of Lone Star Legacy Cookbooks.* Collector's ed. Highland Village, TX: Cookbook Resources, 2001.

———. *Changing Thymes: New Traditions of Texas Cooking.* Dallas, TX: Wimmer, 1995.

———. *Lone Star Legacy: A Texas Cookbook.* Austin, TX: Hart Graphics, Inc., 1981.

———. *Lone Star Legacy II: A Texas Cookbook.* Austin, TX: Hart Graphics, Inc., 1985.

Austin Mothers of Twins Club. *The No Time to Cook Book.* Austin, TX, 1971.

Austin Presbyterian Theological Seminary. *Seminary Women's Cookbook.* Austin, TX, 1977.

Austin Public Library Staff Association. *Librarians Cook Too.* Compiled by Eleanor Harris. Illustrated by Watt Harris Jr. Austin, TX: Felix Shuford, 1962.

————. *There's a Librarian in the Kitchen.* Compiled by Eleanor Harris. Illustrated by Watt Harris Jr. Austin, TX: Felix Shuford, 1968.

Austin School Food Service Association. *Favorite Recipes of…* Kansas City, KS: Bev-Ron Publishing Company, 1975.

Austin Steam Train Association. *Recipes.* Lenexa, KS: Cookbook Publishers, Inc., 2004.

Austin Travis County Livestock Show and Rodeo. *The Cutting Edge.* Collierville, TN: Fundcraft Publishing, Inc., 1977.

Austin Woman's Christian Temperance Union. *Directory and Cook Book.* Austin, TX, n.d. [circa 1920s].

Austin Woman's Club. *La Fête Internationale: Collection of Recipes from Members of the Austin Woman's Club.* Austin, TX, 1979.

————. *Treasure Pots.* Austin, TX, 1940.

————. *Treasure Pots, Too…A Collection of Recipes from the Presidents of the Austin Woman's Club.* Austin, TX, 1990.

Auxiliary to the Texas Society of Professional Engineers. *A Collection of Texas Recipes.* Lenexa, KS: Cookbook Publishers, Inc., 1995.

Baldwin, Linda. *Cook Book America's Favorite.* Austin, TX: Morgan Printing, 1999.

Bank of the Hills, Austin. *Recipes You Can Bank On.* Austin, TX: Hart Graphics, Inc., 1987.

Bauer, Linda, and Steve Bauer. *Recipes from Historic Texas: A Restaurant Guide and Cookbook.* Lanham, MD: Taylor Trade Publishing, 2003.

Bauer-Slate, Patricia, with Cole Henderson and Joseph E. Slate. *A Baker's Twenty Favorite Recipes for 20 Years.* Austin, TX: Sweetish Hill Bakery, 1995.

Bear, Jennie Rees. "Cotton Seed Flour as a Human Food." *University of Texas Bulletin 1727.* Austin: University of Texas, 1917.

Beckhusen, Jeffrey. *Old American Cookbook.* Austin: Texas School for the Deaf, 1976.

Berezovytch, Liz R. *Making It: A Cookbook for Lovers—Elegant and Simple Cooking for Two as Taught by the Great Chefs (and Lovers) of Austin, Texas.* Austin, TX: Crystal Creek Publications, 1986.

AWCTU *Directory and Cook Book* cover.

Bethany School. *30 Year Celebration Cookbook: Bethany School, 1980–2010: A Collection of Recipes.* Kearney, NE: Morris Press Cookbooks, 2010.

Blank, Jeff, and Jay Moore with Deborah Harter. *Cooking Fearlessly: Recipes and Other Adventures from Hudson's on the Bend.* USA: Fearless Press, 1999.

Blazek, Mark. *Pecan Lovers' Cookbook.* Phoenix, AZ: Golden West Publishers, 1986.

Block, Jacqueline, with Dale Kinzel and Diana Latham. *Let Your House Be Open Wide: A Unitarian Cookbook.* Austin, TX: First Unitarian Church, 1973.

Blue Haven Foundation, Inc. *A Texas Hill Country Cookbook.* Austin, TX: Aus-Tex Printing & Mailing, 1982.

Blue-Lake-Deerhaven Cookbook Committee. *A Texas Hill Country Cookbook.* Austin, TX: Aus-Tex Printing and Mailing, 1983.

Bluff Springs Extension Homemakers Club, Austin, Texas. *Cookbook.* Austin, TX, 1983.

———. *Cookbook.* Austin, TX, 1985.

Bon-Ton Bakery. *Bread: The Most Important of All Foods.* Austin, TX: Bon-Ton Bakery, n.d. [circa 1910s].

Brentwood Christian School. *Brentwood Christian School Family Heritage Cookbook.* Lenexa, KS: Cookbook Publishers, Inc., 1997.

Brown, Myrna. *Look What We've Cooked Up!* Austin, TX: Independent Garagemen's Association/Automotive Service Association, 1979.

Broyles, Addie. *The Austin Food Blogger Alliance Cookbook.* Charleston, SC: The History Press, 2013.

Bryker Woods School. *Favorite Recipes.* Austin, TX, 1953.

Bull, David J., and Turk Pipkin. *The Driskill Hotel: Stories of Austin's Legendary Hotel.* Austin, TX: Action Figure, 2005.

Bush, T.L., with Erwin E. Smith. *A Cowboy's Cookbook.* Austin: Texas Monthly Press, 1985.

Callahan's General Store. *5th Anniversary Cookbook: A Collection of Recipes from the Callahans and Their Friends.* Austin, TX: Cantor & Associates, Inc., 1983.

Callan, Kevin, and Margaret Howard. *The New Trailside Cookbook: 100 Delicious Recipes for the Camp Chef.* Austin, TX: Firefly, Poole, 2013.

Cantwell, Charles. *You Cantwell Cook Without Charlie's Book.* N.p., 1983.

Canyon Vista Middle School. *A Collection of Favorite Recipes.* Austin, TX: Canyon Vista Middle School, 2003.

Capone, Luigi. *La Cucina di Luigi Capone: Italian Home Cooking.* Austin, TX: Winner's Publications, 1980.

———. *La Cucina di Luigi Capone: Italian Home Cooking (A Manuscript).* 2nd ed. Austin, TX: Winner's Publications, 1983.

Care and Commitment Committee, University Presbyterian Church. *University Presbyterian Cooks.* Waseca, MN: Walter's Cookbooks, 1989.

Carter, Ruth, with Elaine Martin and Dorsey Barger. *Eastside's Inside Secrets: Recipes from the Eastside Café Menu.* Austin, TX, 1999.

Casis—Dill Cook Book. Austin, TX: Parent-Teacher Associations of Casis and Dill Schools, 1962.

Central Market. *Central Market 20th Anniversary Cookbook.* Austin: Texas Monthly Custom Publishing, 2014.

Cheney, Susan Jane. *Breadtime Stories: A Cookbook for Bakers and Browsers.* Illustrated by Kathy Miller Brown. Berkeley, CA: Ten Speed Press, 1990.

Christian Women's Fellowship. *Kitchen Witchery.* Austin, TX: Central Christian Church, 1957.

———. *Kitchen Witchery.* Austin, TX: Central Christian Church, 1959.

Christian Women's Fellowship of Koenig Lane Christian Church. *Generations: A Collection of Recipes.* Austin, TX: Koenig Lane Christian Church, 2005.

Church of the Good Shepherd. *The Good Cooks of Church of the Good Shepherd.* Austin, TX: Church of the Good Shepherd, 1965.

Circle 2 of the Hyde Park Christian Church. *The Builder Cook Book.* Austin, TX: Blanton Printing Co., 1938.

City of Austin Workplace Literary Task Force. *The New 3 R's: Really Readable Recipes, Workplace Literacy Cookbook.* Waseca, MN: Walter's Cookbooks, 1991.

Claiborne, Elaine Gill. *Recipes from Houston A&M University Mothers' Club 1982.* Austin, TX: Hart Graphics, 1982.

The Clan Cooks, or Penn Family Favorites. Austin, TX, n.d.

Clark, Ann. *Fabulous Fish: Easy and Exciting Ways to Cook and Serve Seafood.* New York: Nal Books New American Library, 1987.

———. *Quick Cuisine: Easy and Elegant Recipes for Every Occasion.* New York: Penguin Group, 1993.

Colaluca, Jo. *The Old Bakery Cookbook.* Austin, TX: Old Bakery and Emporium Guild, Inc., 2002.

Cole, Tyson, and Jessica Dupuy. *Uchi: The Cookbook.* Foreword by Lance Armstrong. Austin, TX: Umaso Publishing, 2011.

Colvert, Lottie Mae. *Easy Entertaining.* Austin, TX, 1968.

Community Garden Club of Johnson City, Texas. *Potluck on the Pedernales: Down Home Cooking from Deep in the Heart of LBJ Country.* Austin, TX: Eakin Press, 1991.

Conlan, Terry. *Fresh: Healthy Cooking and Living from Lake Austin Spa Resort.* Austin, TX: Lake Austin Spa Resort, 2003.

———. *Lean Star Cuisine: Regional Lowfat Cookery from Lake Austin Spa Resort.* Austin, TX: Lake Austin Spa Resort, 1993.

Cookbook Committee. *The Manor Cookbook.* Manor, TX: Manor Athletic Booster Club, n.d.

Cook, Crystal, and Sandy Pollock. *The Casserole Queens Cookbook: Put Some Lovin' in Your Oven with 100 Easy One-Dish Recipes.* New York: Clarkson Potter, 2011.

———. *The Casserole Queens Make-a-Meal Cookbook: Mix and Match 100 Casseroles, Salads, Sides and Desserts.* New York: Clarkson Potter, 2013.

Cooking Recipes of the Pioneers. Printed for Frontier Times Museum. Bandera, TX, 1948.

Corral, Gloria. *Barbecue Lover's Guide to Austin.* Foreword by Mark Miller. Illustrated by Elizabeth Prins. Austin, TX, 2010.

Court Maria Galante No. 115, Catholic Daughters of America. *When the Hostess Entertains.* Austin, TX: Shelby Special Services, Inc., 1940.

Creighton, Sue. *Capitol Cook Book: Favorite Family Recipes of Texas Governors, Senators and Other State Officials.* Waco, TX: Texian Press, 1973.

Crestview Methodist Church [Austin, TX], Women's Society of Christian Service. *Women's Society Christian Service: Crestview Methodist Church, Austin, Texas, Cookbook.* Kansas City, MO: North American Press, 1950s.

Cross, Joe. *The Reboot with Joe Juice Diet Cookbook: Juice, Smoothie, and Plant-Based Recipes Inspired by the Hit Documentary* Fat, Sick and Nearly Dead. Austin, TX: Greenleaf Book Group Press, 2014.

Daughters of the Republic of Texas, District VIII. *A Pinch of This and a Handful of That: Historic Recipes of Texas, 1830–1900.* Austin, TX: Eakin Press, 1988.

———. *Seconds of a Pinch of This and a Handful of That, 1830–1900.* Austin, TX: Eakin Press, 1994.

Delta Kappa Gamma Society, Gamma Omega Chapter (TX). *Our Favorite Recipes.* Kansas City, KS: Cookbook Publishers, 1977.

Delta Rho Delta Sorority, Gamma Chapter. *Gamma's Goodies.* Austin, TX: Delta Rho Delta, 1978.

DeMers, John. *Follow the Smoke: 14,783 Miles of Great Texas Barbecue.* Houston, TX: Bright Sky Press, 2008.

Descendants of Elisha and Mollie Price. *Favorite Family Recipes Cook Book.* Kansas City, KS: Cookbook Publishers, Inc., 1976.

———. *Favorite Family Recipes Cook Book.* N.p., 1985.

Distributive Education Clubs of America, Austin Community College Chapter. *DECA Cookbook.* Austin, TX: DECA, ACC Chapter, 1976.

Dittmar, George John, and Emilie Wende. *Dittmar Family Cookbook.* Austin, TX, 1994.

Division of Home Welfare, Dept. of Extension. "Meat, Its Value as Food and Its Proper Preparation." *University of Texas Bulletin* 347. Austin: University of Texas, 1914.

————. "Seasonable Fruits and Their Uses." *University of Texas Bulletin* 348. Austin: University of Texas, 1914.

Dunagan, Margaret. *Wild About Texas.* Austin, TX: Hart Graphics, Inc., 1989.

Eckert, Travis, and Carol Eckert. *Real Texas Bar-B-Que: A Beginner's Guide.* Austin, TX: Sport-Teck, 1987.

Eckhardt, Linda West. *The Only Texas Cookbook.* Austin: Texas Monthly Press, 1981.

Edwards, Sarah Grace (Monroe). *Our Family History Cookbook: From Slavery to Present.* Northants, England: Marchean Press, 2005.

Egyptian Band of Ruh Neb Temple No. 64, Austin, Texas. *Recipes!* Lenexa, KS: Cookbook Publishers, 1977.

Ellinger, Marko, with Mike Krone and Judy Panek. *Fun Food to Tickle Your Mood: A Cookbook for Children Who Cherish the Earth.* Austin, TX: Picadilli Press, 1992.

Elverson, Virginia T. *Houston Fine Arts Cookbook.* Austin: University of Texas Press, 1983.

Employees and Auxiliary Members of Holy Cross Hospital. *Recipe Exchange.* Edited by Joann Seaman. Austin, TX, 1973.

Enjoy! Recipes from the Women's Symphony League of Austin. Dallas, TX: Taylor Printing Company, 1980.

Episcopal Church Women, Good Shepherd, Austin. *Good Eating with Good Shepherd.* Olathe, KS: Cookbook Publishers, Inc., 1989.

Esquivel, Crystal. *Extraordinary Recipes from Austin Chef's Table.* Guilford, CT: Lyons Press, 2013.

Esselstyn, Rip. *The Engine 2 Diet: The Texas Firefighter's 28-Day Save-Your-Life Plan that Lowers Cholesterol and Burns Away Pounds.* New York: Grand Central, 2009.

Ex-Students' Association of the University of Texas. *Cook 'em Horns: Texas Exes' Cookbook Celebrating the University of Texas Centennial.* Austin, TX: Hart Graphics, Inc., 1981.

————. *Cook 'em Horns: Texas Exes' Cookbook Celebrating the University of Texas Centennial.* 2nd ed. Austin, TX: Hart Graphics, Inc., 1982.

————. *Cook 'em Horns: The Quickbook.* Austin, TX: Hart Graphics, Inc., 1986.

Famous Recipes by Famous People. Austin, TX: Cook Printing Co., 1933.

Favorite German Recipes Translated from Eiband and Fischer's Kochbuch on the 60th Anniversary of Its Original Publication by Soroptimist International of Austin, Texas. Austin, TX: Soroptimist International, 1976.

Favorite Recipes of St. Johns Parent-Staff Association Austin, Texas. Lenexa, KS: Cookbook Publishers, Inc., 1978.

Fayette Memorial Hospital Auxiliary [La Grange, TX]. *Cookbook.* Austin, TX: Aus-Tex Duplicators, 1976.

Feast of Cultures: A Doss Family Recipe-Storybook. Austin, TX: Puck's Gold Projects, 1998.

First Austin African Violet Society. *A Taste of Texas: Second Helping.* Lenexa, KS: Cookbook Publishers, Inc., 1997.

First Cumberland Presbyterian Church. *Our Home Cookbook.* Austin, TX: Von Boeckmann Printers, 1891.

First Presbyterian Church [Houston, TX] Ladies' Association. *The First Texas Cook Book: A Thorough Treatise on the Art of Cookery, 1883.* Forewords by David Wade and Mary Faulk Koock. Texas Sesquicentennial Collectors Edition, from facsimile of the original. Austin, TX: Eakin Press, 1986.

First Unitarian Church. *Let Your House Be Open Wide: A Unitarian Cookbook.* Austin, TX, 1974.

First United Methodist Church [Austin, TX]. *To Serve with Love: A Souvenir Cookbook.* Austin, TX: Nelson Typesetting, 1972.

———. *Traditions.* Austin, TX: Best Printing Company, Inc., 1981.

Forest Trail Booster Club [Austin, TX]. Cookbook Committee. *Falcons Cook!: A Collection of Treasured Recipes by Forest Trail Families and Friends.* Kearney, NE: Morris Press Cookbooks, 2004.

Founders Vision Republican Women. *Cooking in the Capital City.* Lenexa, KS: Cookbook Publishers, 2000.

Fracasso, Michael. *Artist in the Kitchen: A Brief Autobiography of Food.* Austin, TX, 2013.

Friends for Central Texas Children's Home. *Dinner on the Ground: A Collection of Savory Recipes.* Austin, TX: Friends of CTCH, 1990.

Friends of Christopher Guild. *Recipes for Caring.* Austin, TX: Center for Child Protection, 2014.

Future Homemakers of America, Texas School for the Blind. *Cookbook.* Austin: Texas School for the Blind, n.d.

Gannaway, Jackie. *Bake Sales and Birthday Parties: A Collection of Special Treats.* Austin, TX: Cookbook Cupboard, 1995.

———. *Bread in a Flowerpot: A Recipe Collection*. Austin, TX: Cookbook Cupboard, 1996.

———. *Brownies in a Jar: Original Recipes for Brownie Mixes Layered in Jars for Gifts*. Austin, TX: Cookbook Cupboard, 2000.

———. *Cake in a Jar: A Recipe Collection*. Austin, TX: Cookbook Cupboard, 1994.

———. *Cake Mix Cakes*. Austin, TX: Cookbook Cupboard, 1995.

———. *Cinnamon Scented: Cuisine and Crafts*. Austin, TX: Cookbook Cupboard, 1994.

———. *Classy Casseroles: A Recipe Collection*. Austin, TX: Cookbook Cupboard, 1998.

———. *Cookies in a Jar: Recipes for Layered Cookie Mixes*. Austin, TX: Cookbook Cupboard, 1997.

———. *Crafty Cans from the Kitchen: Cake and Bread Mixes to Give as Gifts in Cans*. Austin, TX: Cookbook Cupboard, 2002.

———. *The Cup Collection: Gift Mix Recipes for Cake in a Cup, Soup in a Cup, Fudge in a Cup, Pudding in a Cup, Cobbler in a Cup, Drinks in a Cup*. Austin, TX: Cookbook Cupboard, 2003.

———. *Delectable Selectables: Recipes for Sandwiches, Pastries, Savories, Scones, Butters, Sugars…for Teas and Showers*. Austin, TX: Cookbook Cupboard, 2002.

———. *5-Ingredient Lighten-Up! Less Fat Recipes*. Austin, TX: Cookbook Cupboard, 1994.

———. *Friendship Breads: Starters and Recipes*. Austin, TX: Cookbook Cupboard, 1993.

———. *Frosted Cookie Mixes in Jars*. Austin, TX: Cookbook Cupboard, 2003.

———. *Garden Greetings: Unique Gifts to Layer in Jars*. Austin, TX: Cookbook Cupboard, 2000.

———. *Gift Mixes: Food Baskets for All Occasions*. Austin, TX: Cookbook Cupboard, 1998.

———. *Gingerbread: Recipes and Crafts*. Austin, TX: Cookbook Cupboard, 1994.

———. *Hearts from the Kitchen: A Recipe Collection*. Austin, TX: Cookbook Cupboard, 1995.

———. *The How-to-Cook Book*. Austin, TX: Cookbook Cupboard, 1992.

———. *It's a Piece of Cake: Over 50 Quick, Easy Dessert Recipes that Start with a Purchased Angel Cake or a Purchased Frozen Pound Cake*. Austin, TX: Cookbook Cupboard, 2005.

———. *Jingle Jars: Unique Gift Mixes to Give in Jars*. Austin, TX: Cookbook Cupboard, 2002.

————. *Layered Soup Mixes in Jars: Original Recipes for Gift Giving.* Austin, TX: Cookbook Cupboard, 1999.

————. *Lookie! Lookie! It's Gonna Be a Cookie!: Quick, Easy Recipes that Start with a Cake Mix.* Austin, TX: Cookbook Cupboard, 2000.

————. *Make Your Own Cones: A Unique Way to Give Gift Mixes.* Austin, TX: Cookbook Cupboard, 2005.

————. *Many More Mixes: Food Mixes to Layer in Jars for Gifts.* Austin, TX: Cookbook Cupboard, 2000.

————. *Merry Cookies to All: A Recipe Collection.* Austin, TX: Cookbook Cupboard, 1996.

————. *Mixes for Cocoas, Teas and Cappuccinos: Drink Mixes Layered in Jars for Gifts.* Austin, TX: Cookbook Cupboard, 1999.

————. *Mixes in Jars for Kids!: Original Mixes for Gifts.* Austin, TX: Cookbook Cupboard, 2001.

————. *Mix It Up!: A Collection of Gift Mixes.* Austin, TX: Cookbook Cupboard, 1997.

————. *Mud Pies and Dirt Cakes: A Collection of Chocolate Delights.* Austin, TX: Cookbook Cupboard, 1994.

————. *Muffins in a Jar: Original Recipes for Muffin Mixes Layered in Jars for Gifts.* Austin, TX: Cookbook Cupboard, 2001.

————. *Party Snacks: For the Cookingly Challenged.* Austin, TX: Cookbook Cupboard, 2000.

————. *Presents for Your Precious Pets: Yummy, Easy-to-Make Treats for Your Dogs and Cats (and Wild Birds, Too!): Including Pet Mixes to Give in Jars!* Austin, TX: Cookbook Cupboard, 2003.

————. *Room for Dessert.* Austin, TX: Cookbook Cupboard, 2001.

————. *Second Helping: More Super Simple Delicious Recipes for Your Slow Cooker.* Austin, TX: Cookbook Cupboard, 2003.

————. *Slow Cooker Suppers: For the Cookingly Challenged.* Austin, TX: Cookbook Cupboard, 2001.

————. *Smoothies and Shakes: Also Includes Smoothie Mixes!* Austin, TX: Cookbook Cupboard, 2005.

————. *Special Spoonfuls: A Delightful New Way to Give a Food Mix!* Austin, TX: Cookbook Cupboard, 2002.

————. *Summertime: Recipes and Crafts.* Austin, TX: Cookbook Cupboard, 1994.

————. *The Thanksgiving Table: Traditional Recipes for Turkey, Dressing, Cranberries, Pumpkin.* Austin, TX: Cookbook Cupboard, 1993.

————. *Treat Mixes for Kids: Inside Water Bottles.* Austin, TX: Cookbook Cupboard, 2004.

Garcés, Alicia. *Green Pastures Cookbook.* Austin, TX: Sue Heatly Associates Communication Design, 1986.

Gibson, Frances Ernst, and Edwin Wray Gibson. *Music Lovers' Cookbook.* Austin, TX: Sunbelt Media, 1992.

Giles, Martha. *Redeemer Lutheran Church Cookbook.* Vol. 2. Austin, TX: Aus-Tex Printing and Mailing, 1990.

Gilliland, Tom, and Miguel Ravago. *Fonda San Miguel: Thirty Years of Food and Art.* Text by Virginia B. Wood. Foreword by Diana Kennedy. Fredericksburg, TX: Shearer Publishing, 2005.

Gilmore, Jack, and Jessica Dupuy. *Jack Allen's Kitchen: Celebrating the Tastes of Texas.* Austin: University of Texas Press, 2014.

Gomez, Diane Payton. *Dining with Diane: The Austin Restaurant Cookbook.* Austin, TX: Bougainvillea Press, 1987.

Good Cheer Club, Austin Young Women's Christian Association. *Good Cheer Recipe Book.* Austin, TX: Austin YWCA, 1919.

Gordon, Alice. *Red River's Round-Up Cookbook.* Austin, TX: Whitehead Pub., 1981.

Gordon, Teri. *Avocado Recipes, Etc.* 2nd ed. Austin, TX: Ginny's Printing and Copying, 1988.

Grace United Methodist Church. *Favorite Recipes.* Austin, TX: Grace United Methodist Church, n.d.

Graham, Mary, and Dwain Kelley. *Typically Texas Cookbook: A Collection of Recipes Used by Rural Electric Co-Op Members.* Austin: Texas Electric Cooperatives, Inc., 1977.

———. *Typically Texas Cookbook: A Collection of Recipes Used by Rural Electric Co-Op Members.* Austin, TX: Texas Electric Cooperatives, Inc., 1983.

Gregg, Diane. *The Bubba Cookbook with Jokes.* Austin, TX, 1994.

———. *The Bubba Does Texas Cookbook with Jokes.* Austin, TX, 1998.

Griffiths, Jesse. *Afield: A Chef's Guide to Preparing and Cooking Wild Game and Fish.* New York: Welcome Books, 2012.

Group III of the Christian Women's Fellowship. *Our Favorite Recipes.* Austin, TX: Koenig Lane Christian Church, n.d.

Grove, Peggy S. *Love and Lemon Pie: Recipes for the Body and the Soul.* Austin, TX, 2002.

YWCA *Good Cheer Recipe Book* cover.

Harelik, Tiffany. *The Big Bend Cookbook.* Charleston, SC: The History Press, 2014.

———. *Trailer Food Diaries Cookbook: Austin Edition.* Austin, TX: Greenleaf Book Group, Inc., 2011.

———. *Trailer Food Diaries Cookbook: Austin Edition, Volume 2.* Charleston, SC: The History Press, 2012.

———. *Trailer Food Diaries Cookbook: Austin Edition, Volume 3.* Charleston, SC: The History Press, 2014.

Hart, Deborah. *Spa Specialties from the Kitchen of Lake Austin Resort.* Austin, TX: Lake Austin Resort, 1990.

Hashem's Hair-Em. *Favorite Recipes from Friends & Customers of Hashem's Hair-Em, Austin, Texas, 1979.* Austin, TX: Hashem's Hair-Em, 1979.

HealthPLUS. *Wellness Cookbook.* Austin, TX: City of Austin, 1993.

Health Travel International. *Spa Dining: Luscious, Low-Calorie Recipes from America's Great Spas.* New York: St. Martin's Press, 1986.

H-E-B Grocery Co. *Made in Texas: A Cookbook Celebrating H-E-B's 100ᵗʰ Anniversary.* Austin: Emmis—Texas Monthly Custom Pub., 2004.

Heerensperger, Kathy, and Leonard Heerensperger. *More Than Recipes: Grocery and Café for Every Day of the Year.* Vols. 1 and 2. Austin, TX: Menu Cookbook Company, 1996.

Hein, Peg. *More Tastes and Tales, from Texas with Love: A New Collection of Texas Recipes.* Illustrated by Kathryn Cramer Lewis. Austin, TX: Heinco, Inc., 1987.

———. *New Tastes of Texas.* Austin, TX: Heinco, Inc., 1994.

———. *Tastes and Tales from Texas…with Love: A Collection of Texas Recipes.* Austin, TX: Hein & Associates, 1984.

Heritage Guild of Heritage Society of Austin. *The Old Bakery Bake Book.* Austin, TX: Von-Boeckmann-Jones Company, 1971.

———. *The Old Bakery Bake Book—Special Edition.* Austin, TX: Von-Boeckmann-Jones Company, 1979.

Heritage Society Guild of Austin, Texas. *Austin Heritage Cook Book.* Austin, TX: Hart Graphics, Inc., 1982.

Heritage Society of Austin. *Austin Heritage Cook Book.* Austin, TX: Hart Graphics, Inc., 1985.

Highland Mall Food Court. *Simply Scrumptious Cookbook.* Austin, TX: Highland Mall, 1984.

Higley, Hilda Eicher. *Rolling in Dough.* Austin, TX: C&M Publications, 1984.

Hill Elementary School. *Dillo Delights: Recipes from Hill Elementary School.* Austin, TX: Hill Elementary School, 1987.

Hill, Shelby, with Rosemary Wieland. *Texas Exes in Home Economics Cookbook.* 2nd ed. Austin, TX: Aus-Tex Printing and Mailing, 1983.

Hodges, Hazel Josephine James, with Marthanne Hodges Luzader and Lucy Luzader. *A Three Generation Cookbook, or the Nurture of Mothers Is Visited Upon the Children to the Third and Fourth Generations.* Austin, TX: Luzader & Co., 1983.

Houston Concierge Association. *Houston Concierge Cookbook: Favorite Recipes from 42 of Houston's Finest Hotel Restaurants.* Austin, TX: Eakin Press, 1997.

Hughes, Mike. *The Broken Arrow Ranch Cookbook.* Austin: University of Texas Press, 1985.

Humble, Clara Saenz. *Great Shape Recipes.* Austin, TX: Great Shape, 1984.

Hume, H. Harold. *Citrus Fruits in Texas.* Austin, TX: Von Boeckmann-Jones Co. Printers, 1909.

Hunt, Donna, Kathy Pill and Bobbi Field. *The Texas Press Women's Cookbook.* Austin, TX: Lone Star Publishers, Inc., 1976.

Hutson, Lucinda. *The Herb Garden Cookbook.* Austin: Texas Monthly Press, 1987.

———. *The Herb Garden Cookbook: The Complete Gardening and Gourmet Guide.* 2nd ed. Austin: Texas Monthly Press, 1998.

———. *The Herb Garden Cookbook: The Complete Gardening and Gourmet Guide.* 2nd ed., 1st University of Texas Press ed. Austin: University of Texas Press, 2003.

———. *The Herb Garden Cookbook: Complete Gardening Guide.* 2nd printing. Houston, TX: Gulf Publishing Company, 1992.

———. *Viva Tequila!: Cocktails, Cooking, and Other Agave Adventures.* Austin: University of Texas Press, 2013.

Immanuel Lutheran Church. *Recipes: Christmas Workshop.* Pflugerville, TX: Immanuel Lutheran Church, 1959.

Incredible Edibles: Cookbook of the Texas Cosmetology Association. Austin, TX, 1988.

J.C. Bryant Creamery Co. *A Cook Book for the Modern Home Maker Showing the Value of Using More Milk in the Menu.* Austin, TX: The Company, n.d. [circa 1920s].

Jolley, Ethel. *Cooking with…Hillcrest Baptist Church.* Austin, TX: DuRite Printing, 2002.

The Joy of the Whole Table: An Austin Cookbook. Austin, TX: First Unitarian Church, 1985.

Junior League of Austin. *Austin Entertains.* Austin, TX, 2001.

———. *The Collection: A Cookbook.* Austin, TX, 1976.

———. *Necessities and Temptations.* Austin, TX, 1987.

Kazar, Catherine, with Dennis Kazar and Brady Kazar. *BBQ.* Austin, TX: Thunderball Press, 2002.

Kite Kitchen: Favorite Recipes of Alpha Theta Chapter, Kappa Alpha Theta, University of Texas. Austin, TX: Alpha Theta Chapter, Kappa Alpha Theta, 1975.

Kivikko, Jill. *Casa de Luz Community Cookbook: Sauces, Dressings, Condiments, and Spreads.* Austin, TX: Casa de Luz, 2009.

Knight, Gerri. *Have a Happy Heart Recipes.* Austin, TX: Barton Pub., 1986.

———. *Low Cholesterol…Modified Fat Cookbook: "Have a Happy Heart" Recipes.* Austin, TX: Barton Publishing Co., 1986.

Koock, Mary Faulk. *Cuisine of the Americas.* Austin, TX: Cookbook Associates by the Encino Press, 1967.

———. *The Texas Cookbook: From Barbeque to Banquet—An Informal View of Dining and Entertaining the Texas Way.* Boston: Little, Brown and Company, 1965.

Kramer, Laura Pipkin. *The Waldemar Cookbook: Memorable Savorings from the Waldemar Kitchen.* Austin, TX: Eakin Press, 2001.

Kyle, Edward Jackson. *The Pecan and Hickory in Texas.* Austin: Texas Department of Agriculture, 1911.

Ladies Aid and Missionary Society, Kyle Baptist Church. *The Kyle Baptist Church Cookbook: A Selection of Tried and True Recipes.* Austin, TX: Morgan Printing Co., 1904.

Ladies Association of the First Presbyterian Church, Houston, Tex. *The First Texas Cook Book: A Thorough Treatise on the Art of Cookery.* Edited by George Fuermann. Austin, TX: Pemberton Press, 1963, 1970.

Ladies of Fitzhugh Baptist Church. *Cookbook.* Austin, TX: Fitzhugh Baptist Church, 1976.

Ladies of the Church. *Favorite Recipes of Decker United Methodist Church.* Austin, TX: Decker United Methodist Church, n.d.

Ladies of the Cumberland Presbyterian Church. *The Cumberland Cook Book: A Selection of Tested Recipes.* Austin, TX, n.d. [circa 1920s].

Lake Austin Resort Recipes. Austin, TX: Lake Austin Resort, 1986.

Lanier Valkyries and Vikettes, Sidney Lanier High School. *Favorite Recipes of Lanier Valkyries and Vikettes.* Kansas City, MO: Circulation Service, 1972–73.

Second Cumberland Church cookbook cover.

Latorre, Dolores L. *Cooking and Curing with Mexican Herbs: Recipes and Remedies Gathered in Muzquiz, Coahuila.* Austin, TX: Encino Press, 1977.

Lawrence, Mary Minerva. "Food Conservation Bulletins." *University of Texas Publication* 1744–47. Austin: University of Texas, 1917.

———. "Six Texas Food Products: Recipes and Food Values." *University of Texas Bulletin* 1823. Austin: University of Texas, 1918.

L.C.W. Prince of Peace Lutheran Church. *"Receipts" Old or Unusual Featuring Smorgasbord.* Austin, TX: Prince of Peace Lutheran Church, n.d.

League of Women Voters. *Capitol Cooking.* Olathe, KS: Cookbook Publishers, Inc., 1985.

Leos, Robert, and Nancy Leos. *Lowfat Mexican Cookbook: True Mexican Taste Without the Waist.* Saratoga, CA: R&E Publishers, 1992.

Let's Lasso Our Favorite Recipes. Prepared by Mrs. Worley's Third Grade Unit on "Care of Our Bodies," Lucy Read School. Austin, TX, 1972.

Liermann, Sheila, and Nancy Reid. *Austin Hill Country Celebrity Cookbook.* Ketchum, ID: Lost Trail Productions, Inc., 1996.

Lowery, Joseph, with Donald R. Counts and Kathryn O'C. Counts. *A Texas Family's Cookbook.* Austin: Texas Monthly Press, 1985.

L.T. Eck Pecan Co. *Choice Recipes for Preparing Texas Pecans (The Nut with a Flavor) into Candies, Cakes, Ice Cream, and Salads.* Austin, TX, n.d. [circa 1910s].

Macry-Simpson, Lena Rose "Scooter." *Play a Symphony on Your Palate.* Austin, TX, 1995.

Marbridge Oak Leaves. *Culinary Capers.* Lenexa, KS: Cookbook Publishers, Inc., 1982.

Marchant, Kerena, and Zul Mukhida. *Hindu Festivals Cookbook.* Austin, TX: Raintree Steck-Vaughn, 2001.

Martinez, Matt. *MexTex: Traditional Tex-Mex Taste.* Albany, TX: Bright Sky Press, 2006.

Martinez, Matt, Jr., and Steve Pate. *Matt Makes a Run for the Border: Recipes and Tales from a Tex-Mex Chef.* New York: Lebhar-Friedman Books, 2000.

———. *Matt Martinez's Culinary Frontier: A Real Texas Cookbook.* New York: Doubleday, 1997.

Mary-Martha Guild. *Somethin' Good's a Cookin'.* Austin, TX: Bethany Lutheran Church, 1974.

Pecan recipe book cover.

Mathews Elementary School. *The International Cookbook.* Austin, TX: Johnston High School Print Shop, 1983.

McConnell, Penny, and Kathy Sutton. *Cookie Stories: Life Stories and the Cookies that Inspired Them.* Austin, TX: Falling Star Press, 2005.

McCray, Marilyn. *Canning, Pickling, and Freezing with Irma Harding: Recipes to Preserve Food, Family and the American Way.* Austin, TX: Octane Press, 2014.

McQueary, Carl R. *Dining at the Governor's Mansion.* College Station: Texas A&M Press, 2003.

————. *Ma's in the Kitchen: You'll Know When It's Done: The Recipes and History of Governor Miriam A. Ferguson, First Woman Governor of Texas.* Austin, TX: Eakin Press, 1994.

Meadows, E.H., and Ernestine Meadows. *Meadows' Diet Cookbook.* Austin, TX: Steck-Warlick Co., 1971.

Melville, Betty. *The Hunter's Cookbook.* Austin, TX: Little House Press, 1972.

Meyer, Arthur L. *Texas Tortes: A Collection of Recipes from the Heart of Texas.* Austin: University of Texas Press, 1997.

Miller, Mark, and Andrew Maclauchlan with John Harrisson. *Flavored Breads: Recipes from Mark Millers Coyote Café.* Berkeley, CA: Ten Speed Press, 1996.

Miller, Richard L. *The Official Fajita Cookbook.* Austin: Texas Monthly Press, 1988.

Miller, Rita. *Fresh from the Garden: Time Honored Recipes from the Readers of Texas Gardener.* Waco: Texas Gardener Press, 1986.

Milner, Robert Teague. *Pecans and Other Nuts in Texas.* Austin: Texas Department of Agriculture, 1908.

Morehead, Judith, with Richard Morehead. *The New Texas Wild Game Cookbook: A Tradition Grows.* Austin, TX: Eakin Press, 1985.

————. *The Texas Wild Game Cookbook.* Austin, TX: Encino Press, 1972.

Mott, Dennis R. *Texas Judicial Cookbook.* Austin, TX: Ovation Books, 2007.

Myers, Louise Holland. *The Capitol Cook Book: A Facsimile of the 1899 Edition.* Austin, TX: Brick Row Bookshop, 1966.

————. *The Capitol Cook Book: A Facsimile of the 1899 Edition.* New foreword by Edith Fletcher Williams. Austin, TX: State House Press, 1995.

————. *The Capitol Cook Book: A Selection of Tested Recipes, by the Ladies of Albert Sydney*

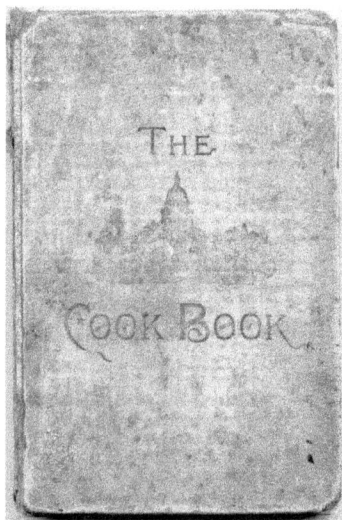

Capitol cookbook cover.

Johnston Chapter, Daughters of the Confederacy. Austin, TX: Von Boeckmann, Schutze & Co., 1899.

Nance, Mildred Hensarling. *Our Favorite Recipes: A Collection of Hensarling Family Recipes Old and New.* Austin, TX, 1986.

Nash Phillips/Copus. *Cookbook Featuring the Recipes of Famous People.* Austin, TX: Nash Phillips/Copus, n.d.

National Guard Auxiliary of Austin. *Ready to Serve: A Texas Cookbook.* Austin, TX: Hart Graphics, Inc., 1984.

Nelson-Erichsen, Jean. *Los Niños International Family Cookbook.* Austin, TX: Los Niños International Adoption Center, 1988.

North Oaks Elementary PTA [Austin, TX]. *Diamond Anniversary Cookbook: North Oaks Elementary School.* Collierville, TN: Fundcraft Pub., 1987.

Nozick, Betsy, and Tricia Henry. *Texas Tuxedos to Tacos: The Mystique of Entertaining.* Austin, TX: Eakin Press, 1997.

Odum PTA. *Our Pantry: Cookbook.* Austin, TX: Odum PTA, 1973.

The Official SXSW 2014 Interactive Cookbook. Austin, TX: SXSW, 2014.

Ogunsanya, Dokpe Lillian. *"My Cooking" West-African Cookbook: Tantalizing Family Recipes that Are Deliciously Unique with Robust Flavor.* Austin, TX: Dupsy Enterprises, 1998.

Opera Guild of Fort Lauderdale. *Libretto: The Opera Society Menu Cookbook.* Austin, TX: Hart Graphics, 1987.

O'Shaughnessy, Marie. *Texas International Cookery.* Edited by Mireille Seewan. Austin, TX: Aylin Printing, 1991.

Parent-Teachers Association. *The P.T.A. Cook Book.* Austin, TX: Parent-Teachers Association, n.d.

Park Hills Baptist Church. *The Good Old Fashioned Downhome Bicentennial Cookbook.* Austin, TX: Park Hills Baptist Church, 1976.

Parmer Lane Elementary School. *Let's Cook with Kids.* Austin, TX: Kids Cookbook Co., 1997.

Parmer Woods Assisted Living [Austin, TX]. *Recipes & Remembrances: A Collection of Recipes.* Kearney, NE: Morris Press Cookbooks, 2003.

Pasterchik, Carolyn. *Favorite Polish Recipes of the Greater Austin Polish Americans (GAPA).* Austin, TX: GAPA, 1982.

Payne, Kate. *The Hip Girl's Guide to Homemaking.* New York: HarperCollins, 2011.

———. *The Hip Girl's Guide to the Kitchen.* New York: HarperCollins, 2014.

Permenter, Paris, and John Bigley. *Gourmet Getaways: A Taste of North America's Top Resorts.* Dollard-des-Ormeaux, Quebec, Canada: Callawind Publications, Inc., 1998.

Petusevsky, Steve, and Whole Foods Market Team Members. *The Whole Foods Market Cookbook: A Guide to Natural Foods with 350 Recipes.* New York: Clarkson Potter Publishers, 2002.

Philippa, Ruby Dee. *Ruby's Juke Joint Americana Cookbook.* Austin, TX: Bando Press, 2012.

Pierce Facemire, Glenda. *Music in the Kitchen: Favorite Recipes from Austin City Limits Performers.* Austin: University of Texas Press, 2009.

Pioneer 6 Unit, Doss School. *A Rainbow of Recipes.* Austin, TX, 1976.

Pirotta, Saviour, and Zul Mukhida. *Christian Festivals Cookbook.* Austin, TX: Raintree Steck-Vaughn, 2001.

Police Wives Club of Austin. *A Book of Favorite Recipes.* Kansas City, MO: Circulation Service, 1974.

Praskac, Amy, and Barbara Williams. *Getting a Piece of the Pie: LBJ School Cookbook for Skilled Generalists.* Austin, TX: Quik Print, 1982.

Price, Janis Bryant. *The Easy Gourmet Cookbook.* Austin, TX: Arnan Publishing Company, 1981.

Professional Secretaries International, Capital Chapter [Austin, TX]. *The Best Little Cookbook in Texas.* Austin, TX: Capital Chapter, Professional Secretaries International, n.d.

Public Employees Credit Union. *PECU 25th Anniversary Cookbook, 1952–1977.* Edited by Jack Gardner and Jolene Wagenfuehr. Austin, TX: Whitley Company, 1977.

Raab, Evelyn. *The Clueless Baker: Learning to Bake from Scratch.* Austin, TX: Firefly, 2001.

———. *The Clueless Baker: Learning to Bake from Scratch.* Revised and updated ed. Austin, TX: Firefly, 2013.

———. *Clueless in the Kitchen: A Cookbook for Teens.* Austin, TX: Firefly, 2011.

———. *The Clueless Vegetarian: A Cookbook for the Aspiring Vegetarian.* Austin, TX: Firefly, Poole, 2006.

———. *The Clueless Vegetarian: A Cookbook for the Aspiring Vegetarian.* Revised and updated ed. Austin, TX: Firefly, Poole, 2012.

Randall, Joe, and Toni Tipton-Martin. *A Taste of Heritage: The New African-American Cuisine.* New York: Wiley, 1998.

Randall, Ronne, and Zul Mukhida. *Jewish Festivals Cookbook.* Austin, TX: Raintree Steck-Vaughn, 2001.

Rather, Rebecca, with Alison Oresman. *The Pastry Queen: Royally Good Recipes from the Texas Hill Country's Rather Sweet Bakery and Café.* Berkeley, CA: Ten Speed Press, 2004.

Rayo, Mando, and Jarod Neece. *Austin Breakfast Tacos: The Story of the Most Important Taco of the Day.* Charleston, SC: The History Press, 2013.

Recipes from Texas Exes in Home Economics. Austin: University of Texas Department of Home Economics, 1977.

Red Cross Canteen Corps, Austin, Texas. *You Asked for It! A Cook Book.* Austin, TX: Cook Printing Co., 1944.

Resident Hostess Association for Women Students, University of Texas. *Recipes.* Austin, TX, 1952.

Rhodes, Kimmie. *The Amazing Afterlife of Zimmerman Fees: A Metaphysical Story and Cookbook, Featuring Recipes from Gracey-Rhodes Family and Friends.* Austin, TX: Sunbird Press, 2000.

Rich, Jessie Pinning. "Cooking Tough Meats." *University of Texas Bulletin* 278. Austin: University of Texas, 1913.

———. "Cooking Tough Meats." *University of Texas Bulletin* 344. Austin: University of Texas, 1914.

———. "The Irish Potato." *University of Texas Bulletin* 350. Austin: University of Texas, 1914.

———. "Nuts and Their Uses as Food." *University of Texas Bulletin Extension Series* 63. Austin: University of Texas, 1915.

———. "Simple Cooking of Wholesome Food for the Farm Home." *University of Texas Bulletin* 303. Austin: University of Texas, 1913.

———. "Uses of the Peanut on the Home Table." *University of Texas Bulletin* 13. Austin: University of Texas, 1915.

Richardson, Anne E. "The Principles of Menu Making." *University of Texas Bulletin* 282. Austin: University of Texas, 1913.

———. "The Principles of Menu Making." 2nd ed. Austin: University of Texas, 1914.

Ridgetop Baptist Church. *Foods We Cook.* Austin, TX: Ridgetop Baptist Church, 1974.

Roberts, Scott, and Jessica Dupuy. *The Salt Lick Cookbook: A Story of Land, Family, and Love.* Driftwood, TX: Salt Lick Press distributed by University of Texas Press, 2012.

Ross, A.E. *The Mexican Kitchen.* Austin, TX: Oasis Press, 1976.

Ruff, Ann. *Cookoffs! Including Blue-Ribbon Recipes from Texas' Most Famous Food Festivals.* Austin: Texas Monthly Press, 1986.

Ruff, Ann, with Gail Drago. *Texas Historic Inns Cookbook: A Delightful Collection of Treasured Recipes.* Austin: Texas Monthly Press, 1985.

Sacred Heart Church. *Family Favorites.* Austin, TX: Sacred Heart Church, 1985.

The Saga of Texas Cookery: An Historical Guide of More Than One Hundred Twenty Recipes Illustrating the French Influence on Texas Cuisine, the Spanish Influence, & the Mexican. Austin, TX: Encino Press, 1973.

SAHELI for Asian Families. *Recipes without Borders.* Kearney, NE: Morris Press Cookbooks, 2005.

St. George Episcopal School. *Fire Up for Cooking!* Collierville, TN: Fundcraft Publishing, 1980.

———. *Mother's Day 1989 Cookbook.* Collierville, TN: Fundcraft Publishing, Inc., 1989.

St. Louis Home and School Association. *Old Fashioned Favorites for the Modern Cook.* Austin, TX: St. Louis Home, 1981.

———. *St. Louis' Favorites: St. Louis Home and School Association Cookbook No. 2.* Austin, TX: St. Louis Home, 1987.

St. Martin's Luther League. *Choice Recipes.* Austin, TX: St. Martin's, 1924.

St. Mary's Catholic Church Altar Society. *Hostess Reference Book.* Austin, TX: St. Mary's, n.d. [circa 1920s].

St. Vincent de Paul Church. *St. Vincent de Paul's Gourmet Secrets.* Lenexa, KS: Cookbook Publishers, Inc., 2001.

Sanitchat, Jam. *The Everything Thai Cookbook.* Avon, MA: Adams Media, 2013.

Sayle, Carol Ann. *Eating in Season: Recipes from Boggy Creek Farm.* Austin, TX: Boggy Creek Farms, 1999.

Schotz, Jane Lilly. *Lilly for Company: Austin Casual Menus for Palm & Plate.* Austin, TX: Culinaria/Jane Schotz, 2004.

Scottish Rite Dormitory. *As You Like It: Scottish Rite Dormitory's 60th Jubilee Cookbook, 1922–1982.* Austin, TX: Hart Graphics, 1982.

Sears, Joe. *Aunt Pearl's Cookbook: A Man's Cooking.* Austin, TX: Morgan Printing, 1991.

Seton Medical Center Auxiliary. *The Seton Family Cookbook.* Austin, TX: Seton Medical Center, 1983.

———. *Silver Anniversary Cookbook, 1950–1975.* Austin, TX: Seton Medical Center, 1975.

Shelf Medearis, Angela. *African American Arts: Cooking.* Brookfield, CT: 21st Century Books, 1997.

———. *The African-American Kitchen: Cooking from Our Heritage.* New York: Dutton/Penguin Books, 1994.

———. *The Ethnic Vegetarian: Traditional and Modern Recipes from Africa, America and the Caribbean.* Emmaus, PA: Rodale Press, 2004.

———. *Ideas for Entertaining from the African-American Kitchen: Recipes and Traditions for Holidays Throughout the Year.* New York: Dutton/Penguin Books, 1997.

———. *The Kitchen Diva Cooks!* New York: Lake Isle Press, 2010.

———. *The Kitchen Diva! New African-American Kitchen.* New York: Lake Isle Press, 2008.

———. *The Kitchen Diva's Diabetic Cookbook: 150 Healthy, Delicious Recipes for Diabetics and Those Who Dine with Them.* Kansas City, MO: Andrews McMeel Publishing, 2012.

———. *Ten Ingredients for a Joyous Life and Peaceful Home.* New York: Lake Isle Press, 2009.

Shulman, Martha Rose. *Fast Vegetarian Feasts: Delicious Healthful Meals in Under 45 Minutes.* New York: Dial Press, 1982.

———. *Garlic Cookery: Delicious Gourmet Vegetarian Recipes.* New York: Thorsons Publishers, Inc., 1984.

———. *Supper Club Chez Martha Rose: A Cookbook of Parties and Tales from Paris.* New York: Atheneum, 1988.

Siga, L.K., and Barbara Light Lacy. *19ᵗʰ and University EATS!* Dallas, TX: Rising Times Books, 2013.

Simpson United Methodist Women. *Favorite Recipes.* Oak Part, IL: Project Cuisine, n.d.

Sims, Carol. *Tea Treasures and More: Favorite Recipes from Sims & Company.* Austin, TX: Sims & Co., 2003.

Singer, Sara, and Kelsey August. *Mad at Martha: Simpler Methods for Success in the Kitchen: A Cookbook.* 2ⁿᵈ ed. Austin, TX: Whisk Pub., 2002.

Sisterhood Agudas Achim. *Our Best Recipes: Bete'avon!* Lenexa, KS: Cookbook Publishers, Inc., 2004.

Smith, Joanne. *A Multiethnic Feast: Cuisine, Texas.* Foreword by Mary Faulk Koock. Austin: University of Texas Press, 1995.

———. *Texas Highways Cookbook.* Austin: University of Texas Press, 1986.

Smith, Luna. *Nourished: The Art of Eating and Living Well.* Santa Barbara, CA: goodwitchbooks, 2012.

Smith, Sue Brantley. *Bon's Apetit.* Olathe, KS: Cookbook Publishers, Inc., 1991.

Snead, James W. *Comemos en Mexico/We Eat in Mexico: Compilation of Tested Mexican Recipes Both Old and New.* Austin, TX: Patrick Publications, 1946.

Southwest Church of Christ. *Feeding the Flock.* Austin, TX: Southwest Church of Christ, 2003.

Spears, Grady, with June Naylor and Erwin E. Smith. *The Texas Cowboy Kitchen: Recipes from the Chisholm Club.* Austin: Texas Monthly Custom Pub. Berkeley, CA: Distributed by Ten Speed Press, 2003.

Spicewoods Springs Pottery. *The Steamer.* Austin, TX: Spicewood Springs Pottery, 1970.

Stanford, Kim, and Bill Backhaus. *Goodbye Gluten: Happy Healthy Delicious Eating with a Texas Twist.* Denton: University of North Texas Press, 2014.

Stanish, Rudolph. *Theatrical Cuisine: A Cooking School.* Austin, TX: Zachary Scott Theatre Center Guild, 1980.

Statewide Committee of the Texas Women's Task Force. *Today's Kitchen: A Collection of Recipes Used by Employees, Directors and Their Spouses of the Rural Electric Cooperative System in Texas.* Austin: Texas Electric Cooperatives, Inc., 1979.

Steed, Frieda Reed. *A Special Picture Cookbook.* Austin, TX: Pro-Ed, 1977.

Sterling, David. *Yucatan: Recipes from a Culinary Expedition.* Austin: University of Texas Press, 2014.

The Story of Butter Krust Bread: Featuring Exciting New Recipes Made with Butter Krust Bread. Austin, TX: Austin Baking Co., n.d. [circa 1970s].

Strachan, Clarice Bowers. *The Diabetic's Cookbook.* Austin: University of Texas Press, 1955.

Styles, Camille. *Camille Styles Entertaining: Inspired Gatherings and Effortless Style.* New York: William Morrow Cookbooks, 2014.

A Super Book for a Super Cook. Prepared by Mrs. Worley's Third Grade Unit on "Care of Our Bodies," Lucy Read School. Austin, TX, 1971.

Szathmary, Louis. *Zachary Scott Theater Guild Presents Chef Louis Conducting a Two-Day Cooking School.* Austin, TX: Zachary Scott Theater Center, n.d.

Tarrytown United Methodist Church. *Eat at My Table: A Cookbook of Tempting Recipes.* Presented by the Tarrytown United Methodist Women of Tarrytown United Methodist Church. Collierville, TN: Fundcraft, 1993.

Tarrytown Wesleyan Service Guild. *Tarrytown Tasty Treats.* Austin, TX: Tarrytown Methodist Church, n.d.

A Taste of Victoria. Austin, TX: Hart Graphics, 1974.

Tate, Itasca, Vera M. Bothager and Eddie Langdon. *The Old Bakery & Emporium Cook Book.* Austin, TX: Best Printing Company, Inc., 1986.

Taylor Area Businesswomen. *Taylor Area Businesswomen Collection of Recipes: 2009 Cookbook.* Austin, TX: Aus-Tex Print and Mailing, 2009.

Temple, Ellen, with Patrick Hieger. *Temple Ranch Cookbook: A Tradition of Texas Conservation and Cuisine.* Austin, TX: Emerald Book Company, 2013.

Texas Association of Disability Examiners, Austin, Texas. *D.D.S. Lonestar Cooking.* Olathe, KS: Cookbook Publishers, Inc., 1991.

Texas Association of General Contractors. *Spec Book for Cooks.* Austin, TX: The Association, 1994.

Texas Department of Agriculture. *The Diabetic Cookbook.* Austin: Texas Department of Agriculture, 1985.

————. *A Honey of a Cookbook: Featuring Recipes Using Texas Honey.* Austin: Texas Department of Agriculture, 1981.

————. "Pecans and Other Nuts in Texas." *Texas Dept. of Agriculture Bulletin, New Series* 24. Austin, TX: A.C. Baldwin & Sons, 1916.

————. *Recipe Leaflets Collection.* Austin: Texas Department of Agriculture, 1970.

Texas Elks State Association. *Texas Elks Cooking 2008–2009.* Austin, TX: The Association, 2009.

Texas Federation of the Blind. *Where Good Cooks Get Together.* Austin: Texas Federation of the Blind, n.d.

Texas Hill Country Wine and Food Council. *Texas Hill Country Wine and Food Festival: A Cookbook, 1989.* Austin, TX: N Business Graphics, 1989.

Texas Wendish Heritage Society. *Our Favorite Cook Book.* Lenexa, KS: Cookbook Publishers, Inc., 1975.

Thompson, Stuart, with Angela Dennington and Zul Mukhida. *Chinese Festivals Cookbook.* Austin, TX: Raintree Steck-Vaughn, 2001.

3M Club. *Cookin' in Texas: A Collection of Recipes from the Employees of 3M Austin.* Austin, TX: 3M, 1988.

Time to Cook Our Mothers' Favorites. Prepared by Mrs. Worley's Third Grade Unit on "Care of Our Bodies," Lucy Read School. Austin, TX, 1964.

Tipps, Esther Knudson. *Cooking without Looking: Food Preparation Methods and Techniques for Visually Handicapped Homemakers.* Louisville, KY: American Printing House for the Blind, 1978.

Travis County Home Demonstration Clubs. *Golden Treasures, 1926–1976.* Austin: Texas Agricultural Extension Service, 1976.

Travis County Home Demonstration Council Cookbook Committee. *Travis County, Texas, 50th Anniversary Cookbook, 1926–1976.* Austin, TX: Travis County Extension Agency, 1978.

Travis County Medical Auxiliary. *Elegant Accents: Recipes from the Tasting Dinner 1985.* Austin, TX, 1985.

————. *Healthfeast.* Olathe, KS: Cookbook Publishers, Inc., 1986.

————. *Tasting Dinner Recipe Book for 1981.* Austin, TX: Travis County Medical Auxiliary, 1981.

————. *Tasting Dinner Recipe Book for 1984.* Austin, TX: Travis County Medical Auxiliary, 1984.

Travis, Roxana. *Emma's Cook Book.* Austin, TX: Alpha Chi Omega, 1963.

Travis-Williamson Counties Czech Heritage Cookbook. Audubon, IA: Jumbo Jack's Cookbooks, 1995.

Troxell, Richard K. *Barbecuing Around Texas.* Plano: Republic of Texas Press, 2000.

United Bank. *Fabulous Food for Fabulous People.* Austin, TX, 1984.

———. *Preview 1984 and Chocolates from Our Executive Dining Room.* Austin, TX, 1983.

———. *United Bank of Texas, 1983.* Austin, TX, 1982.

United Methodist Women. *Let's Break Bread Together.* Austin, TX, 1985.

United Methodist Women Evening Group. *A Rainbow of Heartwarming Recipes.* Austin, TX, 1988.

United Methodist Women of St. John's United Methodist Church. *St. John's Sampler.* Austin, TX, 1981.

United Methodist Women of Westlake United Methodist Church. *Food, Flame, and Friends.* Austin, TX, 1982.

University Methodist Church. *University Methodist Church Cookbook.* Austin, TX: University Methodist Church, 1907.

University of Texas at Austin. *The University of Texas at Austin Staff Cookbook.* Vol. 1. Austin: University of Texas Press, 1997.

University of Texas at Austin, College of Business Administration, Faculty Wives. *Spring Bouquet of Garden Salads.* Austin, TX: CBA Faculty Wives, 1979.

University of Texas at Austin, Department of Spanish and Portuguese. *Christmas Cookbook.* Austin, TX, 1969.

University Presbyterian Church. *Highland Cook Book: A Collection of Recipes Tested and Approved by the Women of Highland.* Austin, TX: Everybody's Book Store, n.d. [circa 1920s].

Urdaneta, Maria Luisa, and Daryl F. Kantor. *Deleites de la cocina Mexicana/ Healthy Mexican American Cooking.* Austin: University of Texas Press, 1996.

Uvezian, Sonia. *Recipes and Remembrances from an Eastern Mediterranean Kitchen: A Culinary Journey through Syria, Lebanon and Jordan.* Austin: University of Texas Press, 1999.

Violet Crown Garden Club. *Food by Design: A Cookbook.* Kearney, NE: Morris Press Cookbooks, 2010.

Von Rosenberg, Edna Lydia von Gonten. *Von Rosenberg Family of Texas Cookbook.* Austin, TX: Nortex Press, 1993.

Wagner, Candy, and Sandra Marquez. *Cooking Texas Style: A Heritage of Traditional Recipes.* Austin: University of Texas Press, 1984.

Walker, Rebecca. *Becky's Brunch and Breakfast Book: Recipes and Menus to Get Your Day Off to Its Very Best Start!* Memphis, TN: Wimmer Brothers Books, 1983.

Walker's Austex Chile Co. *Rare Recipes "From Mexico."* Austin, TX: Walker's, n.d. [circa 1930s].

———. *Walker's Red Hot Chile Con Carne Recipe Booklet.* Austin, TX: Walker Properties Association, 1918.

Walsh, Robb. *Texas Eats: The New Lone Star Heritage Cookbook, with More Than 200 Recipes.* Photographed by Laurie Smith. Berkeley, CA: Ten Speed Press, 2012.

Westlake Bible Church. *Celebrating Life: Westlake Bible Church Family Cookbook.* Austin, TX: Westlake Bible Church, 1988.

What's Cookin'. Prepared by Mrs. Worley's Third Grade Unit on "Care of Our Bodies," Lucy Read School. Austin, TX, 1970.

What's Cooking Good-Looking. Prepared by Mrs. Worley's Third Grade Unit on "Care of Our Bodies," Lucy Read School. Austin, TX, 1967.

White, Cissy, with Sue Reid. *In Short Order: A Convenience Foods Cookbook for the Instant Epicurean.* Austin, TX: Hart Graphics, Inc., 1981.

Williams, Edith Fletcher, with Mrs. E.G. Myers. *The Capitol Cookbook: A Facsimile of the Austin 1899 Edition with Added Photographs.* Austin, TX: State House Press, 1995.

Wills, Joany Bewley. *Who Is that Short Chef? The Official Cookbook for Kids.* Austin, TX: C&M Publications, 1983.

Wilson, Edwin O., and Jack Jackson. *Threadgill's: The Cookbook.* Atlanta: Longstreet Press, 1996.

———. *Threadgill's: The Cookbook.* Austin, TX: Eakin Press, 2002.

Wimberly, C.W. *Stone Milling and Whole Grain Cooking.* Austin, TX: Von Boeckmann-Jones Press, 1965.

Windle, Janice Woods. *True Women Cookbook: Original Antique Recipes, Photographs, and Family Folklore.* Austin, TX: Bright Books, 1997.

Winn Ford, Marjorie, Susan Hillyard and Mary Faulk Koock. *The Deaf Smith Country Cookbook: Natural Foods for Family Kitchens.* New York: MacMillian Publishing Co., Inc., 1973.

———. *Healthy Cooking from America's Heartland. Deaf Smith Country Cookbook: Natural Foods for Natural Kitchens.* Garden City Park, NY: Avery Publishing Group, Inc., 1991.

Wittenburg, Margaret M. *Experiencing Quality: A Shopper's Guide to Whole Foods.* Austin, TX: Whole Foods Market, 1987.

Women Interested in Serving Him (WISH). *Ladies Ministries Favorite Recipe Cookbook.* Austin, TX: Austin First Church of the Nazarene, n.d.

Women of Covenant Presbyterian Church. *Salads Galore.* Austin, TX: Covenant Presbyterian Church, 1971.

Women of Hyde Park Baptist Church. *Sharing Our Best: A Collection of Recipes.* Kearney, NE: Morris Press Cookbooks, 2004.

Women of Saint George's Episcopal Church, Austin, Texas. *Keeping the Feast: A Cookbook for the Christian Year.* Iowa Falls, IA: General Publishing and Binding, 1972.

Women of Saint Luke's on the Lake. *Manna from Heaven.* Lenexa, KS: Cookbook Publishers, Inc., 1978.

Women of the Dallas Southern Memorial Association. *The Old Dallas Cookbook: Remembrance of a Simpler City Life.* Austin, TX: Hart Graphics, Inc., 1985.

Women's Architectural League. *Designs for Food.* Austin, TX: Women's Architectural League of Austin, 1959.

Women's Art Guild of Laguna Gloria Art Museum, Inc. *Sampler.* Austin, TX: Hart Graphics, Inc., 1986.

Women's Society of Christian Service, Central Methodist Church. *What's Cooking in Our Swedish American Kitchens.* Austin, TX, n.d.

Woods, Estelle. *Buckeye Cookery and Practical Housekeeping: Compiled from Original Recipes.* Facsimile reproduction of the 1877 edition. Introduction by Dorman H. Winfrey. Austin, TX: Steck Warlick Co., 1970.

Yarborough, Ralph. *Campaign Cookbook: Recipes to Serve a Campaign Crew or Crowd.* Austin, TX, 1972.

YWCA. *Recipes from Around-the-World.* Austin, TX: YWCA, n.d.

Zilker Garden Club, Member Austin Area Garden Center. *Our Favorite Recipes.* Lenexa, KS: Cookbook Publishers, Inc., 1983.

Zonta Club of Austin. *Cook Book.* Austin, TX, n.d.

ABOUT THE AUTHOR
ABOUT THE
AUSTIN HISTORY CENTER

Mike Miller grew up in Plano, Texas. He has enjoyed eating food for most of his life, and before embarking on his career as an archivist/historian, he worked his way through grad school holding various jobs in the restaurant business, including having a minority stake in a small Italian restaurant in Princeton, Texas. He has been an archivist for more than fifteen years and has specialized in documenting and preserving local history, especially social and cultural issues (all history is local!). He is currently the city archivist for the city of Austin and the manager of the Austin History Center, Austin Public Library, where he directs all operations of the center, which basically means he pushes a lot of paper and attends meetings and his staff gets to do all the fun work. He has a BA in history from St. Edward's University and an MA in history and an MS in information science from the University of North Texas. Prior to coming to the History Center, he worked as the special collections librarian in the Texas/Dallas History & Archives Division of the Dallas Public Library, where he curated the Historic Maps and Kennedy Assassination collections. His primary research interests are in Texas sports history, and he has published articles on minor-league ice hockey in Dallas and Dallas sports czar Lamar Hunt; he is currently working on a book on ice hockey in Texas

(while the hip check may be a lost art on the ice, it can come in handy during a budget meeting). In fact, he's surprised he came out with a food book before a hockey book. In addition to his work at the History Center, Mike is also active with the Archivists of Central Texas, Society of Southwest Archivists and Texas State Historical Association and is a certified archivist.

AUSTIN HISTORY CENTER

The Austin History Center (AHC) is the local archives division of the Austin Public Library and is dedicated to preserving and celebrating the history of Austin and Travis County. The AHC is one of the premier local history collections in the country. It began in 1955 as a small collection of vertical file folders called the Austin-Travis County Collection in the Reference Department of the library and has grown to include:

- More than forty-five thousand published books and City of Austin reports
- More than seven thousand linear feet of archives and manuscript material
- More than one thousand historic maps
- More than one million photographic images
- More than twenty-five thousand audio and video recordings

In addition, the AHC acts as the official archives for the City of Austin, caring for all historic and archival city records. The City Archives includes copies of city reports published by all departments; records of former mayors, council members, city managers and assistant city managers; and records created by various city departments. The AHC procures, preserves, presents and provides access to information about local government, businesses, residents, institutions, organizations and neighborhoods in the Greater Austin area. MyTravelGuide™ calls the AHC "one of the state's best local history collections," Fodor's calls the AHC "a priceless collection of things relating to Austin, and *Library Journal* calls it "one of the premier local archives in the country." The AHC is housed in the historic 1933 Austin Public Library building (Recorded Texas Historic Landmark and National Register of Historic Places), located at 810 Guadalupe in downtown Austin. Learn more at www.austinhistorycenter.org.